BRING THE FUNNY

THE ESSENTIAL COMPANION FOR THE COMEDY SCREENWRITER

Finally . . . a funny book about comedy screenwriting from a successful screen-writer that uses recent—as in *twenty-first century*—movies you've actually seen as examples!

Greg DePaul (Screenwriter, *Bride Wars*, *Saving Silverman*) has sold comedy screenplays to Miramax, Fox, Disney, New Line, Sony, MGM, and Village Roadshow. He's worked with stars like Jack Black, Kate Hudson, Jason Biggs, and Amanda Peet.

Now Greg takes everything he knows about writing funny and breaking into the biz, tosses it into a blender, and serves up this tasty, fat-free smoothie of a book that's easy to read, brutally honest, and straight from the heart . . . of Hollywood.

If you're looking to write comedy screenplays, buy this book now. But if you're ready to pack up your car, drive to Los Angeles, and live your dream of becoming a comedy screenwriter, steal this book, jam it into your pocket, and hit the gas.

HIGH PRAISE FOR *BRING THE FUNNY*

Bring the Funny is a manual on writing comedy screenplays that is for all levels: beginner, intermediate, and advanced. It can be highlighted, bookmarked, and kept right by the computer throughout a career. With directness and wit, DePaul covers a wide range: the exploration of genres, finding your own style, creating characters and premises—all framed by a pragmatic road map for the film industry. It's filled with brass-tacks pointers for making your comedy work on the page—for readers, buyers, and performers.

Jim Uhls, Screenwriter, *Fight Club, Jumper*

Comedy demands high stakes, and telling the truth within those stakes requires very careful construction. *Bring the Funny* is a crucial reminder of all the factors that determine whether or not a great idea becomes a successful piece of comedy. Greg's points on character, premise, style and genre illustrate why this handbook is the essential guide for the comedy screenwriter. Greg DePaul writes Funny.

Kevin Kane, Emmy-winning Producer, *Inside Amy Schumer*,
Consulting Producer, *MTV Movie Awards*,
Special Consultant for Judd Apatow, *Trainwreck*

If you want to get into screenwriting—buy this book. *Bring the Funny* is no-nonsense, insightful, and really good. Our only hesitation in recommending it would be that, if you actually follow DePaul's advice, there will be more competition for us.

Lisa Addario and Joe Syracuse, Screenwriters, *Parental Guidance*,
Surf's Up

DePaul's credentials are impeccable as both a successful comedy screenwriter and an instructor of comedy writing. *Bring the Funny* covers all the bases in a way that's fun to read. It also contains lots of practical, hard-won advice for the aspiring writer. I can't wait to use *Bring the Funny* in my comedy writing classes.

George Rodman, Professor, Brooklyn College

Bring the Funny is a primer on twenty-first century film comedy. Using only movies made after 2000 as examples, Greg explains the craft and business of comedy screenwriting in a way writers can grab and immediately use. He also gives you a whole new vocabulary for writing and working with producers—tools you need to succeed in this crazy industry. Buy it, read it, and keep it close by when you screenwrite. You'll need it.

Hank Nelken, Screenwriter, *Are We Done Yet?*

Greg DePaul totally brings the Funny!

Alan Riche, Producer, *Southpaw, Starsky and Hutch, Tarzan*

BRING THE FUNNY

The Essential Companion for the Comedy Screenwriter

Greg DePaul

Routledge
Taylor & Francis Group

NEW YORK AND LONDON

First published 2017
by Routledge
711 Third Avenue, New York, NY 10017

and by Routledge
2 Park Square, Milton Park, Abingdon, Oxon OX14 4RN

Routledge is an imprint of the Taylor & Francis Group, an informa business

© 2017 Greg DePaul

Library of Congress Cataloging-in-Publication Data
CIP data has been applied for

ISBN: 978-1-138-92926-5 (hbk)
ISBN: 978-1-138-92925-8 (pbk)
ISBN: 978-1-315-68132-0 (ebk)

Typeset in Times & Courier
by Apex CoVantage, LLC

CONTENTS

Act 2: You vs. The Page

Act 3: You vs. The World

ACKNOWLEDGMENTS

A whole lotta folks deserve to be thanked:

First, my wife, Dvora, supported the writing of this book, though most of it happened at the expense of our time together; after all, I could have spent those hundreds of hours rubbing her back or cuddling in front of an old movie. My loss. But thanks, sweety.

The same could be said for Sophie and Max, whom I could always happily be coaching, hugging, and watching grow. Thanks, guys. You're the best.

A handful of people have influenced my screenwriting. Hank Nelken was a great partner and remains the industry's most under-utilized talent. Jim Uhls was the first great writer to help me. Dennis Palumbo listens. Sure, he gets paid, but . . . still, he listens.

You can always learn something from actors. I thank the gifted performers at The Collective in New York, as well as the Clark Street Players and the Writers and Actors Lab in Los Angeles.

Will Akers advised me about writing a book. That's a pretty nice thing to do. Again, great thanks to Dvora, who read and re-read. Amy DePaul helped as well. Thanks also to my good friends in the Stillwater Writers Group: Dave Hanson, Craig Nobbs, Sharon Cooper, Craig McNulty, and William Fowkes. Thanks to Johnny Coppola for help with pictures.

And thanks to my students at The New School and New York University. Without you, I'd just be standing in a room, talking to myself.

Act 1

YOU vs. YOURSELF

1

THE FUNNY

WHAT IS THE FUNNY?

Honestly, I have no idea.

I can only tell you that I have the Funny and I know plenty of other screenwriters who have it, too. I also know screenwriters who do *not* have it.

I once dated a successful TV drama writer. She took everything she did very, very seriously and couldn't crack a joke to save her life. Years later, I met a woman who was born with a considerable funny bone, my wife. We have two kids. Sometimes I think back on what I could have gotten out of marrying that first woman, the woefully unfunny one. As we were in California, I could have ended up with half of her bank account in a massive divorce settlement. But, alas, I wanted the funny girl. And funny kids.

And thank God for it. Because I love them funny kids. And the wife.

In any event, the Funny is hard to define. But I certainly know when I see it . . . in movies.

In *The Hangover*, it's the fun-loving desire to see everything get more crazy, more out of control, more dangerous.

In *The Lego Movie*, it's the urge to tell an epic story in a tongue-in-cheek manner, making fun of the yarn as it is being spun.

In *Anchorman*, it's the silly thrill of seeing a big, goofy curmudgeon bungle and misstep through every situation he finds himself in.

I don't know how I got the Funny. My parents weren't funny. My mother was a housewife, and my father was an attorney who specialized in defending murderers. That's not funny, right? Well, it was to me. There was something about a guy making a living from death that always struck me as funny.

But enough about me.

Now I want you to ask yourself . . .

DO I HAVE THE FUNNY?

I sure hope so.

If you love to joke around with your friends and live for those moments when you can crack wise, you probably do. If you were the class clown, almost certainly. If you're normally shy, but secretly giggle to yourself when you see an old lady slowly pushing her walker up a steep hill toward a banana peel, most definitely. Note: if you put the banana peel in her path, then you are both funny and *sick*, for which you should seek help.

Of course, not everyone who has the Funny shows it. I've known comedy writers who rarely utter a funny word and then sit down and write themselves a cracklingly raucous screenplay. Perhaps that's you.

If you want to find out how funny you are, spend no time doubting yourself. Think instead of that quote from the Bible—which, to some, is a very funny book, indeed. The quote goes something like this: "Act as if ye have the Funny, and the Funny will follow."

OK, that's not exactly, word-for-word, from the Bible, but you get the idea. The point is—if you have the Funny and you want to apply it to screenwriting, you're holding the right book. Stick it in your back pocket and it'll be like you've got a little me hanging onto your butt wherever you go. OK, that came out wrong. Let's start over . . .

Years ago, when I was breaking into screenwriting, I had a difficult struggle on my hands. I had moved to Los Angeles,

had no friends, and was working a dreary day job to pay the rent. At night, after work, I fought to keep myself glued to the chair so I could write my way into Hollywood. Sometimes I fell asleep at the computer and woke up the next morning with the imprint of a space bar on my forehead.

When I called my dad back East and told him how hard I was working and how exhausted I was, he mailed me a note that read, "Hang in there. Sleep less, work more."

Dad was practical.

So I quit my day job, sold my car for rent money, and did nothing but write for months. Thus began my full-time pursuit of the Funny.

Eventually I started writing with a partner, Hank Nelken, who also quit his day job in search of the Funny. Together, we pushed ourselves to sleep less and work more. Within a year we sold our first script. Within three years, Sony Pictures was shooting our movie.

So if you're still unsure if you have the Funny, the best advice I can give is to act as if ye have faith and find out.

NO, YOU CAN'T ORDER IT ONLINE

Would you believe there is screenwriting software that purports to make you funny? Would you believe there are writers who would buy it? *That's* funny.

When I first decided to screenwrite, I bought all the reigning books on the subject by all the well-known gurus. I urge you to do the same. In fact, read *every* book about screenwriting—twice. After all, if you really want to write screenplays that sell and get made, you should be reading everything you can possibly find on the subject you're about to spend years of your life pursuing.

However, most of those books suffer from one or more of these faults:

1) The authors have little or no track record as screenwriters.
2) Their books don't deal with writing *funny*.
3) They often use old movies as examples—movies you probably haven't seen unless you're, well, *old*.

To my knowledge, this is the first and only book by a produced screenwriter about comedy screenwriting that only discusses recent movies. And by "recent," I mean movies made in the twenty-first century—the one we're living in. The oldest movie I reference here is a classic called *Saving Silverman* (2001). The latest is *Trainwreck* (2015).

Now that I've implied *Bring the Funny* is the greatest thing about this new century (other than, say, smart phones or pizza delivery by drone), I want to take a quick step back and make sure you've read *Screenplay*, by Syd Field. It explains the three-act structure, which applies to almost all movies, and is referenced in this book. Read it along with Robert McKee's *Story* and Blake Snyder's *Save the Cat!*, both of which should remain on your bookshelf throughout your screenwriting career.

Remember: there is no fast and easy way to bring the Funny. It requires heaping amounts of talent and hard work. From this point on, I'm going to assume you have the Funny and show you strategies and habits for writing comedy screenplays that will shorten your learning curve and maximize what God (or nature or whatever) gave you.

This book isn't a step-by-step guide or a paint-by-numbers workbook. It's a *companion*—organized by subject matter and meant to be kept by your writing table for repeated use. Read the chapters in reverse order if you like. But read them.

And just to keep you on your toes, I want you to take this . . .

POP QUIZ!

1. The Funny is:
 A) Hard to define.
 B) Easy to see in movies like *The Hangover*, *The Lego Movie*, and *Anchorman*.
 C) What that TV drama writer in Greg's story did not have.
 D) All of the above.

2. **If you wanna find out if you have the Funny, you should:**

 A) See a doctor immediately.
 B) Ask Greg's dad. He seems to know stuff.
 C) Toss a banana peel in front of an old lady. Laughing yet, sicko?
 D) Act as if ye have the Funny.

3. **When it comes to books about screenwriting, you should read:**

 A) Books by Robert McKee, Syd Field, and Blake Snyder.
 B) Books by Greg DePaul.
 C) All of the above, over and over, until you can recite them out loud by memory. Personally, I like to do mine with a Scottish accent, but it's up to you.
 D) The Torah. Hey, can't hurt.

2

EVERYTHING MATTERS

When I first arrived in Hollywood, I had no friends and no connections. But before I could start making friends and connections, I needed to pay the rent. So I went to a temp agency.

That's where I met Doug, the manager of the agency. Doug was extremely heavy and very chatty. Before I could hand him my resume, he cut to the chase . . .

"Writer or actor?" he said.

"Writer," I told him.

"I'm a comic actor," he told me. And he went on to explain exactly how he intended to be the next hugely successful overweight movie star.

This was the late 1990s. According to Doug, there was an unbroken chain of funny obese movie stars stretching all the way from Fatty Arbuckle in the 1920s to John Belushi in the 1980s and Chris Farley in the 1990s. Naturally, Doug would be the next to break . . . soon.

Now if I had a dollar for every wacky story every crazy Hollywood actor ever told me about how he or she was destined for fame, I'd be a bazillionaire. But Doug did tell me something useful.

He told me to go see John Shaner.

John Shaner is a produced screenwriter who, as far as I know, still lives in Hollywood, where he gives private lessons in screenwriting to a small group of students.

I started taking lessons from John. And John happens to be an old friend of Jack Nicholson, who apparently once told John that his motto for success in the entertainment industry is this: *everything matters*.

That's right. Everything.

So if you're a screenwriter, it means the story matters, the dialogue matters, the format, the punctuation, the spelling, the title, the type of brads you use to bind the script . . .

It all matters.

And if you want to succeed as a screenwriter, you must bend every part of your life toward that overarching goal. Because it all matters. The car you drive, the place you live, the people you date, your socks.

Yes, your socks. You probably think I'm kidding at this point, but even *that* matters. Yes, even your attitude about me, Greg, matters because following my advice will help you, and I can't help you if you think I don't matter.

OK, I'll stop.

But know this: if you're diving into a career as a comedy screenwriter, you're jumping headfirst into a hornet's nest of talented, desperate people from all over the world . . . all with an overwhelming drive to make it before you. *Despite* you.

They will feast on your bones. Your comedy bones.

Which is why you need to close your eyes, kick your feet together like Dorothy in *The Wizard of Oz*, and say, over and over, to yourself—*everything matters*.

Then do some heavy breathing and read on, because I'm only just starting to school you.

PREPARE YOURSELF

Speaking of stuff that matters, I'm going to tell you the most important key to success as a screenwriter—diagramming.

Bored yet? Don't be. Skip ahead and ignore this section at your peril, because the skill I am about to show you is as necessary for your success as would be a compass to a person lost in the wilderness. Or flint. You use flint to make fire, right? I don't know. I've never been lost in the wilderness. But I have been lost in Hollywood, and diagramming is the skill that kept me from panicking and running back to Maryland, from whence I came, with my tail between my legs.

Whenever I go to a party hosted by a successful screenwriter—and I define successful as, well, having better credits than, say, me—I find myself nosing around.

At some point, I'll need to visit the rest room, and, when I do, I make sure to wander there via the longest possible route through as much of the house as possible. The reason— I want to see the host's office, or at least the library. Wherever she or he actually sits and writes.

And what I inevitably find in that office or library—and sometimes the bathroom—is a huge pile of scripts. And those scripts are usually accompanied by extensive notes. That's because successful screenwriters read each other's work. Compulsively.

If you are a TV writer, you read TV scripts. If you are a comedy screenwriter, you read every comedy screenplay for every comedy film that's ever been made: the ones you love, the ones you hate—all of them. And that includes unproduced spec scripts—by your friends, by writers you've never met, by anyone. You read everything and study it, especially everything in your genre or any genre you're considering writing.

And when you read those scripts, you make notes. You chart the structure of the story so that you can easily review it later. All successful screenwriters do this differently, but they do it.

Not only do you diagram to unlock the secrets of a particular script, but you diagram to coach yourself into being a better writer. Check this out . . .

Here's a diagram of *Trainwreck*. Each paragraph represents a scene in the movie.

———

TRAINWRECK (2015)
Written by Amy Schumer

Act 1

Flashback: In the 1990s, Gordon TELLS his daughters (including young Amy) that monogamy is impossible.

CUT TO current day: Amy, grown up, SLEEPS with random guys, never stays the night after sex, and tells us in voiceover she cheats on her boyfriend.

Amy BREAKS her no-sleepover rule with a guy. (6)

At work (Amy works at a magazine), Amy and Nikki, her friend, JOKE about sex.

Their boss (the editor) BULLIES Nikki.

Writers PITCH ideas for articles to the boss.

Amy PITCHES an idea, but the boss REJECTS it and INSTRUCTS her to write an article about a sports doctor. Amy RESISTS, but the boss DANGLES a promotion if Amy does well with the piece. Amy TELLS her she needs money to help Gordon, who now suffers from multiple sclerosis.

Amy and Kim, her sister, MOVE Gordon into an assisted-living home. They REMINISCE about, and CRITICIZE, Gordon for being a bad father years ago.

In bed, Amy MAKES Steven, her boyfriend, TALK DIRTY. He TRIES, but FAILS.

Amy BEFRIENDS a homeless man.

Gordon ACTS OUT at his new home. Amy struggles to CONTAIN him. (21)

Act 2

Amy INTERVIEWS Aaron, the sports doctor, and meets his best friend, Lebron James. Amy PRETENDS to know a lot about sports but Aaron FIGURES out she's lying.

At a movie, Steven CONFRONTS an angry guy but USES words that make Amy WONDER about his sexuality.

Steven DISCOVERS that Amy cheats on him.

Amy LEARNS Kim is pregnant.

Amy and Kim TELL Gordon about Kim's pregnancy and Gordon CRITICIZES Kim's stepson for appearing weak.

Amy INTERVIEWS Aaron and JOKES with him, FLIRTING.

Kim TELLS Amy she's moving Gordon to a cheaper home and Amy PANICS, worried. Aaron TAKES Amy to dinner.

Amy and Aaron MAKE LOVE. Amy wants to leave before morning and STRUGGLES to stay the night. (45)

At work, Donald, Amy's young intern, tries to LEARN from her, but Amy IGNORES him.

Aaron REACHES OUT to Amy, CALLING her the day after sex, but Amy REFUSES to believe it's really happening.

Aaron ASKS for Lebron's advice about Amy, but Lebron tries to CONVINCE Aaron to move to Cleveland. (52)

Amy WATCHES Aaron OPERATE on a patient. Aaron ASKS Amy to make a commitment to him, but she RESISTS.

Gordon gets hurt at the home, and Amy GOES there to help. (54)

Aaron TREATS Gordon, CHARMING Amy.

Amy CONFESSES to Kim that she likes Aaron so much it scares her.

Lebron GRILLS Amy about her intentions with Aaron.

Montage: Amy and Aaron in love and happy . . .

Lebron PLANTS doubts in Aaron's mind about Amy. (67)

At Kim's baby shower, Aaron MAKES friends, WORKING his way into Amy's life.

Aaron SAYS he wants to have kids, GIVING Amy an anxiety attack.

Kim's husband PLANTS doubts in Aaron's mind that Amy is promiscuous. (70)

Amy ALIENATES other women by TALKING bluntly about her sex life.

Gordon dies. (73)

At the funeral, Amy EULOGIZES Gordon, EMBRAC-ING his complexity.

Kim CRITICIZES Amy for how she treats her family. Amy REJECTS her criticism.

Aaron TELLS Amy he loves her, but Amy BERATES him.

Montage: Amy is sad without Aaron . . .

Amy's boss CANCELS the article she wrote about Aaron. (80)

The night before an event honoring Aaron, Aaron TELLS Amy he is nervous and ASKS for her support.

At the event, Amy TAKES a phone call during Aaron's speech, causing them to FIGHT. He ACCUSES her of not supporting him. (90)

Aaron and Amy TRY to work out their problems but ARGUE all night.

The next day, Aaron goes to work, exhausted, and accidentally HARMS a patient.

Amy and Aaron FIGHT. He CRITICIZES her life-style. They BREAK UP. (95)

Act 3

Donald COMES ON to Amy and she GOES TO BED with him before she LEARNS he's underage and his mom CATCHES them in bed.

Amy's boss FIRES her because of the incident with Donald. (100)

Montage: Amy and Aaron both feeling lonely . . .

Aaron OPERATES on the patient he harmed and, this time, SUCCEEDS.

Lebron STAGES an intervention to CONVINCE Aaron to get Amy back, but Aaron RUNS away. (105)

Amy APOLOGIZES to Kim for mistreating her and CONFESSES that she feels "broken." Kim's stepson MAKES Amy miss Aaron. Amy and her family BOND.

Amy CLEANS out her life. (111)

Amy SELLS her article about Aaron to a different magazine.

Amy STAGES a big dance number with cheerleaders to WIN Aaron's heart, and they KISS.

I've diagrammed hundreds of movies, and I always learn something from it. You can diagram while slowly watching the movie—your finger perched over the pause button—or reading the script.

In either case, the diagram should be written in shorthand. Don't tell the whole story or get into the details. Just break the story into three acts, as per Syd Field, occasionally noting

Amy Schumer diagramming her next screenplay in her head.

the amount of minutes or pages that have passed by putting that number in parentheses.

Most importantly, describe the actions of the story using CAPS. A screenwriter's greatest enemy is passivity. When characters fail to act—especially protagonists—they bore us. And, as we'll discuss later in this book, good drama usually results from active characters making choices and taking actions throughout a story. Use CAPS to remind yourself that screenplays need ACTION in every scene. Again, you're coaching yourself to be a better screenwriter.

Of course, actions can be subtle and subtextual. Diagramming a different movie—one that I'll make up for purposes of example—you might write something like this:

```
Wendy UNDERMINES Paul's feelings of self-
worth by IMPLYING he can't handle his new job.
```

Or this:

```
George RECONSIDERS marrying Wendy, then
EMAILS her to TELL her the marriage is off.
```

But don't stop there. If you're anything like me—or many other screenwriters—you may also need to remind yourself that actions need obstacles. You can do that by using the words *despite* and *but* in your diagram.

So instead of writing this:

```
Martha SEDUCES Simon and tries to STEAL the
diamond.
```

You write this:

```
Martha SEDUCES Simon despite Simon's drunk-
enness, and tries to STEAL the diamond
despite the fact that he doesn't have it.
```

Or possibly this:

```
Martha SEDUCES Simon and tries to STEAL the
diamond, but Simon THROWS UP on her dress
and CONFESSES he hasn't got it.
```

Below is the beginning of a diagram of *21 Jump Street*. The movie made over $200 million, so it's worth more than a passing glance. As you'll see, I use *despite* and *but* in liberal amounts.

––––––

21 JUMP STREET (2012)
Screenplay by Michael Bacall, Story by Michael Bacall & Jonah Hill

Act 1

Flashback to eight years ago: Schmidt, a nerdy high schooler, ASKS a girl to the prom *despite* the fact that he's incredibly nervous, *but* Jenko, a jock, HUMILIATES him.

The principal BARS Jenko from prom because his grades suck *despite* Jenko PLEADING with him.

CUT TO present day: Schmidt and Jenko meet at the police academy. Jenko FAILS an exam, then ASKS Schmidt to be friends *despite* what happened in high school. Schmidt AGREES *despite* his fear of Jenko.

Schmidt and Jenko BOND as they HELP each other graduate *despite* the difficulties of making it through the academy.

Later, as cops, they try to PATROL on bikes, *but* hate it.

They try to BUST some drug dealers, *but* fail. (9:21)

––––––

I'll stop here. You can find a full outline of *21 Jump Street* in the back of this book.

Again, it's amazing what a few little words can do. *Despite* and *but* help identify the dramatic obstacles that

prevent characters from achieving their goals—or at least achieving them easily.

As a general rule, it should be incredibly difficult for characters to achieve their goals—otherwise there's no story. After all, Little Red Riding Hood needs her Big, Bad Wolf. There's no story without him.

In the movie *The 40-Year-Old Virgin*, Andy (played by Steve Carrell) needs his fear of intimacy. In *Meet the Parents*, Greg Fokker (Ben Stiller) needs his imperious father-in-law (Robert De Niro). In *Anchorman*, Ron Burgundy (Will Ferrell) desperately needs Veronica Corningstone (Christina Applegate). Without her, who would confront his bloated self-image and keep him from achieving his goals?

I didn't invent diagramming. I just personalize it to fit my unique needs as a screenwriter. You should do the same.

How long must screenwriters continue diagramming movies? For as long as they want to continue working in the industry.

Seriously. This is what working writers do to stay working. If I'm lucky enough to get hired to write an adaptation of a comic novel about soccer, then you can bet the first thing I'm going to do once I get the gig—after I pay off my credit card balance and take my agent out to dinner—is to diagram every comedy movie I can find about soccer.

Actually, by the time I get that gig, I've probably already diagrammed those movies because that's how I earned the job—by researching every soccer movie and sports comedy ever made. Which allowed me to explain to the producers why mine would be even better—no, wait: the greatest sports comedy ever put on film.

I know what you're thinking. If you spend a lot of time researching other people's movies, you'll lose yourself. Your sense of specialness as a writer will slip away. Or even worse—you'll become redundant. Your writing will stink to high heaven with the pungent odor of recycled moments from other peoples' movies.

You should be so lucky.

Becoming a successful screenwriter means building on your knowledge of what other successful screenwriters have done and are currently doing. It means never writing in the dark.

Whether you use the most basic form of diagram, like the one I showed for *Trainwreck*, or the more comprehensive type I used for *21 Jump Street*, the point is to do it—over and over until your eyes hurt and your fingers beg you to stay far, far away from the keyboard. Because that's a good sign. It means you may actually be doing enough diagramming.

And as you diagram all these screenplays, you need to ask yourself this question about each one: *Did the writer seek to sell or make this script?*

If the writer was strictly a screenwriter, looking only to *sell* the script, then the writer was writing to be read by a buyer. But if the writer intended to direct the movie, then, to some degree, the writer was writing for herself. And that's a very different kind of communication.

If you're writing scripts to sell, you should diagram screenplays that were strictly written for sale. They will be your best templates.

I've heard of screenwriting teachers who use *The Big Lebowski* as an example for students. Well, I have a problem with that.

Don't get me wrong. I love *The Big Lebowski*. It's one of my favorite Coen brothers movies. When Walter tells Donny, "I don't roll on Shabbos!" I'm on the floor laughing until I cough up my gefilte fish (and if you don't know what gefilte fish is, consider yourself lucky).

But here's the problem: *The Big Lebowski* is a Coen brothers movie. They are auteur filmmakers. And by the time they shot that script, they'd made six previous films, including the hugely successful *Fargo*.

So it's safe to say they were not writing for the studio reader—as you may be doing. No, it's safe to say they were writing primarily for themselves. After all, they know—unlike most screenwriters—that they will be the people shooting and producing their scripts. So their writing will naturally be different. Very different. They may write all sorts of camera angles into a script that you should not write unless you intend to shoot your screenplay. They may have already known which actors would play the lead roles, which you won't know when writing your spec script.

In fact, let me go out on a limb here and say that if *The Big Lebowski* had been written as a spec script by an aspiring screenwriter with no track record, it would never have gotten close to being bought or made. That's because the script presents a largely passive protagonist. And that's a killing flaw in just about any script, but it's even more deadly in a script that a writer intends to sell. After all, an aspiring, unknown screenwriter cannot say—as the Coen brothers can—"I can make it work."

And there's the rub. If you're not an acclaimed filmmaker with a long history of success, don't expect the industry to sit back and let you violate the rules of screenwriting. Nope, as an aspiring comedy screenwriter, you will be held to the highest standards of the profession. There will be no room for error, because nobody trusts you. So write with that in mind. Cut the camera angles and directorial description. Don't assume anything about who will be playing the lead roles.

But back to researching other peoples' scripts—when you are doing it (and you *must* do it), it is critically important that you know what you're reading and whether it's a good template for your own writing.

The same goes for *whom* you are reading, which is why you must . . .

FOLLOW YOUR HEROES

A great man once said, "If I have seen farther than other men, it is because I stood on the shoulders of great men." That man was Sir Isaac Newton, and it is a fair bet he never expected to be quoted in a book about comedy screenwriting.

If you want to be a writer/director/producer like Judd Apatow, study Judd Apatow. Know what he did to break into the business. Did he go to film school? (He didn't, actually.) Did he start by moving to Los Angeles? (He moved there after producing live comedy shows in other places.) It took me five minutes to learn that. Use Google. God gave it to us for a reason.

Research everybody and everything related to the industry you want to break into. Read *Variety* and *The Hollywood*

Reporter and visit IMDB, Donedealpro, Box Office Mojo, and other websites that give you background information on people whose careers you seek to emulate. If someone has sold a script or made a movie, find out how he or she broke into the business. This will help you craft your comedy screenwriting career.

Sure, you could break in using some new strategy that nobody's ever thought of. But actually . . . no, you won't.

And, for the record, you probably won't break in as a screenwriter via the internet—whether by making short videos and sticking them on the web or by putting your scripts online, as some aspiring screenwriters do. The reason: the web has no barrier to entry. When you tell people, "I have seventeen short videos on YouTube," you have told them nothing. There are unborn children with videos on YouTube.

Of course I realize that, after this book is published, there may be the occasional screenwriter who succeeds by doing what I said not to do—just as there will be the occasional writer who somehow gets discovered from, say, Saskatoon. (That's a place in Canada.)

But those events, if they ever occur, will be atypical. Anomalies. And, no matter your level of talent, if you are committing years of your life to this profession—which rewards so few and leaves so many brokenhearted—you are already betting on a long shot. Don't make it even longer. Stick to the established paths of entry and save your creativity for the page, where it counts.

I guarantee you that, if you study up on your comedy screenwriting heroes, you will discover the common strategies that vaulted them to the top. And then you should do as they do.

Of course, there's only so much you can learn from afar. Most of us can't take a class from Judd Apatow. But we do need to be constantly learning, and that requires teachers, which is why you should . . .

MIND YOUR MENTORS

The world isn't hurting for teachers of screenwriting. It seems like everywhere you look, there are more and more

people offering themselves as instructors in the craft. Some have degrees in screenwriting, for whatever that's worth. A few have actually had success selling scripts, and only a small percentage of those have actually gotten movies made. An even smaller number have been there and done that, and are effective at explaining to others how to do the same.

Who is qualified to teach the craft? After all, many of the best sports coaches were not stars when they played ball. Clearly, someone who is not gifted as a writer may nevertheless be gifted as a teacher of writing. That person may simply be able to recognize what others need to do to succeed and be good at helping them do it.

I've had three movies made, and I won't claim any of them are Oscar worthy (though *Bride Wars* did earn $115 million). So factor that into your judgment of what I teach.

The point is that great teachers don't have to be great writers.

And there are great writers who shouldn't teach—writers whose creative work is spun gold, but who can't teach to save their lives. There is a reason for this phenomenon. Many of those great writers have internalized their writing habits and strategies to such a degree that they can't articulate them; they can only *do* them. But if they can't explain to a room full of writers what they actually do when they sit down to write, they're useless as teachers.

And then, of course, there's the (previously) unstated theme of this book, which I'll state here: *you must teach yourself how to screenwrite.* I would put that on the cover, but then you wouldn't have bought the book. Thanks, by the way. My kids need to eat.

Don't get me wrong: as I said earlier, you need this book. But your main resource is yourself. To follow my method, you must diagram a great many scripts and learn from them. Then you must sit down to write for . . . I dunno . . . *years.* That's my method—research and endless work. I only teach you how to fish—you're the one who must bait the hook and sit there hot summer day after hot summer day.

If you feel the need to seek out other teachers, I won't be insulted. You must be selfish. Your only goal must be to

improve your craft. Just be choosy. When you decide whose advice and teachings to follow, I strongly suggest you read their scripts.

Just as I read the work of John Shaner before I took his class, I also read the work of Mark Stein, whose screenwriting class I took. Mark wrote the script for the movie *The House Sitter*, as well as many plays, some of which I read.

Why? Because I needed to confirm that Mark knew something about writing. After all, you wouldn't go to a college you hadn't read up on, would you? You don't see a play or a film before at least scrolling through the reviews, do you?

But when you're checking up on possible mentors, remember this: *you can't judge screenwriters by their movies.*

Notice that I didn't say I had *seen* Mark's movie, *The House Sitter*. Yes, I have actually seen the film, but that wouldn't tell me if he's a good writer. After all, great screenplays don't always become great movies. Very often, the opposite occurs. There are talentless directors, bad actors, horrible editors . . . and a host of other reasons a good script can go bad.

And I won't even start about *re*-writers, whose sole goal is usually to gain screen credit. (One trick to making it seem like re-writers have made a major contribution to scripts is for them to change all the characters' names. This takes about three minutes using "Find and Replace," and . . . *voila!* . . . they re-wrote it!) OK, I *did* go on about re-writers, but now I'll stop.

So when you're doing background checks on prospective screenwriting teachers, remember to get ahold of scripts that the writer actually wrote and that were not *re*-written by someone else. The writer's *work* should impress you, not the movie's production values. After all, you're not trying to shoot movies; you're trying to write them.

Hold your mentors up to scrutiny and see what shakes out. Being able to say "I took a class with so-and-so" means nothing to a producer whom you want to buy your script. All the producer will want to know is this: *Is the script great? Can I make money with this?*

And those questions can only be answered on the page.

LIVE THE PAGE

In case you haven't guessed from what you've read so far, comedy screenwriting isn't a nine-to-five vocation. It's not even nine-to-nine. It's an every-moment-of-your-life kind of thing. To maximize your chances of success in a field where almost all aspirants fail, you must wring every possible drop of advancement from every possible minute of every day.

In other chapters, I discuss how to mine your daily life for script ideas and how to overhear dialogue to improve your own. Here I will tell you how successful comedy screenwriters walk and talk and go about their daily lives . . . so that you may emulate them.

First, a successful comedy writer is a social butterfly. I know what you're thinking (especially if you've skipped ahead and read Chapter 3): "Greg, you write over and over that I should keep my ass in the chair for as long as possible. But now you say I need to be a social butterfly?"

Yes.

You must sit alone in a quiet room and write for as long as you can possibly stand it, and you must also—in your rare breaks from your lonely toil—go out and meet everybody who can help you. And when you're an aspiring comedy screenwriter, that's just about anybody in the industry.

I'm not just talking about mere socializing. Yes, it's important to attend parties and other events where writers, actors, and other creative types can be schmoozed. But it's also critical that you roll up your sleeves with other screenwriters. And that means writing classes and writing groups.

When I first showed up in Hollywood, I took a day job at a company that published entertainment-industry reference books. The office was situated within a complex of post-production facilities where stars, directors, and the like could be seen on a daily basis. My boss took the profits he made publishing books and ploughed them into movies, which he wrote, directed, and produced. I hated my job, but the location was hard to beat for a young screenwriter looking to meet the right people.

Eventually my boss introduced me to members of his writing group, the Writers and Actors Lab. They met on Monday nights in a creaky, old theatre in Hollywood. For a while, the Writers and Actors Lab was the only extracurricular activity I had. Monday night felt like a holiday to me because I had waited all week for it.

In the WAL, actors performed scenes from writers' unfinished screenplays. Afterward, the audience critiqued the writing. This gave screenwriters a chance to try out their work among colleagues before exposing it to the industry. When the work was finished, we all went to a bar and schmoozed. That's how I met the group of creative professionals I would depend on for years to come, including screenwriters with studio deals and produced credits. I was playing in the minor leagues, but there were major leaguers all around.

And some of those major leaguers became my mentors. The notes they gave me were invaluable to my maturation as a screenwriter because I knew exactly where they were coming from. When you know the background of the person giving you notes, the notes resonate.

It takes a village to raise a screenwriter—a village full of other writers, actors, and filmmaking professionals. Working writers who want to stay working populate their world with friends who can help them and whom they can help. (They also carry a little notebook to scribble down ideas and do some pretty crazy stuff to come up with stories.) But let's save that for a later chapter so we can get to our . . .

POP QUIZ!

1. **Before taking someone's screenwriting class, you should always:**

 A) Watch their movies. That's how you know if they can write, right?

 B) Sleep with them. Hey, it's Hollywood.

 C) Watch their movies *while* sleeping with them.

 D) Read their writing. Preferably in its original, unproduced state. Decide for yourself if they have something to teach you.

2. *Everything matters*, **including:**

 A) The quality of your writing.
 B) The number of brads in your script.
 C) Your ability to make friends in Hollywood. And that includes everyone from presidents of production to bathroom attendants. Because that guy selling mints and handing out towels could be the *next* president of production.
 D) All of the above. And, yes, this quiz matters, too, so concentrate . . .

3. **As an aspiring comedy screenwriter, you shouldn't compare yourself to some big-time comedy screenwriter who has totally made it because:**

 A) It'll only cause you to re-examine your strategy for success, which might actually increase your chances of breaking into Hollywood. So don't do it. OK?
 B) You're gonna be the first successful comedy screenwriter to make it from Michigan's Upper Peninsula, so there's no need to move to L.A. like almost every other screenwriter who's ever broken in.
 C) Everybody does things their own way, so some other writer's life story isn't something you can learn from. Better to blaze a new trail and do everything *your* way. Sorta like Sinatra. Or Carrot Top.
 D) For Pete's sake, compare yourself. It's for the best.

4. **To meet as many people in the industry who can help you as possible, you should:**

 A) Join a writers group.
 B) Join an improv group.
 C) Move into a hospice.
 D) All of the above, assuming at least one patient in the hospice is related to a successful agent or producer that the patient can get your script to.

3

GET ON YOUR HORSE

Talent. That's what you are.

I don't mean talent in the sense that you're good at something (though I hope you're darn good at writing if you intend to become a screenwriter). I mean it in the *Hollywood* sense. "Talent" is the Hollywood term for all the creative folks who work in the entertainment industry: writers, actors, directors . . .

And talent is like a horse—that needs to be ridden.

That's why there are agents and managers. Because their clients need to focus on doing what they do best. Which does not include sending out headshots, scheduling meetings, or negotiating contracts.

Talent focuses on being creative and lets everybody around talent do the rest.

But while you, the comedy screenwriter, can have all those extra people working for you, you still need to manage yourself. You must be the rider of your own horse. And as a rider, you need to know your mount. Then you need to control it and ride it to victory.

In this chapter, we will focus on ways that you, the comedy screenwriter, must manage and apply your talent.

But first we need to clarify something . . .

WHAT IS A SCREENPLAY?

A screenplay is a proposal for a movie.

That's all.

When you, the screenwriter, embrace this definition, you will be happier. You will focus on doing the only thing a screenwriter must do—help make a movie.

Some claim screenwriting is an art form. But unlike other forms of creative writing, a screenplay does not stand on its own. It is not literature. You cannot read a screenplay to yourself and have a true artistic experience. You may be able to imagine the movie that would be made from that script, but that's a different experience altogether because you're imagining the end product. Screenplays are about potential.

Once a movie is made, the script becomes useless. Right into the shredder. Unlike a play, no one will ever produce another version of that script.

I'm not saying a screenplay should be as dull as, say, a contractor's proposal to renovate a basement. Totally the opposite. When you screenwrite, you must not only tell a compelling story; you must communicate in a nuanced manner to a variety of sophisticated professionals. You must show the producer why the concept will succeed, give the director a game plan for making the film, and tell the actors what to do and say onscreen.

But remember—they know their jobs.

Don't tell the director how to shoot. Avoid directorial narration. That's right. Unless you have a damn good reason (i.e., it is story relevant), do not bother the reader with camera angles, music cues, florid descriptions of sets, etc. Let the director read your script and imagine all of that.

The same goes with the producer. Don't tell the producer that the lead character's hair is red (again, unless it's story relevant). The producer knows how to cast the film. Let the producer do so.

And while you're at it, cut everything designed to specifically direct the actors, such as the dreaded "wrylies." A wryly is an adverbial parenthetical that tells the actor how to say the lines, as in:

```
          DRACULA
        (wryly)
   Care for a bite?
```

Trust me, the actors know how to say their lines. Don't tell them when to roll their eyes or be sarcastic. It's their job to read the script and decide exactly when, if ever, to do those things. Don't give them acting advice unless you want writing advice in return.

So what DO you write?

Everything necessary to tell the story and help make the movie. Nothing more.

We screenwriters love to bitch about our status in the industry: how we're not treated as filmmakers, how we get re-written by directors, and how actors often jettison our dialogue and improvise new lines on set.

It's all true.

But keep in mind that screenwriters—unlike poets and playwrights—sell their work. And by sell, I mean we sell everything, including our copyright, and waive all "moral rights of authors." We even sign a document called a Certificate of Authorship, in which we attest that we are no longer the author of the script we are handing the producer, who becomes the new author.

Naturally, there is a psychological downside to this. Once a script is purchased, you, the writer, are usually elbowed aside. The people who make your movie are under no obligation to be kind to your "baby." And in many cases, they will hack your baby up into bloody, indistinguishable pieces.

Welcome to the biz. If you think of your script as a proposal—a first step toward something great—you won't be so distraught when you watch it morph it into something totally different.

What if you don't want to sign away your rights, can't refrain from telling others how to do their jobs, and can't stand the thought of watching someone destroy your baby?

There's only one alternative: make your own movie. Become your own producer, director, lead actor. Oh, and finance the flick as well.

In that case, you can do whatever you wish. And write all the "wrylies" you want.

A.I.C.

So now you know what a screenplay actually is and you still want to write one, huh?

Excellent. Glad you're up for the challenge. Remember—you're not in this alone. I'm here to help. So keep this book close by your writing table and turn to it whenever you're stuck, out of ideas for funny scenes, or just plain scared to go on writing. I've got your back.

So now what do you do?

You write. A lot.

To become a successful comedy screenwriter, it helps to have talent. But you must also work like a dog. And I mean a dirty dog that never gives up, never stops growling, and never stops acting like a dog.

Hollywood is full of funny, gifted writers who aren't working. And a few who live on government assistance. (I've met them.) The competition is beyond fierce. So the deciding factor—the element that pushes you over the top—is hard work. Relentless, hard work.

That's why your motto must be A.I.C.: Ass In Chair. If you don't keep your A firmly planted in the C, your writing won't improve and you won't become a successful comedy screenwriter.

I can usually tell when writers aren't keeping their A in the C long enough—they will ask me to read their latest script, adding that it's a "first draft." Either they're telling the truth, in which case they haven't spent enough time writing, or they're lying because they know the script sucks and want to be able to hide behind the newness of it, as in, *Well it's just a first draft.* In either case, they should go back to the woodshed until they've got something ready to show.

None of that should be taken to indicate that you can ever write enough. You can't.

Almost all screenplays can be improved with another draft. The vast majority of scripts, including those that have sold for seven figures, should be. And they will be—usually many, many times before the camera starts rolling.

When I'm working on a screenplay, I don't give anybody—whether they're my best writing buddy or my agent—anything to read until at least the tenth draft. I consider it grossly unprofessional to do otherwise. If your script really is a first, second, or third draft, I guarantee it's pretty bad, or at least it's not nearly as good as what you will be holding many drafts later.

In fact, I can say with absolute certainty that the eleventh draft of your latest script will not be worse than the tenth— if only because you will have had to re-read the same story at least a couple times to produce each draft. And every time you read it, you will find something else that needs to be cut or changed. And that's improvement.

Remember: you get only one good read from anybody.

After that point, the script is tainted. The reader has developed an impression about the concept, and no matter how much you re-write it, the reader will hold on to that original impression. So beware.

Here's my rule for when I can show my work to a colleague for constructive criticism—I show work when I can't possibly write another page. Because that's when I need help. And as you'll see later in this book, great screenwriters have terrific endurance. They keep their A in the C until their work sparkles.

But wait, you say. *Couldn't an aspiring comedy screenwriter, a young gun, be some kind of savant and manage to write a great first draft of a first script?*

I suppose. But I've read thousands of scripts, and only once have I read a script that was any good by a writer who claimed it to be a first draft. And I still think he was lying.

Writers improve with experience—the experience of writing, re-writing, being read, and suffering withering critique. Becoming a great screenwriter without going through all that is, well . . . not going to happen. If you intend to become successful, you need to block some serious years off your life.

Oh, and you should move to Los Angeles. Did I mention that yet? If I failed to tell you to move to Los Angeles, it's only because it's so blitheringly obvious I forgot to mention it. Sorry, I won't bring it up again. Promise.

So why, then, do so many aspiring screenwriters violate A.I.C. and get up from the chair?

Well, sometimes they need to pee. That's understandable. Once a day, maybe. But if you're like me, there are magazines in the bathroom, and a trip to the toilet can soon become an extended vacation if I happen to chance upon an especially interesting article in, say, *American Sportsman.*

Or, for that matter, in *Spudman*, the magazine of the potato industry. (Yes, it exists.)

Then, of course, there's my iPhone, and, if I bring that into the john, it's a sure bet I'm going to max out my data plan.

In fact, practically anything can divert my attention when I'm in the middle of a writing session. Because the biggest impediment to writing is procrastination. And as Shakespeare once said, "Procrastination taketh what talent provideth the opportunity for."

OK, he never said that. But he would have. If he had running water. And an iPhone.

You must write as if you are training for a marathon. Force yourself to stay in the chair for two, three, four hours straight without getting up or going online. Even when you have nothing to say and don't feel the least bit funny. Actually, *especially* when you have nothing to say and don't feel the least bit funny. That's when you need to force it. Fill the page with whatever you've got left. Run on fumes.

Keep in mind—if you succeed, you will have to continue writing. And if you get married or have kids, you will have even less time to write. And there will be even more pressure on you to maximize the time you spend in the chair. So get comfortable and start making that time productive.

I know what you're thinking: *I may get creative sparks anywhere at any time. So I'll just bring this little notebook with me and go to Disneyland to write.*

Wrong. Yes, creativity can happen anywhere, and, yes, it helps to write ideas down as you get them. But, at a certain point, you need to focus all your energy on the page, and, when that happens, procrastination—the mother that birthed your creative impulses—must be forcefully rejected.

Use your sudden creativity for what it gives you—inspiration—and then shut it out when you need to write. Because you do need to write. A lot.

WRITING HAT

By now you must think I'm more drill sergeant than writing teacher. But, obviously, comedy screenwriting is more

than just sitting in a chair for endless hours. There's all that *writing* to do.

When you start a script, set targets. I write seven pages a day when producing a rough draft. At that rate, I can finish in a few weeks.

When writing new pages, pour everything onto the page. Don't question what you've written; move forward. You don't have the time or energy to stop after every page and think, *Hmmmm, maybe that could be funnier.*

In other words—don't re-write when you write. In fact, don't ever look back.

As a produced screenwriter and a former script reader for agents, I know that most screenplays break down in the second act, usually right in the middle. That can happen because the plan (or treatment or beat sheet) wasn't well thought out. More commonly, it happens because the writer simply loses his or her nerve.

It takes a lot of courage to write. Even more to write comedy. And courage is cheap when you're writing page four and you feel fresh and positive about the next hundred pages. After all, you haven't closed any doors yet. But as soon as you tell us the bad guy is, say, Romanian, you have made it virtually impossible for him to be from any other country. And once you tell us the hero has only one arm, well . . . you get the idea.

That's why once you've battled your way to page sixty, you are likely to lose heart. It's called the "second-act blues," and it happens to almost every screenwriter, including plenty with Oscars.

So while it takes guts to start writing, it takes even more guts to keep writing. Yet most screenwriters are chronically self-doubting, if not self-loathing—a potentially catastrophic combination.

That's why you need to forge a solid plan for writing your script, then you must block off the time necessary (the more, the better) and write. Without regret. Without fear. Without reading your work as you go along.

Otherwise, your doubts will kill you. Or at least they'll kill your script.

As you write, don't stray too far off course. As discussed elsewhere in this book, you don't want your screenplay to be episodic. If so, it's dead in the water. So avoid tangents.

For comedy screenwriters, the biggest tangents are usually jokes and set pieces that are over-written and do not feature the protagonist. When writing a rough draft, if you find yourself lavishing pages on a funny character who is not the protagonist, or milking a joke long after it's dead, you should feel a little tingling on the back of your neck. That's your scribey-sense telling you, *Get back on track.*

When I'm writing new pages and my scribey-sense tells me I'm taking the story in the wrong direction, I immediately end the scene I'm working on, type the words "CUT TO" at the bottom, and start a new scene. That new scene usually focuses on the protagonist and advances the story. At that moment I think to myself, *Phew! Dodged a bullet.*

Some of you will think my never-go-backward writing process is risky. You wonder, *What happens when I suddenly realize, halfway through the draft, that there's a character I want to insert into the story even though I didn't introduce her earlier?*

You write her in.

If she's truly needed, you'll see that when you go back and read the rough draft. If she's unnecessary, you'll cut her when you re-write.

But if you start questioning yourself during the rough draft, you may fall into an endless pit of despair (which is, I suppose, filled with crumpled up sheets of printer paper). And that's a hole from which few writers return.

So let's say you never stop writing, pay dutiful attention to your plan, and listen acutely to your scribey-sense.

Chances are, if you do, you will finish your first rough draft.

EDITING HAT

Now what?

Be proud. You got through it. But don't go renting a tux for the Oscars just yet.

Instead, get some sleep and do something else for a while. Play golf. Paint a portrait of your pet. Make some crank calls. Whatever. Just print the script, leave it on your desk, and stay away from it long enough to forget most of what you've written. For me, that's about a week.

CUT TO one week later:

On your desk sits a rambling, bloated mess, held together by brads, that only vaguely approximates a completed screenplay.

But don't let that bum you out. You are standing on the brink of the next level. You need to prepare yourself because . . .

This is where novice screenwriting ends and professional screenwriting begins. This is when you raise the bar on yourself and declare—through your actions—that you are only going to accept great work.

You do that by sitting down in a quiet room with your rough draft, clearing your head, and reading it straight through as if you've never seen it before and you are a producer looking for your next hit comedy.

You'd better have a red pen handy. Because most of what you've written should be marked up when you leave that room.

After you've marked it up, ask yourself, *How much needs to change?*

If the answer is *very little*, you're almost certainly lying to yourself.

Diagnose what ails your screenplay. A good re-write begins with a stone sober assessment of what you've got on the page. Don't look back to your old treatment or beat sheet. That will only reinforce your original characterizations of the scenes and story lines. You'll think about the scenes as you *wanted* them to be, not as they *are*. Instead, deconstruct your rough draft and make a *new* diagram. This is what you actually have.

Think about the original goal of the script. Was it high concept (as per chapter 5)? If so, did you convince the reader of the premise? If not, you've got even more work to do because high-concept comedies don't work unless the reader is sold on the premise.

Take a hard look at your second act. Does it conform to the Basic Drama Rules (which you'll read about in chapter 6)? If not, scrub up and prepare to operate.

Read the dialogue out loud. Or, better yet, get some friends together (preferably actors) and have them read it out loud. If the dialogue doesn't sound real, use your red pen. Are there enough laughs throughout the script? There can't possibly be enough, because you're hoping to make the reader laugh until doubled over in pain. If not, cut, change, wash, rinse, repeat.

I'm not saying everything must go. That would mean starting over with a new story and a new script. (Although, in truth, that sometimes happens. And if it does, accept it and move on.)

Draw up a plan of action. Your re-write should start with fundamental, structural changes. That means moving scenes and sequences to where they should be and deciding what new scenes must be written.

You're going to improve everything that's not fantastic. Because great screenplays impress from beginning to end, and, unless you've recently married into Hollywood royalty, that's the kind of script you will need to break into the biz.

Once you've settled on your plan for re-writing, start. Set a schedule and maintain strict habits as you did with the rough draft. You must ruthlessly execute the next draft. If you've decided to cut, say, a montage, cut it. Don't get all nostalgic and hold back. Trust me, the scenes will beg you not to cut them. They will cry out to you, pleading to be spared.

And you will listen—because you gave birth to them and because you are (as are all writers) vain. After all, that scene is your favorite, right? And it's your best work, right?

Wrong.

A screenplay is more than the sum of its parts. It's a story, and its structure is paramount. No scene, no sequence, no joke trumps the whole story. I've seen a lot of potentially great screenplays fall into the shredder because the writer failed to cut his or her "best work." And, yes, many of those screenplays have been mine.

Here's the truth: your best work can only come in the form of a completed screenplay. Thus, no scene or sequence can constitute your best work. So, when re-writing, kill your cutest babies and get over it. You cannot have a future as a successful Hollywood screenwriter until you do.

So mark it up, suck it up, and come out re-writing.

ASS HAT

OK, I just threw this section in to lighten the mood.

But if there were such a thing as an ass hat, it would be worn by the writer who does the worst thing a writer can do after completing that first rough draft—panic. Like a new parent who has just seen his baby for the first time, the writer thinks, *Yikes! It's ugly, fat, wrinkly, and covered in blood!*, and promptly runs off, screaming, for the hills.

OK, most parents don't do that. In fact, most spend their lives boasting to the world about how amazing their children are, despite their kids' many flaws. Kinda like writers who stop working on their scripts just at the time when they should be rolling up their sleeves and digging in.

So don't wear the ass hat. Instead, go back, face your baby, and edit, re-write, edit some more, make more coffee, re-write . . . you get the idea.

THE LONG HAUL OF THE FEATURE SCREENWRITER

Of all the types of writing you can do, screenwriting is the most fraught with peril, the most potentially disappointing.

So much is dependent upon the concept. And the market. Plenty of well-written scripts are marketed at the wrong time—perhaps three months too early or six weeks too late—to meet the right reader at the right moment.

Hollywood decision-makers are surprisingly of one mind. Executives and producers all read the same trade magazines and websites. They schmooze at the same watering holes. They jump ship from job to job like they change their . . . you get the idea. So they tend to want the same things at the same time.

When Hank and I first started going to meetings, every executive in town told us, "We want a pot comedy."

So we wrote one. And we earned fans.

By the time we took meetings with those fans—merely weeks later—their tastes had already changed. Suddenly they were telling us, "We want a teen sex comedy."

That was right before *American Pie* sold to Universal.

So the business moves fast, and it moves en masse. Buyers have a herd mentality. Position yourself at the right time with the right script and you can win the blue ribbon.

Hollywood readers—the assistants and interns who are the first to read most of what pours into studios and production companies from agents' offices on a daily basis—are also of one mind. Send a script to the story department at DreamWorks and that reader's coverage will soon find its way to every studio in town. No matter what an agent tells you, there is no such thing as a "confidential" read.

Why is this?

Nobody moves up in Hollywood without friends, and keeping up those friendships means spreading information around. When a reader dislikes a script, the reader tells his or her friends. To warn them. To curry favor. To stay part of the friendship circle. So once it's out there . . . it's out there.

It takes time to produce a completed, marketable screenplay. For me, at least six months. An idea that seems unique and original now may seem absolutely passé and overdone two months from now. That's how fast Hollywood operates.

Every script is a massive leap of faith in the writer's talent and perseverance, as well as the market. After all, most scripts—even those written by industry veterans—have a lifespan roughly equivalent to that of a newborn infant in the Middle Ages. In the desert. During a plague.

So those of us who screenwrite for a living stay up nights chewing our fingernails to the nub. That idea we're working on . . . Is it already old? That script we're writing on spec . . . Is somebody else, somewhere across town—or in this very coffee shop—already writing it?

Poets never expect to make a dime. Novelists hold out hope that the *New York Times* will embrace their work and start the royalty checks streaming in, but the vast majority

of published novelists must work a day job. Playwrights dream of Broadway while toiling away in Brooklyn garrotes at night and working at organic, fair-trade coffee shops by day. But those writers are artists. In the end, they find satisfaction in the work. The writing.

Screenwriters need to succeed. We want fame, we want fortune, we want those blondes (of either sex) by the pool. And we want them now. Our scripts look lonely on the shelf without movie posters with our names on them. Satisfaction comes on opening weekend.

I have a talented friend who has been writing for decades. After college, he wrote young-adult novels. One was published and can still be found at libraries and bookstores. And while the book paid very little, he enjoyed the feeling that came along with being published and knowing he's being read.

Then he went to Hollywood, where he has struggled for over twenty years, typing away at screenplay after screenplay. About fifteen years ago, he had a screenplay optioned by a well-known producer, but it never got made. Then he briefly worked as a "baby writer" on a TV show. But he was on staff for only one season, and none of his scripts ever aired.

After that he failed to get hired onto another show and his career fell into disrepair. Since then he's been tirelessly writing new scripts, always showing a new feature spec to agents.

But he's never broken through. He has nothing to show for those many years except the bruises. All that time spent writing and re-writing screenplays hasn't left him with anything close to the satisfaction of that novel he wrote decades ago.

This is the long haul of the feature screenwriter. Unless you break in, everything you write goes nowhere. Slowly. And that's not healthy. Writers need to know they are being read and something is resulting from their work.

This is why screenwriters who write only feature scripts need to do something to feel a connection to somebody on the receiving end. This goes double for comedy writers, who need to feel the laughter resulting from their work. If you're writing your life away every night in some stucco apartment

in West L.A. while holding down a day job and doing little else, I recommend you consider one of the following steps to keep your sanity so you don't end up like my friend the young-adult-novel-author-turned-frustrated-screenwriter:

Join a writers group. This will allow you to show your work and receive criticism on a regular basis. This could involve writers reading scripts and getting together to give criticism, or actors reading work out loud. Either way is better than writing exclusively for a handful of studio readers and agents' assistants.

Write other material than just screenplays: short stories, freelance news articles, sketches, whatever. Do this to reassure yourself that you are, in fact, a real writer—whether Hollywood loves you or not. Because Hollywood often ignores great writers. Just ask F. Scott Fitzgerald or Ray Bradbury.

Well, OK, you can't ask them now, but anyway . . .

SEASON TO TASTE

Screenwriters love to crow about all the soul-wrenching compromises they must make to succeed. Go to any coffee shop in West L.A. and you'll hear their whines rising over the screech of the cappuccino machine.

But it's bunk. Nobody becomes a screenwriter to change the world. You do it for money or recognition. Or to write your way into the biz so you can move on to directing or starring in your own films, or . . . you see what I mean.

I'm not telling you that screenwriting must be hell or that you must abandon all hope of doing meaningful work. Not at all. I want you to enjoy it and write scripts that deeply affect people.

But to succeed, you must not work in such a way that you are enigmatic or self-indulgent. Your work must fit the medium, not the other way around. Your talent serves a purpose, and that purpose is film.

So, as you go through the many stages of concepting, writing, re-writing, and the like that make up the hours, weeks, months, and years of your life, you must always season to taste.

I know that some of you will turn up your noses and say, *No way. I'm writing this script to change the world and I'm sure as hell going to speak in my unfettered voice to do it!*

Bully for you. I hope you intend to shoot, edit, produce, and distribute what you write. If not, tie on an apron and get used to seasoning to taste.

You may also be under the mistaken assumption that certain A-list writers don't need to worry about satisfying the reader or the buyer. Or that writers of independent movies need not do so. Or that Oscar-winning writers don't need to fuss about pleasing folks. You'd be wrong on all counts.

Years ago, I attended an event hosted by the Writers Guild in which Michael Arndt was interviewed about his screenplay for *Little Miss Sunshine*, for which he earned an Oscar for Best Original Screenplay. I found him after the event, standing in the lobby, surrounded by a bevy of admiring, aspiring writers.

I waited as all those writers asked all the wrong questions, such as "What was it like to work with such-and-such a star?" and "Did you get to watch them shoot the movie?"

None of that interested me. Nope. I was—and remain—primarily concerned with one thing when it comes to other screenwriters. So when I got my chance, I launched into my question and took notes as he answered.

My question: "What is your writing process?"

Arndt took a deep breath and began to answer, particularizing the answer to *Little Miss Sunshine*. He told me about the many, many drafts he wrote and how hard it was for him to cut the scenes that he loved most but had determined were unnecessary to tell the story. And then he told me something that I never forgot because it partly explained the success of the film:

He talked about how he used readers during his re-writing process. At a certain point, when he decided he needed to get a response from a colleague, he would send the latest draft to a trusted fellow writer along with a questionnaire. The questionnaire asked what characters the reader liked best, worst, and why.

Now it should be stated that a lot of screenwriters I know would have trouble doing this. For a writer who has spent

months, if not years, on a script, it's a little like asking someone to stab you in the face, over and over, with a fork.

If a reader said she or he disliked something about a character, that quality—and any scenes or parts of scenes in which that quality was shown—was cut or changed.

That's what I call seasoning to taste. Arndt wanted to succeed, and he accepted that, at a certain point, he would not be able to recognize the pimples on his baby. So he invited criticism and reacted accordingly. There's no point in trying to sell a script with pimples if you can be rid of them, and that's exactly what he set out to do—cleanse his script of anything that might keep the reader from absolutely loving the characters. Which is one reason his movie is so memorable—because the audience comes to love every one of those characters: the grandfather, the mom and dad, the uncle, and the two kids. All of them shine because Michael Arndt put them all through extensive dermabrasion and wiped them clean of anything that might make us dislike them. He got rid of all those reasons to put the script down and stop reading—and all those reasons for the audience to stop watching. He didn't do it by being strident and self-indulgent; no, it was an act of professional humility.

Because, after all, somebody has to enjoy eating this goulash you're cooking. So you might as well ask your dinner guests to sample it as you cook.

And when they tell you what it needs . . . listen.

POP QUIZ!

1. **If you want to improve your screenwriting and succeed in Hollywood, you should spend approximately this much time per day in the chair writing:**

 A) Four hours.
 B) Six hours.
 C) Eight hours.
 D) All of the above. That is, all of the above amounts added together. You should spend eighteen hours a day writing. Do that, schmooze aggressively, be very, very lucky, and you just might break in.

2. **What in tarnation IS a screenplay?**

 A) It's art, dammit, and everybody who reads my latest three-hundred-page script had better understand that.

 B) It's an opportunity for me, the writer, to tell the actors exactly how to say their lines.

 C) It's a proposal for a movie.

 D) It's a proposal for a movie. (I put this answer in twice to make sure you'd get it.)

3. **Which hat do I wear when going out in a rainstorm?**

 A) My writing hat.

 B) My editing hat.

 C) My ass hat.

 D) None of the above. The "hat" in "writing hat" is metaphorical. You need not actually wear it. But if you do wear it, make sure you don't edit until you put on your editing hat. And never, ever wear an ass hat. Because that's just silly.

4. **I've been writing screenplays and getting nowhere for the last five years. As a result, when I tell people I'm a writer, even I have trouble believing it. Therefore, I should:**

 A) Quit writing, move back to Paramus and take a job working in my dad's unregulated asbestos factory.

 B) Get out of my little apartment occasionally and maybe even take a short walk.

 C) Write some freelance newspaper articles on the side, just so I can remind myself I'm a writer.

 D) Join a writers group.

 E) Everything except A. Though Paramus is kinda nice this time of year.

5. **The most important rule of writing is A.I.C., which means:**

 A) Abe's in Cleveland.

 B) Amy isn't chaste.

 C) *Arggggh*, I'm Canadian.

D) Ass In Chair. Ass In Chair. Ass In Chair. Say it a hundred times fast while sitting in a chair to remind yourself.

6. **As a screenwriter, I know that whatever I write is:**

A) Sacrosanct. I do not write to please the audience. I write to please myself. Then I shoot, edit, and produce my own movies and watch them in a little room by myself.

B) Going to be twisted, torn, disemboweled, and flushed away by a herd of re-writers before it ever gets close to the screen. And that's if I'm lucky enough to sell it and see it get made at all.

C) Chiseled into stone, never to be even slightly altered by the directors and the actors.

D) Gold. Absolute box-office gold. Because I read Greg's book and used everything I learned when writing my latest screenplay. Thanks, Greg! (Disclosure: I wrote this myself.)

Act 2

YOU vs. THE PAGE

Act 2

YOU vs. THE PAGE

4

FUNNY PEEPS

You can't *write* funny characters unless you *know* funny characters. I'm talking about the funny people you encounter everywhere you go.

What's that? You don't think everybody in your life—every parent, lover, bartender, train conductor, and dental hygienist—is funny? Mind-bogglingly funny? Fall-on-the-floor-and-make-you-convulsively-puke-up-your-lunch funny?

You're wrong.

Great comedy writers are like that kid in *The Sixth Sense*—they see funny people. They see them wherever they go and no matter what is going on. And if you don't do the same, you better start. Or stop reading this book right now.

You may be tempted to think that Hollywood's top comedy screenwriters create funny characters by sprinkling magical fairy dust in the air and—*Poof!*—funny peeps appear.

But no. By the time characters show up in a script, they're already well into middle age. That's because the writer has been carrying them around in his or her head for a long, long time. And *that's* because most characters are at least loosely based upon people the screenwriter knows from personal life.

Once you embrace yourself as the source of all your characters, you'll start to realize that everyone around you

is unbelievably, outrageously, ludicrously funny. You just weren't seeing it before.

You must *see* the Funny to *write* the Funny.

That wallflower you avoided in high school who could never get a date, works at an electronics store, doesn't drive a car, and has never had sex? You could write a whole script about that guy. Actually, someone already did—*The 40-Year-Old Virgin*.

That security guard you never make eye contact with when you go to the museum? Who just stands there and does absolutely nothing all day? That's the guy from *Night at the Museum*.

That frumpy office assistant whose idea of a life-changing New Year's resolution is to write in her diary every day? Bridget Jones from *Bridget Jones's Diary*.

You just need to see these folks all around you.

I had an uncle, may he rest in peace, who was shot in the head on two, separate, unrelated occasions. One was a robbery; he got shot, was saved on the operating table, and eventually recovered. Then, years later, he was hunting with his brother, who failed to tell the difference between him and a deer. *Boom!*

Again, doctors saved him, and he eventually recovered from his second gunshot wound to the head.

Now you may find that story dark—*and it is*. But it's also funny. And from that uncle I've created many a character: goofballs who are prone to shooting themselves, absent-minded hunters, unlucky people, etc.

And when you are combing your family for funny characters, pay attention to their peculiar obsessions.

My father-in-law is one of those people who cannot stand disorganization. Everything must always be in its right place. In his garage, every rake and every tool has a demarcated spot. He gets his cars cleaned—inside and out—monthly. He recently emailed my wife because he was about to have minor surgery and he wanted her to be able to immediately cancel his internet and cell phone service if he died while under anesthesia. After all, why pay for a single day of service after death?

He's funny. Naturally, he doesn't know it. And that's a cardinal rule of observational comedy; the funniest people usually don't know they're funny. In fact, they take themselves very seriously. It's up to us to find them and use them in our work.

But remember to change their names. Otherwise you're liable to get sued.

Now before you start adapting your entire family to the screen, I want you to take a step back and ponder . . .

WHAT IS CHARACTER?

Go to a dictionary for this one. Usually you'll find a few meanings. Most dictionaries hold it to be the *sum* or *aggregate* of the many traits making up someone's personality. Those same dictionaries will also tell you that traits related to morality and ethics are the primary focus of that aggregation.

That's why so many Greek tragedies are concerned with presenting how the protagonist of a drama handles terrible dilemmas and painful choices—because the authors of those ancient plays wanted their dramas to peel back the layers of their protagonist's personality to reveal his inner moral strength. And that could only be done if the character was supremely tested.

As we watch him wrestle with fateful decisions, we get to see inside the character and discover his true nature. If, for instance, he chooses to run from his fate, then we may conclude that his essential nature is *cowardly*. If he boldly confronts the truth—as does Oedipus—then we may conclude that his essential nature is *brave*.

There, I bet you never thought I'd mention *Oedipus* in a book about comedy screenwriting. But to delve further . . .

For this analysis of drama to work, you have to believe that people—and characters in a story—have natures, and *essential* natures at that.

Now here's where I loop it all back to comedy screenwriting:

Comedy depends upon the idea of essential natures. Great comic characters can usually be defined in a single word, and that word is usually an adjective.

Andy, the protagonist in *The 40 Year-Old Virgin*, is fearful. Sandy and Diana, the dual protagonists of *Identity Thief*, are careful and reckless, respectively. Ron Burgundy, the protagonist of *Anchorman*, is vain.

So there you are—I just compared Oedipus to Ron Burgundy. But there *is* a resemblance. Both can be reduced to a single adjective. And both stayed classy.

Now it's important to recognize that there is no moment in *Oedipus* or *Anchorman* when the protagonist ever verbally articulates his or her essential nature. Ron never says, "I am vain."

Rather, a series of escalating incidents, tied together by a story, prove the protagonist's essential nature. We, the audience, intuit this trait as we add up what we've seen onscreen. That's what makes character compelling; it's ours to figure out.

In a thriller or a melodrama, character may be developed over time. There may even be moments when the audience is made unsure about the true nature of the character it's watching. *Is she good or bad? Is she a craven killer or a misunderstood hero?*

In comedy, it is usually the opposite.

The audience needs to know the essential nature of the protagonist as early as possible. This is because the Funny is usually found in the stark contrast between the protagonist and his or her situation. A boring family man trapped next door to a raging frat house—as in *Neighbors*—can be funny. But we need to know early on that our protagonist is, in fact, a boring family man.

That being the case, there are two basic ways to go about creating characters . . .

THE INSIDE-OUT METHOD

You know this method. This is when you come up with the protagonist first—brainstorming various details about the character—before tackling the story.

This naturally leads to a character-based story, such as *Trainwreck*, *Anchorman*, or *Silver Linings Playbook*. In

these movies, concept takes a back seat, and the story is dictated by the protagonists' unique traits and flaws.

Consider *The 40 Year-Old Virgin*. Judd Apatow and Steve Carrell dreamed up a painfully shy, hesitant, middle-aged man and built a story around him. I wasn't in the room when they wrote it, but I can think of myriad possible ways they could have revealed and developed his character. To their great credit, they came up with some hilarious ones.

Remember the poker scene? That's a great example of story revealing character. In that scene, Andy's potty-mouthed co-workers confront him with randy stories of their sexual conquests, making him squirm. Challenged by them, he lies about his sexual past. When he fails, we learn the hilarious truth about him.

The inside-out method makes sense when the protagonist will be played by a great comic actor like Steve Carrell or Will Ferrell, who apparently have stables of developed characters to draw upon. It also works when the lead role will be played by a stand-up comic with a pronounced, well-honed persona, such as Amy Schumer.

But most of us are not those people. We're screenwriters looking to sell a script or make a movie. And starting with character ain't easy. In fact, it's often the wrong way to go.

I was once in a meeting with a producer who was looking for me to collaborate on a project. He sat me down, served me an ice-cold beverage, and waited for the room to get quiet before finally looking me straight in the eye and giving me his two-word pitch:

"*School Nurse*."

That was all he had.

"You can totally see the poster, right?" he demanded.

Actually, I *could* see the poster. In fact, I could imagine a movie theatre standee of Will Ferrell dressed in a tight, white nurse's skirt and one of those little white hats, leaning against a wall of lockers in a high school hallway.

"Yup. I can see it."

He got excited. He'd been looking for the right writer for this idea for a long time.

"So you want it?" he asked me, hoping I would work up a full story based upon those two words.

But I said no.

"Why not?"

"Because all I can see is the poster. What happens once the audience sits down for a hundred minutes and actually watches the whole movie?"

"That's *your* job," he said.

Again, I shook my head no. Then he said the most painfully condescending words you can ever say to a screenwriter:

"But it writes itself."

"So *you* write it," I told him.

That was our last meeting.

To be fair, I have no doubt that a truly gifted screenwriter could write a great script out of *School Nurse*. Hey, they made *Pirates of the Caribbean*, didn't they? And that came from nothing more than the title of an amusement park ride.

But then again, *Pirates of the Caribbean* implies a story. You know the characters are likely to go out and do some *pirating* at some point. And they'll probably do it in the Caribbean.

The same could be said for *Mall Cop*. You know at some point he'll have to take on some criminals. In a mall.

But *School Nurse*?

OK, I know where it's likely to be set, but what's he going to take on—the flu?

My point is that it's very hard to create a story from character unless the very nature of the character—or the character's job—implies the story.

Nevertheless, there are teachers of screenwriting out there who implore their students to rack their brains to create an original character and fill the character out with all kinds of nuanced details before working on the story.

This can lead to another problem, which I like to call the Overly Conceived Character. Seriously. Don't load your protagonist up with a laundry list of distinct personality traits unless those traits are truly *story-important*—that is, they should be traits that prompt their characters to take definitive action in the story.

Non-story-important elements of a character's personality don't matter. After all, if your protagonist hates asparagus,

but it never comes up in the story, who cares? But if we see him on a date with the woman of his dreams, and she has cooked him asparagus, and he eats it rather than hurt her feelings, then his hatred of asparagus matters. It's story-important.

If you do—against my advice—decide to create a protagonist using the inside-out method, keep it simple. Create only as much character as you need. Pair character traits with contradictory desires and needs. This way you can create *Fish Outta Water* situations, which are discussed further in a later chapter.

Again, look at *The 40-Year-Old Virgin*. Andy is a painfully shy man, so the writers have him pursue something that's terribly difficult given his shyness—love.

Look at *Trainwreck*. The protagonist is promiscuous. By pursuing love in the form of a monogamous relationship, she's entering difficult—and also very funny—territory.

If your protagonist is a pompous ass, like Ron Burgundy in *Anchorman*, you drop him into a story that will confront everything pompous about him. Because that's what we want to see happen to a pompous ass.

Clearly, I am proposing that all character creation be done with the story in mind. But there are some teachers of screenwriting who tell students that good comic characters are interesting *even when they are doing nothing*.

I wish they'd stop saying that.

I have yet to see a movie that boasted both a static plot and a satisfied audience.

OK, actually, there is one—*My Big Fat Greek Wedding*. It's a story without much W.H.N. (What Happens Next?). There is a wedding, but no real risk that the wedding will fail to go off. There is romantic tension, but we never get the feeling that the lovers will break up. It's basically all about the funny characters—Toula and her wacky family. That's it.

My Big Fat Greek Wedding violates the rules of screenwriting. It has little more dramatic action than *My Dinner with Andre*. If you're too young to remember, *My Dinner with Andre* is a movie in which two guys have dinner. That's it. Dinner.

And by the way, I love *My Big Fat Greek Wedding*. Love. It. But it's a rare exception to the universally accepted rules of dramatic storytelling that only a rare, exceptionally gifted writer like Nia Vardalos could create.

The rest of us should remember this: character needs story, stakes, confrontation, and all the other elements I outline in later chapters.

So while a few, rare screenwriters may break the rules, I urge you to mimic the overwhelming majority who stick to them.

Which brings me to . . .

THE OUTSIDE-IN METHOD

This means story first, character second.

Take, for instance, *Bride Wars*. You may remember that movie was cruelly denied an Academy Award.

Bride Wars started as a one-liner: *When two best friends schedule their weddings on the same day, they go to war.*

It came at a time when I was working ten or more hours a day to brainstorm ideas for a script I could sell to a studio. Every morning I went through the same ritual—I sat down with a cup of Joe and faced a white screen. Sometimes I read the trades, and other times I surfed the net for ideas. But mostly, I pulled from what I knew—the detritus littering my brain. I wrote whatever fell into my head.

It so happened I was engaged to be married and my wife and I were planning to be part of a double wedding with her sister and her sister's fiancée. This got me thinking about two brides fighting over a wedding . . . which somehow morphed in my head into a story about two women who accidentally plan a wedding on the same day.

At this point I didn't have characters of any type in mind; I just needed two women.

I figured the concept would drive the creation of characters. After all, what kind of women would fight over their weddings? *Wedding-obsessed* women. So I created two wedding-obsessed women.

Another thing became clear—they needed to be close. Sisters or BFFs. After all, if they're not close, who cares? The closer, the better—to keep the stakes high.

But somehow sisters seemed implausible. After all, wouldn't mommy and daddy talk sense to them? And couldn't they just have a double wedding since they're family? So I made them best friends.

I asked this question as I crafted the protagonists: *What character details will best serve the story?*

Considering that the story rests on a shaky premise—the idea that some mistake puts the wedding on the same day and the mistake cannot be reversed—I looked for ways to use character to support the premise. Here's what I came up with:

One of the women is the leader of the friendship; the other, the follower. So . . . meet Liz and Abby. (Their names were later changed, but more on that later.) Liz is the alpha dog in relation to Abby's lamb. Liz pushes and Abby gives.

This supported the premise. When the complication arises regarding the wedding date, there needs to be a strong reason neither woman backs down. They can't be reasonable and accommodating, or else there's no movie. I reasoned that if I establish that Liz is pushy, we'll believe it when she pushes Abby to change her date. And if we also establish that Abby harbors longstanding resentment of Liz for being so pushy, we might buy it when Abby finally stands up and refuses to bend *this time*. Thus, a standoff ensues. One woman pushes; the other refuses to budge. The war is on.

Through this process I came up with close friends who are wedding-obsessed. One is pushy. One has previously been on the wimpy side but is now—awkwardly—standing up for herself.

Where to put them? Seattle? Tokyo? One producer I pitched the story to wanted them to live in Houston. Turns out he hails from—big surprise—Houston. But ultimately that producer didn't attach himself to the project, and the producers who did wanted Manhattan. So Manhattan it was. After all, the exact setting wasn't story-important. Two brides can battle anywhere. Why not New York?

So that was my outside-in process for character creation—every character trait was prompted by the story. I even came up with a sub-plot involving Abby's brother falling in love with Liz.

Naturally, that meant Abby had to have a brother and *his* character traits also had to serve the story. And so on . . .

RELATABILITY

At various points in this book I am telling you either how to write your best or how to satisfy the market. Screenwriters must do both at once. The word you see in bold above this paragraph will help you do that.

For a writer, it is highly advisable to create characters the audience can relate to. As a salesperson looking to sell your script, it is mandatory.

But what does relatable mean?

It means the character has some trait, or combination of traits, that the audience can grab onto—either because they possess it themselves or because it reminds them of someone they know.

Call it a *handle*.

I watched the movie *The Heat* in a crowded theatre. When Detective Mullins, played by Melissa McCarthy, went home to see her trashy, bickering family, a woman sitting in front of me leaned over and chuckled to her friend, "Her family's just like yours."

The other woman chuckled back, and the two of them snuggled closer and paid rapt attention to the rest of the movie.

Bingo! *The Heat*'s trashy, bickering family worked as a handle for two audience members.

Ron Burgundy loves his dog—just like you do. So does Elle Woods from *Legally Blonde*. Andy from *The 40-Year-Old Virgin* enjoys a good egg salad sandwich—just like you do.

OK, to be fair, you may hate dogs. Or egg salad. You may even hate *both*. But if you do, you're in the minority. America loves that stuff. And you want America to love your characters. So give them handles.

My first major produced movie, *Saving Silverman*, is about what happens when the friends of a weak-willed nebbish learn he's marrying a control freak. Sound like anybody you know?

When Hank and I pitched *Saving Silverman* to various studio executives and producers, they went wild for it. Many of them told us their own personal stories about friends who married the wrong person and how they wished they could liberate their friend from that wrong person. We had multiple bidders on the project—a screenwriter's wet dream.

You may be wondering, *What's the difference between relatability and likability? Aren't they basically the same thing?*

Answer: usually. What's relatable to us is usually likable as well. But there are exceptions.

Which brings me to that rarely seen beast—the Unlikable Protagonist.

You see unlikable protagonists on TV in dark HBO shows like *The Sopranos* or *Veep*. Selfish people doing bad things. Yet we love to watch them because they're so darn relatable. After all, Tony Soprano was such a "normal" suburban Jersey guy—when he wasn't killing somebody. Selina Meyer struggles with her argumentative daughter just like an average mom. We love that. Makes her human.

But in comedy movies, an unlikable protagonist is hard to find.

Bradley Cooper's character in *Silver Linings Playbook* is arguably unlikable. We see him dismissively break a window at his parents' house, brutally beat up another man in a shower, and even strike (sort of) his mother.

Nevertheless, he's relatable as heck. After all, he enjoys jogging, music, tailgate parties . . . oh, and he's struggling with bi-polar disorder—like plenty of people. Just about anybody can find something relatable in his character.

I know what you're thinking—*Silver Linings Playbook* was adapted from a novel. And the success of the book supported the filmmaker's decision to present an arguably unlikable protagonist. If it had been a spec, a producer would have balked, "We can't root for that guy!"

And he'd be right. Studios don't want to take a risk on a spec screenplay featuring a morally ambiguous lead character. Thus, it is about as easy for a screenwriter to sell an original comedy spec script featuring an unlikable protagonist as it is to pass a camel through the eye of a needle.

But that doesn't mean it can't be done, and maybe you're the screenwriter to do it.

Now let's look at . . .

YOUR CHARACTER STABLE

Here we discuss everybody in your screenplay who is *not* the protagonist.

All characters in your script must exist to serve the needs of the story. And since the purpose of the story is to reveal the truth of character, the supporting cast must help you do that.

Anchorman is about a blithering curmudgeon who must navigate an evolving world in which (Sakes alive!) women can be news anchors. The deeper truth of his character is that, despite all his macho pretensions, he is actually capable of loving an assertive career woman.

But before he redeems himself, Ron must first resist all attempts at change. Only after doing that and losing everything does Ron realize what he must do to win back the woman he loves and save his soul.

How best to present a blithering curmudgeon? Surround him with characters like this:

1. Brian Fantana: a playboy who uses bizarre colognes to seduce women.
2. Brick Tamland: an idiot who inappropriately speaks his mind.
3. Champ Kind: a redneck who wrongly sees himself as catnip to the ladies.

Take a look at this list and think back on the characters as you remember them from the movie. You will likely realize that Ron's ensemble is made up of dimmer shades of Ron.

And that's a strategy you can employ when forming your own ensembles of supporting characters—make them knock-offs of the original. I call these *Shadow Characters*.

The audience wants to see Ron confront the modern world. And when they're not watching *that*, they enjoy watching other little *shadows* of Ron do the same. Because

that—an oaf confronting modernity—is what they came to see. Over and over again in various forms.

But what about comedy movies that have no true protagonist? I'm not talking about a "two-hander," the Hollywood term for a movie with two leads, which I discuss in chapter 5. I'm talking about a true ensemble as in *The Hangover*.

In *The Hangover*, three men share a common dilemma—how to find their buddy, who is mysteriously absent when they wake up in a Vegas hotel room.

Unlike a supporting ensemble, a true ensemble is usually a more well-rounded group, as we see in *The Hangover*:

1. Phil: confidant, a leader, but hiding a secret that makes him vulnerable.
2. Stu: weak-willed, nebbishy, easily pushed around by his domineering girlfriend.
3. Alan: narcissistic, lazy, lacking social graces.

The key to this character gumbo is diversity within a common whole. And no redundancy: After all, the group needs only one crazy guy—Alan. It needs only one good-looking, charismatic fellow—Phil. It needs only one wimp—Stu.

Three men share a common dilemma . . . and one very photogenic baby.

The goal of the screenwriter when creating a true ensemble is to make the characters easily identifiable and distinct. And, as I've written elsewhere in this book, the way to establish characters is through action. So if you plan to introduce the members of a true ensemble, give each of them a defining action that we see demonstrated in the first ten or so minutes of the movie. This will reserve a unique place for each one in our brain.

That way, as we watch the first handful of minutes, we can say to ourselves:

She's the bossy one.
He's the fearful one.
She's the bully.

And so on . . .

POP QUIZ!

1. Oedipus and Ron Burgundy have one thing in common:

A) Both are Greek.

B) Both are accomplished jazz flutists.

C) Both slept with their moms, killed their fathers, plucked their eyes out, and exiled themselves from Thebes.

D) Both can be described with a single adjective.

2. The character of Andy in *The 40-Year-Old Virgin* is a good example of . . .

A) Why you should save yourself for Miss Right, no matter how long it takes.

B) What living without a car in L.A. will do to your sex life.

C) A character probably created using the outside-in method. Please don't choose this answer. It's wrong.

D) A character probably created using the inside-out method because the story serves the character, not the other way around. Oh, and "B" is also a good answer. Trust me, I've lived in L.A. You can either buy a car or marry your hand.

3. Not only is *Bride Wars* a mind-blowingly fantastic film, but it's also a great example of . . .

A) Why you should always check with your BFF before booking a wedding.
B) Candice Bergen's best work.
C) What an industrious screenwriter can come up with if he shuts himself in a room every day for a year with nothing but a coffee maker and a laptop.
D) The outside-in method of character creation.

5

THE BIG IDEA

Any good comic screenplay is far more than the sum of its parts. Great jokes, great moments, funny characters, a mind-blowing beginning, and an equally mind-blowing ending—they're all as useless as pretty lights wrapped around a dead Christmas tree if the script doesn't have a Big Idea. Or if the Big Idea doesn't satisfy.

I've written and re-written scripts, changing characters and entire story lines—and then re-written them all over again. Draft after draft after draft until it barely resembles what I started with. But I never throw out the Big Idea. If I do, the project is over.

I'm using the *Big Idea* in the general sense. It can mean concept, story premise, logline—whatever makes the story special. The Big Idea is what makes me want to write the story—it's what the script *aspires* to be. I'm not talking about a sales tool. I'm talking about a handful of words that you, the writer, use to express what lies at the heart of your storytelling process for a particular feature screenplay.

I can't give you ironclad examples of what the Big Idea was for somebody else's movie, because I didn't write it. Only the writer of a script knows what lies at the heart of a particular script for that writer. I can tell you that when Hank and I were writing *Saving Silverman* we held onto this Big Idea: *two guys save their buddy from his evil girlfriend.*

The story changed many times as it was pitched, re-pitched, written, and re-written along with the help of producers, studio executives, a director . . . but that Big Idea always stuck around.

But if the people in power—the folks who were paying us to write—had said, "We like your main characters, but we hate that big idea, so take Wayne and J. D. and put them in a different story," that would have killed it. Big Idea dead on arrival.

Thankfully, they didn't say that. But they did make us change just about everything else. Early versions of the story were darker and had a body count. Yup, characters *died*. There were shootings. And there was no Neil Diamond. We were forced to write him into the story by the director, who had his own Big Idea, which was to put one of his favorite singers in *his* movie. So we did.

Yup, we whored.

But that only proves we like to eat. After all, nobody wants to get fired from their first big movie and replaced by new writers who will naturally be gunning to earn themselves credit, which requires major changes to the story.

Again, if the powers-that-be had asked us to change the script's Big Idea, we would have walked away.

Why?

Because then we would have had nothing to turn to when the writing got tough. As it usually does.

That's the greatest thing about the Big Idea—it's there when all else is lost. When you're stuck in your umpteenth draft. When you forget why you started writing this script in the first place. When you've cut and pasted all your best and worst scenes so many times that you can no longer tell which are the best and which are the worst. That's when you need to remember your Big Idea.

Hank and I re-wrote *Saving Silverman* a zillion times (OK, it *felt* like a zillion; it was probably more like fifty) over a period of about eighteen months. During that time, we took everybody's notes: the director, producers, studio executives, actors, etc. I'm not sure, but I think we even took notes from a guy flipping burgers at Carl's Jr. He hadn't read the script, but they were good notes. And they came with a side of fries.

But when things got bad and we had scratched all the hair out of our heads, we could always turn to each other and say, "They've gotta save their buddy from his evil girlfriend!"

And we were OK.

So before we get into the differences between a log-line and a premise, let's take a moment—as writers—to acknowledge that we need our Big Idea when we write. We need it like a five-year-old needs a teddy bear. Because it keeps us warm at night, makes us feel cozy, and protects us from harm. And without it, we are lost.

Now that I've told you what you must hold dear *while* you write, let's look at *what* you write . . .

ACT TWO IS ALL

In 1979, Syd Field published his groundbreaking book, *Screenplay*. In it, he described conventional screenplay structure based upon a total of 120 pages. The second act constituted half—60—of those pages.

Syd did screenwriters, and the whole industry, a great service. He made things clear and provided a simple road map for what is an incredibly complicated process—writing a screenplay.

But, last I checked, this is no longer 1979. And in the twenty-first century, most feature screenplays—especially comedies—run closer to one hundred pages, if not less.

And those middle pages—now more likely to constitute about fifty pages—are the *important* pages.

If you hand me a screenplay with a wretched first act, a great second act, and a horrifyingly painful third act, you've handed me gold. I can re-write the first and third acts to conform to the second act. Seriously. I can fix that baby with one arm tied behind my back. I can make *all* of it sing. Guaranteed. I'll send it to you when I'm done, and you'll buy it.

And that's not because I'm a genius. That's because somebody else has already done most of the hard work.

Now you may be thinking . . .

But Greg, first acts can be tough, too.

Like hell they can. First acts are easy. I would wager that, of all the millions of unfinished screenplays ever written,

more than half end before page fifty. That's because bad writers, weak writers, unprepared writers, and even good writers who should know better can all dream up the best opening and follow it up with great character introductions and fun scenes . . . all leading nowhere.

Remember—the first act is merely setup. The plane is merely taking off. The ship is merely leaving port. For all the fanfare and toasts, the beginning of a journey doesn't tell you if it will be a great ride. The aircraft that looks so shiny and grand during take-off might just be about to explode once it reaches cruising altitude. Or, more likely—as with the majority of all scripts ever written—it will stall and fall to earth. Very few of them will smoothly fly from page 25 to page 75—if they even get that far.

But if they do, I guarantee you they can be landed. And I promise—on my sacred honor as a comedy screenwriter— that for every great second act there is, in fact, a great ending. That's because it can't be a great second act if it doesn't engage the dramatic forces of the story and build to a resolution. And if it's building to a resolution, it can be resolved.

Let's say you're writing your comedy screenwriting butt off and you get to the end of your second act.

Phew! you think.

Then you find that, after trying over and over, you cannot finish your story. You cannot resolve it—no matter how hard you try. In that case, I submit that you do not have a great second act because it does not beget and set up its own ending.

And if that is so, I say this to you—go back and make it great. Don't try to fix the script in Act 3. That cannot be done. No, you must go back and wrestle with Act 2 until you have won.

Why is the second act so . . . everything?

Because the second act is more than just the middle of the script. It's where the premise hits the road and either rises to life or falls flat on its face. And it's what the audience pays to see.

Put this book down right now, go online, and watch the trailer to any successful comedy movie. Most of it will be made up of moments from the second act. Think of the best

moments of any movie and chances are you're recalling something from the second act.

Do you hang out with aspiring screenwriters? How many times have you heard an aspiring screenwriter pitch you a script? They'll start telling you the details of the opening, the camera angles, what the protagonist is wearing, etc. . . . and after five minutes they're still telling you about the first act. Because that's what they've written. Then their voice will start to slow down as they get toward the end of Act 1.

This is where I've still got a few kinks, they'll say.

This is why you don't have a script, I'll think.

Always decide on your second act before you write. Even if you're a "process writer" and you like to start writing without an outline or even a foggy notion of your ending. Come up with the main body of the story in advance. Even if it's just a sentence. Know what happens in Act 2—who faces off against whom, what the nature of the conflict is and where it takes place, etc. If you can't settle on this before you write, don't start writing.

I can think of plenty of successful comedy movies where the second act is so strong that the screenwriter could have written totally different first and third acts without harming the story. Most of them are high-concept films or films with strong hooks where the main point of the first act is to set up the otherwise-hard-to-believe second act.

After all, there are a lot of ways a screenwriter can get to the second act of *Neighbors*. If you haven't seen it, *Neighbors* is about a feud between a married couple and a fraternity living next door.

In the version that made it to the big screen, the married couple, played by Seth Rogen and Rose Byrne, are already ensconced in their suburban home when the fraternity moves in next door.

Imagine a version where the fraternity has already been living there and the married couple move in. How different would it be?

Not much. The main conflict—a war between the couple and the frat—would still be the core of Act 2. Most, if not all, of the same set pieces and story turns could be used.

What about *We're the Millers*? In that movie, a small-time drug dealer is forced to smuggle drugs from Mexico. To accomplish this, he puts together a fake family to help him drive the drugs over the border in a recreational vehicle.

Does it really matter which of his two "children" is introduced first? In the version that played onscreen, Kenny is introduced before Casey. Would the second act change if the reverse was true?

No. Because first acts are interchangeable. For every great second act, there are a variety of possible first acts. In *We're the Millers*, there are many ways to introduce the dealer's family—as long as it is done early.

OK, Greg, you may be thinking, *but what about the ending? Aren't endings terribly important?*

Not to me. And they shouldn't be to you, either.

Third acts of comedies are notoriously short and unsubstantial. That's because many film comedies operate on what I call the *Moliere Principle*.

You don't need to have studied French or drama in college to understand the Molière Principle. You don't even need to have read his plays. All you need to know is that hundreds of years ago there was a very funny playwright named Molière who constructed stories out of very simple premises.

For instance, he wrote a comedy called *The Imaginary Invalid*, in which a hypochondriac tries to force his daughter to marry a doctor so he can always have a doctor in the house.

Molière also wrote *The Miser*, in which a miser schemes to get his hands on more and more money. As you might guess, his miserly-ness drives the plot.

And then there is Molière's *Tartuffe*, in which a charismatic, religious man seduces others into becoming his disciples and obeying his whims.

In all of these plays, a character fault drives the story. The character faults of the protagonists in *The Imaginary Invalid* and *The Miser* are clear enough. They're right there in the titles. As for *Tartuffe*, the protagonist is the head of a household who falls for Tartuffe's trickery. Thus, the protagonist is easily led—another character fault.

So character faults can drive a story. But if those faults are cured—if, for instance, the miser sees the error of his ways—the story must soon come to a close. The engine of the story is gone. Finish your popcorn and go home.

That's the Molière Principle. And it exists in comedy movies as well. When Andy in *The 40-Year-Old Virgin* finally gets over his fear of intimacy, the story comes to a quick ending. Yes, the director occupies a handful of minutes with Andy trying to *get* to his girlfriend. But once they kiss and make up and jump into the bed, the story has come full circle.

The load, she is shot.

Let's look at the Molière Principle at work in *The Silver Linings Playbook*.

As you may recall, Pat, played by Bradley Cooper, has many problems. But his biggest problem is that he hasn't given up on his ex-wife, with whom he has been estranged for some time. His desire to get back together with her drives the story because it causes him to spend time with Tiffany, played by Jennifer Lawrence. Once Pat realizes he no longer wants to be with his ex-wife, the story is on the verge of ending. The load is about shot. Pat need only chase Tiffany down a street and beg for a kiss. The movie is over because Pat's personality defect has been solved as per Molière.

Who knew a seventeenth-century French dude could be such a great screenwriter?

So, to review: *Act 2 is all, and everything else is small.*

Say it to yourself five times fast and keep reading this book.

HIGH CONCEPT

When I first arrived in Hollywood, a television producer took me to lunch. He was a friend of a friend from the East Coast, and I was hoping more social occasions like this might follow shortly.

Turned out I was wrong. I didn't lunch with another producer for a couple years. For those about to pack up and head to Los Angeles to make it as a screenwriter, know this: you will burn through your early contacts after crossing the Midwest. That's part of the game. Don't sweat it.

At lunch, the producer tried to educate me on a subject that gets a lot of attention in the screenwriting world—high concept.

I had actually written one attempt at a high-concept comedy screenplay. It was called *Brainchild*, and it was about a boy who accidentally swallows a pill that makes him the smartest person in the world. Not a great idea, but a big one. And not a great script, either. But it was my attempt at high concept.

Producers, agents, writers . . . all define high-concept differently. Some say it's a catchy logline. Thus, if a script or movie can be summed up in a catchy logline, it is high concept. But just about any successful movie can be summed up with a catchy logline, so that definition is useless.

Newsflash: you are reading this book to get actionable information. You need news you can use. To launch your big comedy screenwriting career. Now.

So let me define high concept in a way that is immediately useful and specific. A high-concept story is one that couldn't happen in real life—but can happen through the magic of moviemaking.

Leaving aside comic book movies, horror films, and science fiction flicks, my definition of high concept embraces such movies as these:

Bruce Almighty
What Women Want
Night at the Museum
Ted
Click
This Is the End
Midnight in Paris
The Santa Clause
Hancock
Elf
Evan Almighty
Freaky Friday

This is the stuff that only happens in the movies. Stuff that can't possibly be real.

So, now that you have the idea, let me ask you . . .

Is *Old School* high concept?

Old School is about a group of middle-aged men who cre-
ate a fraternity so they can relive their youth and hold wild,
drunken parties with college co-eds.

Nope. *Old School* is not high concept. Why not?

Because, while I know of no instance in which a bunch
of middle-aged men created a fraternity and held drunken
parties with college co-eds, it could actually happen. It's
not physically impossible. It's just highly unlikely. Hard to
believe.

Lots of stories are hard to believe. That's what makes
them remarkable. But it doesn't make them high concept.

What about a man who can hear women's thoughts?

Now that's impossible. Totally, totally impossible. That
can only happen in a movie, which is why *What Women
Want* is high concept.

But, you say, what about the catchy-ness of a concept?
What about a concept that sticks in your head and makes
you want to see the movie? Doesn't *that* make a story high
concept?

No.

Many of the high-concept films I listed above are extremely
catchy because they have a *hook*—something that sticks in
your head when you first hear it and makes you want to see
the film. A hook may allow you to visualize the story and
"see" the poster for the movie. It can also tap into the zeit-
geist and reach people based on some shared cultural under-
standing, or because the concept gives life to some thought
you've already been carrying around in your head.

There, I used the word zeitgeist. Am I a smarty-pants, or
what? Anyway . . .

Bruce Almighty has a very zeitgeisty hook. After all, most
of us have wondered what it would be like to be God for a
day. The concept taps into the zeitgeist and hooks you in.
Same goes for *What Women Want*. Lots of men have wished
they could hear what women are thinking. The concept
draws on that shared, easily identifiable common desire.
Again, high concept with a hook.

Contrast those movies with other high-concept flicks like
Midnight in Paris or *Elf*, neither of which have particularly

strong hooks; they are just imaginative concepts that could only happen in the movies. I've never wondered what it would be like to wander into Paris in the 1920s. Similarly, the idea that an elf from the North Pole would search for his human father in Manhattan was totally novel to me before I saw Will Ferrell do it onscreen. That's why—in my book—*Midnight in Paris* and *Elf* are high concept, but without hooks.

I'm not making a judgment here about what's best—I love all four of the movies I just mentioned. I'm simply distinguishing them for screenwriting purposes.

LOW CONCEPT

Here is where we lump all the screen stories that *could* happen in real life.

21 Jump Street is low concept. It is possible for grown-up cops to go undercover as teenagers. Not likely, but possible.

The Hangover is low concept. Yes, the bizarre series of events presented in that film would be unlikely to all occur to the same group of guys (let alone, the events of *The Hangover II* and *III*), but they could happen.

Many low-concept movies are what the industry likes to call "execution dependent." That means the story idea alone doesn't sell the film or even tell you what the film is. You have to watch the movie to find out.

Tammy is low concept. In fact, you could say there's no concept at all. *Tammy* is a story about a woman who quits her life and goes on a journey with her mother.

See how memorable that logline is? To see that movie, either you have to be a sucker for Melissa McCarthy or you have to walk into the theatre hoping the movie is well-executed. In other words, the movie's gotta be good because the concept is nothing remarkable.

If we leave aside, for a moment, the issue of how sellable a low-concept movie may be, as compared to a high-concept movie, there is the issue of how writeable a movie is.

As a writing teacher, I prefer that my students write low-concept screenplays. Why? Because writing is its own teacher. When you're writing a high-concept script, you must sell the concept on every page. You are always

justifying the idea. Not an easy task. You may even have to do some bad writing to keep the concept alive. The idea is everything.

When I'm working on high-concept ideas for a screenplay I want to sell or pitch, I do very little actual writing. I sit in a chair holding a mug of coffee, staring at a white screen. On that screen is a list of ideas—every silly thought I've had since I sat down that morning. I may have a small notebook open on my lap—with notes I made about funny or remarkable things that have happened in my life or the lives of others. I may surf the web, scouring it for the seeds of stories. I might peruse websites showing synopses of scripts that have recently sold. I might look at *The New York Times* or Drudge Report or Salon . . .

In other words, I'm idea farming. For a working screenwriter, idea farming is no less exhausting than real farming. OK, I've never actually worked on a farm, so I may be projecting a tad here, but I have *been* to a farm. Once. That's how I know.

Idea farming is a necessary part of the process of making a living as a screenwriter in Hollywood. But when you're doing it, your writing muscles aren't being used. You're leaving them on the shelf while you scratch for that next idea, which will hopefully pay your mortgage and put braces in your kid's mouth.

So be wise and weigh the costs and benefits of working on the farm. For most aspiring screenwriters, the way up the ladder is through writing. Thus, I urge you to pick a low-concept idea and get cracking. In the long run, you are more likely to be discovered as a result of a great script than a great idea for a script.

Writing a low-concept script means less time spent worrying over the idea and more time spent on the writing. And by writing I mean the fundamentals—strong characters, funny moments, great story turns, etc. You won't improve your writing without doing more of that.

So you can write to sell or write to improve your writing, but not both at the same time.

That being said, let's get more specific about the gradations of concepts. Understanding and being able to see

the differences between concepts is the key to creating and managing them on a consistent basis.

Somewhere between very high-concept films like *What Women Want* and very low-concept movies like *Tammy* is where you'll find most movies.

Let's place them on a ladder and check them out:

High Concept with Hook

What Women Want
Bruce Almighty
Click
Night at the Museum

High Concept without Hook

Ted
This Is The End
Elf
Evan Almighty
Midnight in Paris

Low Concept with Hook

Legally Blonde
Daddy Daycare
The 40-Year-Old Virgin
I Now Pronounce You Chuck & Larry
Meet the Parents
Bride Wars
School of Rock
Old School
Saving Silverman

Low Concept without Hook (AKA Execution Dependent)

Knocked Up
Bridesmaids
Superbad
Sweet Home Alabama
Get Him to the Greek

Charlie's Angels (I & II)
Pineapple Express
The Hangover (I, II & III)
We're the Millers
Friday
My Big Fat Greek Wedding
One Fine Day
Think like a Man
Big Daddy
Grown Ups
Forgetting Sarah Marshall

Sure, we may disagree about a few of these. You may think *Knocked Up* or *Forgetting Sarah Marshall* have hooks. I just see them as funny situations. The point is this: there is a hierarchy of concepts that movies can be plotted on. If you don't like my hierarchy, make your own; but make sure you are aware of, and categorizing, every movie you see and every script you read. This is how you come to know the industry you want to be a part of. This is one of the skills that will raise you from an aspiring to a working screenwriter.

Now you may be wondering how my ladder—or yours, if you devise your own—affects your writing.

This question arises: What kind of comedy screenplay should you write? In answering that question, raise another: What kind of story can I write best? That will tell you what kind of script to write.

For aspiring writers looking to get noticed, writing your best script is the way to go. After all, your goal is to get read by people who can help you—agents, managers, producers, etc. Your career is only going to pick up steam if there is a host of people in the industry who can attest to the quality of your work.

Stay in your wheelhouse. If you usually write broad comedy, don't spend six or more months of your life writing and re-writing a horror flick. (Trust me. I've done it.) You don't have the time, and it's not your best choice. If your best writing is usually done in service of a high concept, write high concept. If you're best at low-concept,

execution-dependent stories—as I think most writers are—write them and nothing else.

Throw the pitch you throw best, and throw it often. That's the way to play to your strengths and increase your chances of success. The moment you start to expose your work to agents and producers, you're in the big leagues. When a big-league pitcher, who is known for his fastball, is playing in the ninth inning of a big game and facing a serious batter, he doesn't suddenly decide to throw a change-up. He dances with who brung him. He throws the fastball he's known for.

Had enough sports analogies?

Fine, then let's talk about . . .

COMIC JUSTICE

How many times have you heard that movies are wish fulfillment? The world is not always fair, and folks work hard for their entertainment dollar. So when they walk into a movie theatre, or go to Netflix, they hope to visit a better place for two hours where good guys get rewarded and bad guys get what they deserve. A world of karma and payback—unlike the one they live in.

Comedy screenwriters must create with *that* world in mind. And in that world, people are taught lessons they desperately need to learn.

A guy who thinks he could do God's job better than God will wake up as God. That's *Bruce Almighty*.

Two female friends who value their weddings over their friendship are forced to choose between them. That's *Bride Wars*.

A loner who retreats from adulthood and commitment is forced to take care of a child. That's *Big Daddy*.

In each of these movies there is a force hovering over the film. You may call it karma or some other name. I call it Comic Justice. The force that teaches lessons to mistaken or misguided protagonists. Lessons they need to learn.

Comic Justice is the manifestation of wish fulfillment for the audience. In *Bruce Almighty*, we see the protagonist questioning God, and we think, *If only he could get what he deserves*. Comic Justice satisfies that desire.

We see two women focusing on weddings over friendship and we think, *They need to be taught a lesson.* Comic Justice to the rescue.

We see this selfish loner who eschews commitment and we think, *He should suddenly become a dad.*

Comic Justice to the rescue!

Comic Justice is the avenging angel of humor that swoops down, kicks butt, and takes names. Oh, and makes us laugh along the way.

Again, the story matches the protagonist, who must get what she or he needs. Creating concepts using Comic Justice is as simple as matching situation to character. The second act—the main body of the story, where the premise thrives—satisfies a need the protagonist has. And here's the key—protagonists don't know they need justice. We know it because we see it. They don't know it and that's why they need it.

Chances are you've been employing Comic Justice in your own private fantasy world for years. After all, we like to believe that everything happens for a reason, don't we? So when you see your jerky neighbor—that guy who roars down your block in his sports car every day without worrying about the kids playing around every corner—crash into a huge pile of cow manure, causing crap to rain down upon him and his car, you naturally think, "Thanks, God!" You would have paid to see that. And it happened. Satisfaction.

Sadly, that sort of justice is rare in real life, which is why the world needs you—the comedy screenwriter—to make it happen on screen.

So if you dream up characters before concepts, as discussed in the previous chapter, then you need to keep the principle of Comic Justice in mind—because any character fault can be confronted and resolved in a comic way.

Did you see *Ant Bully*? In it, a kid who beats up ants gets shrunken to the size of an ant. He struggles in his new situation and learns a lesson, and we laugh.

Comic Justice—like almost everything I write about in this book—is a *strategy.* Use it wherever and whenever you can. Whether you're brainstorming big ideas for a new

script or trying to find an ending for a scene you've been working on all night, Comic Justice is now another tool in your toolbox.

Movies Using Comic Justice

Get Hard
Friends with Benefits
Bride Wars
The Ugly Truth
Fool's Gold
Forgetting Sarah Marshall
Knocked Up
Bruce Almighty
The Game Plan
Failure to Launch
Bringing Down the House
What Women Want

Where's the Comic Justice in *The Ugly Truth* and *Fool's Gold*? Easy. Both are romantic comedies featuring two people who first hate each other, but then ultimately fall in love. When the person you most hate is actually the person you most love, you're being punk'd by Comic Justice. Both lovers are taught a funny lesson.

In *Friends with Benefits*, we see something a little different. The two leads of that movie both agree that it's possible to have casual sex without falling in love. Naturally, Comic Justice teaches them they're wrong.

The Game Plan, of course, works much the same as *Big Daddy*. The protagonist runs as far from family and commitment as he can, but Comic Justice traps him with a child that he will ultimately come to love.

In *Failure to Launch*, Comic Justice is carried out via a conscious plan hatched by characters in the story. A grown man who refuses to leave the house is taught a lesson by his parents, who naturally want him to grow up and get out.

Comic Justice can also be applied to supporting characters and their side plots. The examples are easy to spot, so I won't detail them. Just remember that this strategy cannot be overused. The audience wants everybody to get their

due—from the protagonist on down to the waiter who has one line in the movie.

But what happens when fate gives the protagonists—or any character—what they do *not* deserve? That's comic *in*justice. Otherwise known as dark comedy.

Dark comedy is not favored by Hollywood, largely because it is not desired by most audience members. Dark comedy proposes an unkind world ruled by either an absent or an unsympathetic god. There are few examples of successful dark comedy movies, with the best—*Pulp Fiction*—having been produced before this century. Thus, in keeping with what I told you in the introduction about only referring to twenty-first-century movies, I'll skip a full-blown discussion of it.

Am I telling you *not* to write dark comedy? Nope. I'm telling you to be realistic; if you write dark material, know that it's not for everyone and may earn you a lifetime of rejection from Hollywood.

That being said, if your dark comedy is as good as spun gold and you are determined to sell it or see it made, you must give it to the right readers. Don't waste your best work on readers who aren't sympathetic to your goal. After all, how many darkly comic films were made last year, if any? I suggest that, if you insist on writing dark comedy, you look to television, where it thrives. After all, the question is, *Where can you peddle what you love to do?*

GENRE-BENDING

I can think of very, very few movies that don't fall within an easily identifiable genre. Actually, one comes to mind— *The Trip*. It was made in 1967, and it's about a guy who takes LSD and goes on a drug trip that lasts for much of the film. And it's really, uh, wacky. Funhouse lenses are used; a goat shows up and does stuff; a bunch of unconnected and irrational events take place.

Kinda hard to place *The Trip* within a genre, right? Well, actually, it *is* part of a genre called Roger Corman movies. But a discussion of Corman's low-budget flicks would require another, very different, book. And again, I promised I wouldn't discuss movies from *that* century.

In the world of feature-film comedy, are there any movies that fit into no genre at all? I can't think of one. At least not in this century. Nope. For our purposes, every movie and every script has a genre; in fact, most scripts fit into, or borrow from, more than one genre.

Why is it so important that you understand genre and classify your work by genre?

Because you don't write movies to please yourself. You write to please others.

And those other people who are going to read and, hopefully, sit through your movie—they expect genre. They crave it. For the same reason you read labels before you buy food.

Before they become familiar with your movie, the audience is always wondering, *What kind of story is this?* Nobody gets on a ride in Disneyland unless they have some idea what the ride is like. If it's a roller-coaster, they want to know in advance. I know I do, because I'm afraid of heights and get motion sickness. If the ride is *It's a Small World*—I, and everybody else over ten years old, want to get off.

But wait, you say. Won't it kill your comedy mojo to submit to the restrictions of some cookie-cutter form?

No. After all, does using a typewriter—and conforming to its rules—restrain you from doing your best writing? What about standard screenplay format? Does it hold you back?

I tell you this to save you effort and speed you along to success as a comedy screenwriter: *don't fight the form.*

First, because you *can't* do it. And second, because you *can't* do it. So don't try.

Instead, give some credit to all the comedy screenwriters that came before you and just accept that genres exist and they are there for you to use. When you are working in a genre, you are taking advantage of the many decades of film history in which it has been established that:

- Western shoot-outs generally take place in the center of town with the whole town assembled to watch.
- Buddy cop movies always have at least one interrogation scene where the two cops try their different strategies to make the perp talk.

- Mentors die. A lot. If you're writing a story with a mentor, kill him. Thank me later.
- In romantic comedies, the protagonist's best friend of the opposite sex, who gives him (or her) the best advice, is usually in serious love with him (or her).
- When the officiant of a wedding asks if anybody present knows a reason these two people should not wed, somebody actually speaks up. (I've been to plenty of weddings and have yet to witness this in real life. But then, Hollywood ain't real life.)

Again, recall Sir Isaac Newton, screenwriter extraordinaire, who said, "If I have seen further, it is by standing on the shoulders of giants."

Write that in your little notebook of ideas!

The point is: Don't fight the form. Don't reinvent the wheel. It's a good wheel. You need only ride it your way. And remember it's the bad screenwriters who agonizingly try to build a whole new mousetrap every time they type "FADE IN."

Moreover, the great thing about learning and replicating the conventions of a genre—whether it's bromantic comedy or zombie road trip—is that by doing so, you will add to the genre. You'll find your own unique spin on the convention. You'll push the genre a few inches further than it's been pushed before. When that happens, the audience—and the reader—will thank you. After all, you breathed life into something they wanted but had become bored with. You gave them both the new and the familiar.

So what's *genre-bending*? It's when a screenwriter merges elements of two very different films to imagine or describe a third, new film.

When you're up all night scratching the walls for ideas to start your next big feature comedy script, I suggest you play a game that most professional screenwriters play on a consistent basis—start sorting movies by genre and tossing them around.

I call it *X meets Y*.

Take a bloody shoot-'em-up and set it in France in the twenties. What do you have? *Django, Unchained at Midnight in Paris.* I can see the poster—an African American man in a ten-gallon hat unloading his six-guns at the great artists of the expatriate era. It's brilliant. Laughably brilliant. And it could never happen.

That's how you play the *X meets Y* game. You take two types of movies—usually polar opposites—and jam them together into a freaky, shocking shit sandwich. And then take a bite.

Every once in a while it tastes OK. Or it tastes bad enough to actually get bought.

When Hank and I first started pitching, we used *X meets Y* to come up with the freakiest combinations of movies you can imagine. We churned them out like a little factory. Here's one that might make you chuckle:

It's called *Wrecked.* Here's the logline:

When a group of Beverly Hills High School students flies to Vail for a ski weekend, their plane crashes in the Rocky Mountains and now it's *Clueless* meets *Alive.*

That's right. You heard me correctly. *Clueless* meets *Alive. Clueless* is about the social life of wealthy, privileged teenagers. *Alive* is about a bunch of soccer players whose plane crashes in the Andes. As you may remember, they are forced to eat their own dead to survive.

When we pitched *Wrecked*, everybody laughed. Our agent laughed. Studio executives laughed. Producers laughed. Naturally, the story had everything you might expect. There were jokes about a bulimic girl who throws up her meal of cannibalized human flesh to lose weight, and a demented football coach who pushes his students to eat him, piece by piece. (At one point, they carry his still-alive, limbless torso around in a backpack.)

And then New Line bought it and paid us to write it.

Where is *Wrecked* now? I have no idea. Probably on a shelf somewhere or being re-written by some other pair of screenwriters. It doesn't matter.

What matters is that we used the *X meets Y* game to pitch a script that we got paid to write. And who knows. Maybe

New Line will pull it off the shelf someday and make the movie. Heaven knows the world needs to laugh.

Here's how I pitched *Bride Wars*:

"It's about two women, best friends, who accidentally schedule their weddings on the same day. So it's *Dirty Rotten Brides*."

That's not exactly an example of *X meets Y*, because there aren't two movies being referenced. But it's the same crashing together of two movie types—the wedding movie and the mano-a-mano con man movie.

And it worked. Kate Hudson loved it, and Miramax made me a deal.

So be a genre-bender and play the *X meets Y* game. You don't know what you might come up with. The first fifty times you do it, you'll probably get something you wouldn't want to see, like *Django, Unchained at Midnight in Paris*. But every once in a while you find a *Wrecked* or a *Bride Wars*. And in case you're wondering—yes, I still get residual checks in the mail every three months for *Bride Wars*, and, yes, they pay the mortgage.

It's the gift that keeps on giving.

So tonight . . . pour yourself a hot mug of Joe, sit down to write for the night (and maybe into the day), and play *X meets Y*. Healthiest thing you can do with your pants on. Nobody needs to get hurt. Just do it. Grab ahold of a story, or a character, and toss it smack-dab into a totally different environment. Or even a totally different film. See yourself as crashing cars together for the sheer fun of it. Expect weird stuff to come out of it, but also look for some ideas that are so wacky that they just might work. Those are sometimes the funniest ideas of all.

And if your husband or housemate or old Uncle Bert happens to suddenly turn on the basement light and walk downstairs and find you there smashing movies together—just smile with pride and tell him you're genre-bending. And watch his expression change. Chances are he'll just give you a quizzical smile and say something like, "Well, OK, sweety. Just make sure to turn off the light when you go to bed."

But, of course, you won't be coming to bed, because you're a comedy screenwriter and you're going to stay up all night genre-bending, right?

FISH OUTTA WATER

If you are a comedy screenwriter—or intend to become one—the fish is your friend. The fish is everything. Don't give up on the fish.

Have I made it clear just how important this comedy writing strategy is? Your fish must stay out of water. It must never swim.

Dream up any character. (This is the fish.) Any height, weight, ethnicity, hairstyle . . . any point of view or background. Now all you need to do is throw the fish into an unfamiliar environment or situation.

Obviously, the fish needs to have goals and drive. Without purpose, the protagonist may fail to take action like a gerbil thrown into a tiger's cage. It may just curl up in a ball in a corner and wait to be eaten. That's not fun to watch. But give that gerbil a goal and it will try to find or fight its way out of that cage, and we want that. We want to watch it try.

As discussed elsewhere in this book, farce depends on characters struggling against their situation. Fish Outta Water (F.O.W.) is a tried-and-true strategy to help screenwriters manufacture farce.

When a bumbling security guard is suddenly forced to deal with gun-toting badasses—as in *Paul Blart: Mall Cop*—the fish is no longer wet.

When a pompous anchorman is forced to deal with a changing world that has left him and his kind behind—as in *Anchorman*—the fish is turning somersaults on the end of a fishing line, caught and flailing.

And when a group of Hollywood hipsters are forced to deal with the end of the world—as in *This Is the End*—the fish is flopping on the deck.

But when a seemingly ditzy sorority girl gets into Harvard Law School, we have the sharpest F.O.W. of the twenty-first century—*Legally Blonde*. The concept is pure platinum. In

fact, it's so platinum that it supported a second, equally successful flick, *Legally Blonde 2: Red White & Blonde*, in which the fish stayed the same, but the environment was escalated to the U.S. Congress.

So, when you are sitting at your laptop in the middle of the night in that apartment you rented in Mar Vista the day after you arrived in Los Angeles to become a comedy screenwriter, and you are wondering to yourself, "I've got this great, new character to write about. Now how do I make her funny?"

The answer is simple—yank her out of the water. Make her struggle to cope with a new, painfully difficult situation. Then watch her squirm.

Fish Outta Water also gives the audience a newcomer's point of view into the world of the story. Movies are experiential. We journey through the pits and snares of the world we are thrown into once the lights go down. But we don't want to go at it alone. We want to be holding the hand of another uninitiated person—the protagonist. That way we laugh and cry together. And if the protagonist is an even bigger bumbler than we are, we laugh at him.

Look, there he tripped again! Look, there, he fell on his face!

The last thing we want him to do is leave the funhouse. After all, only in its unfamiliar environs will our jester trip and fall so much—to our great delight.

As a comedy screenwriter, you need to play games with yourself (or your writing partner) to come up with situations that appropriately (or, rather, *in*appropriately) match the story up with the protagonist you're imagining.

Imagining a wealthy socialite housewife who's never had to work a day in her life? Put her in a restaurant waiting tables. Or better yet—the marines. Or even better—make her take a job as a maid. Or a shit-shoveler. Is that a job? If it is, make her do it. Put her in whatever environment she is most foreign to.

Adversity teaches lessons and breeds character. This is connected to another, more general, writing rule that is discussed elsewhere as well—conflict requires obstacles. Pulling your fish out of the water immediately escalates

the obstacles. And that's what separates the many, many *good* screenplays from the very few *great* ones—the degree of adversity. Great comedy screenwriters keep making it tough on their protagonists.

Elsewhere in this book, I talk about the importance of the second act as the comprehensive incarnation of the main idea of the film. OK, "incarnation" sounds a little pretentious, but stick with me as I use an example from a movie you probably know:

Let's say you're writing *Get Him to the Greek*, Nick Stoller's low-concept comedy about a young music executive who must escort a fading rock star to a concert in order to save his job.

Yes, I know. Nick Stoller already wrote that movie. But let's imagine he didn't and you're the writer.

The second act is heavily loaded with conflict—the conflict between Aaron (the young, idealistic executive) and Aldous (the middle-aged, cynical rock star). Aaron wants to keep his job, but Aldous couldn't care less and merely wants to follow his tripping heart wherever it leads. And it leads away from the Greek Theatre. Aaron is pathetically loyal to his girlfriend, whom he lives with. He's never strayed from her—unlike Aldous, whose promiscuity is legendary.

Since you've tied the two lead characters together at the hip, you have Aldous's entire personality to mine for obstacles. And you also have everybody around Aldous—his rippingly outrageous rocker pals. You're basically going to have Aldous make Aaron's job as hard as he can possibly make it. Whenever you need more obstacles, you turn to Aldous.

And every time Aaron thinks he understands Aldous and has made some kind of peace with him that will allow him to get him to the Greek, you complicate the story by having Aldous do more outrageous stuff that tightens the screw on Aaron. And when you run out of stuff to pull from Aldous, you pull from the characters *around* Aldous—like his dad. Just to make things worse for Aaron, have Aldous's dad pick a bloody fight with Aaron's boss, Sergio, who is just the kind of unyielding ass-kicker that never backs down from a fight.

I'm telling you how to adopt F.O.W. as more than just a strategy; adopt it as a mentality. Just keep making your protagonist's world harder and harder to exist in and you're on the right track—at least until you're ready to finish your story. Then, and only then, can your protagonist finally start to get comfortable in a new world.

Only then. Not before.

And when you construct your second act, you're going to list—in ascending order of explosiveness—each and every possible moment of conflict between Aaron and his goal. The biggest moments will become your *set pieces*, which we'll discuss in chapter 7.

So there you are. You can now go and write *Get Him to the Greek*. Just change the title and character names and maybe throw in a few new plot details.

You think I'm kidding, don't you? Hardly. I'm telling you how Hollywood works.

But to return to our more scholarly discussion of Fish Outta Water . . .

F.O.W. is a strategy that helps the comedy screenwriter accomplish the main goal of drama while creating farce—it helps determine exactly the nature of the protagonist's character. As the protagonist struggles to surmount escalating obstacles, we see what the protagonist is made of.

In *Get Him to the Greek*, we see that Aaron is a sincere, earnest person who perseveres. That's proven over the course of the story.

When a protagonist like Aaron journeys through a challenging environment and comes out with his integrity intact, we say to ourselves, "He's a good man."

And hopefully we say that after laughing our asses off.

THE IDEA FACTORY

I've told you about some basic strategies that will help you create strong stories that can make people guffaw with laughter for about ninety minutes—the average running time of the modern film comedy. If you do that, you'll rise to the top of Hollywood, and, hopefully, you'll thank me at the Oscars. Hey, one can hope, right?

But now I want you to imagine the comedy screenwriter you're going to become. I want you to picture Detroit in the fifties—a thriving beehive of industry pushing out cars. Cars of all shapes and styles. Each model a little different, but all having the same basic features underneath the hood—an engine, a drive train, transmission, etc.

Yes, I'm making an analogy here because I want you to become an *idea factory*. You must develop a system for churning out uniquely funny ideas for screenplays. And once you pick one of those ideas and start writing it, you'll need a uniquely funny idea for each of the seventy to ninety major scenes that will make up that comedy screenplay.

That means every day must be an industrious day. Like Japan in the eighties. Or China, well, *now*. Or think of the way they're pushing out app after app in Silicon Valley. Like there's no tomorrow. No time to wait. The ideas just *flow*.

So how do you do that? It's a two-step process.

STEP 1: Become a keen observer of funny phenomena. Keep a journal, keep a notebook, record yourself on your iPhone whenever you get the feeling, whatever. Just start keeping track of every last funny thing you see, hear, or think every day. Most of it will be crapola. Some of it will later, upon review, turn out to be funny.

When the tattooed guy with a bone in his nose makes eyes at you in Starbucks, write it down. Make eyes back, if you like, or ignore him, but *write it down*.

When somebody's overweight grandpa decides to do a cannonball at the local pool and splashes half the people there, don't joke about it to your best friend sitting next to you, *write it down*. Scribble quickly before you forget. *Then* you can snicker about it to your friend. But first things first.

The most basic purpose of writing is to record stuff. Thousands of years ago, before there was electricity, before there was a Roman Empire, and even before there was screenwriting, people wrote stuff down simply for the purpose of keeping track . . . of stuff. Merchants dealing with many accounts needed a way to remember who owed them how many gold pieces. Kings needed to remember how many soldiers they'd killed or how many ships were in their navy. And now, after

all those generations throughout history, you need to keep track of all the funny stuff you see on a daily basis. So buy a little notebook, OK? And keep a pen handy.

After all, you're a comedy screenwriter, not just some person who snickers to your friends at the pool.

Write the funny stuff down. Write so much of it down that you have trouble keeping track of it all. Then spend hours indexing what you've got and alphabetizing it and . . . you get the idea.

Be your own research assistant. Catalogue your funny life and the funny lives of those around you. If you're unsure if something's funny, write it down and figure it out later. You call yourself a *writer*, right? Not a . . . *not*-writer.

Here are some example entries from one of my many notebooks:

> Idea for a romantic comedy—a guy who has to learn to be less selfish. Possible title: Selfie!
>
> Modern people should have family crests like people did in the middle ages . . .
>
> Character idea—a female proctologist who falls in love with one of her patients, but she alienates him when she gives him an especially rigorous prostate exam.

See how lame this stuff is? Pathetic. *Anybody* can write this stuff. And by the way, none of these ten-cent ideas were the germs of something useful. I'm just showing you the kind of detritus I create on an everyday basis.

Yes, any moderately talented comedy screenwriter can discover a whole world of funny ideas by just paying attention to herself and the people around her. Again, you must see funny people everywhere . . .

But after you scribble those notes—or type them into your iPhone, as the case may be—keep working. And move on to . . .

STEP 2: Now that you have lists of funny stuff, go back over those notes and review them. This is another form of idea farming. You're pulling the wheat from the chaff and scouring it for further ideas. I make lists that are like

daily updates on my creative activity for the day or week, such as:

> I now have three characters to use for a zombie/ romantic comedy if I can get the concept down.
>
> That Greek diner on sixth avenue—a good place for a set piece in which characters have a food fight, throwing everything, including the plates, burgers . . .
>
> What if my mom woke up in a Game of Thrones world . . . ?

Now sit down with your daily updates and work up a list of screenplay ideas based on them. Most of those ideas will suck. A few may fly. One may be worth writing.

So you write . . .

Cut to six months later. Or three, if you're incredibly fast and you don't have a spouse or kids to bother you. If you have both, call it a year. But eventually you'll have something and you'll work it and re-work it.

Let's say you just wrote yourself a great spec comedy screenplay. So great that everyone in town loves it. And you know which town I mean (if not, see chapter 2). Producers, executives, agents, and managers are all coughing up their over-priced sushi in spastic appreciation.

That doesn't mean they're going to buy your brilliant script. In fact, most great scripts never sell. Why?

There's little need for brilliant scripts. Each major movie studio will make maybe fifteen feature films a year: a handful of comedies, a couple horror flicks, a few big comic book and animated movies, etc.

So even if your, say, rom-com happens to be the best rom-com screenplay to grace their desks in many a year, it still isn't likely to get bought or—even less likely—made.

So you're just outta luck.

Thanks for playing, right?

Wrong. Yes, of course you want to sell every script you ever write for high seven figures, but the more immediate goal is to earn *fans*. And when people in the industry read your script and laugh out loud—you've made more of them.

Fans matter. In fact, they're absolutely essential.

OK, so let's say your script is utterly beloved but no one buys it. Now what do you do?

Meet your fans.

Any decent literary agent can use a hot, funny script to set you up with meetings all over town. And off you'll go with a skip and a hop . . . down to the studios.

And what will you do when you get there?

You'll listen. Producers and executives take those meetings, in part, to tell screenwriters what they need from them. If they're looking for a new sci-fi rom-com, they'll tell you. If they want the next Bradley Cooper vehicle, they'll tell you. Whatever they want from you, they won't be shy about letting you know.

And more often than not, you'll hear the same general message from every producer and executive you meet. After all, Hollywood is a town of one mind. The industry is made up of people who spend every waking moment with each other. It's a sewing circle, a cabal of like-minded puppies all sucking from the same teat. When a few of them decide there hasn't been a really good family comedy since *Meet the Parents*, you should probably go back to your dingy apartment in Mar Vista and write a modern take on *Meet the Parents*.

Trust me. If they want it and you write the heck out of it, they'll buy it.

THE TWO-HANDER

Sounds almost pornographic, doesn't it?

Get your mind out of the gutter. I'm trying to educate you.

A *two-hander* is industry-speak for a movie with two leads: *The Heat, Wedding Crashers, 21 Jump Street, Ride Along, Identity Thief, The Campaign*, etc.

And they're multiplying. In 2012, four of the eight highest-grossing live-action comedy films were two-handers. A fifth, *Ted*, could be considered one. In 2013, at least two of the top-grossing films were two-handers. In 2015, they were back with a vengeance: five of the seven top-grossing

live-action comedies were two-handers (*22 Jump Street, Neighbors, Ride Along, Dumb & Dumber To, Let's Be Cops*).

Why has Hollywood started leaning so heavily on two-handers? I suspect it's because they make use of two stars—two box-office draws—doubling their chances of making a profit.

But *Why* doesn't matter to us as much as *How* . . . as in *How to write them*. So now I ask the question . . .

What special tricks does a writer use when writing the two-hander comedy screenplay?

Before even thinking about writing a two-hander, you, the comedy screenwriter, must set aside some serious time and research the hell out of this sub-genre. You have plenty of examples to choose from.

First, let me make a distinction between three types of two-handers:

1. Mano-a-mano stories in which the protagonists are pitted against each other: *The Campaign, Bride Wars, Neighbors*, etc.
2. Buddy movies in which the protagonists work together: *The Heat, Let's Be Cops, 21* and *22 Jump Street, Wedding Crashers*, etc.
3. Romantic comedies with co-equal leads who fall in love, such as *How to Lose a Guy in Ten Days, Just Go With It, 50 First Dates, Knocked Up, Fool's Gold, The Ugly Truth*, etc.

You may have noticed I didn't include *Silver Linings Playbook*. That's because it's not a two-hander. Pat, played by Bradley Cooper, is the unequaled protagonist of that film. It's *his* story. We see Tiffany, played by Jennifer Lawrence, almost exclusively through his eyes. She is introduced in the twenty-fifth minute of the movie and has few scenes of her own. So, while the Academy rightly gave Lawrence a "Best Actress" Oscar for her performance, it is important to understand that, from a screenwriting perspective, Tiffany is not a protagonist. She's a love interest.

As for buddy comedies, there are two basic approaches. In Approach A, the buddies aren't buddies—and may not even know each other—at the start of the story. This usually implies a more sweeping story structure, like a romance, with a "meet-cute" scene and initial tension between the buddies eventually growing into some form of partnership. In Approach B, they are already buddies when the story begins.

In both approaches, at the end of Act 2, the buddies usually break up for a while before reuniting in Act 3 to resolve the conflict. Thus, the end of Act 2 is the lowest point for the *friendship*. In Act 3, they ride onward together to victory.

In *21 Jump Street*, that break-up scene occurs in the seventy-seventh minute of the movie when Jenko and Schmidt fight onstage during the school play, briefly throwing their friendship away. In the subsequent two scenes, they are expelled from the school where they were working. Then, a few scenes later, they make up and gather themselves for the third-act battle.

So if you're writing a buddy comedy, look to romance movies for templates; they work.

There is also one huge advantage—or disadvantage, depending on the nature of your talent—to writing a two-hander. Two-handers tend to simplify story structure. In buddy comedies and romantic comedies with co-equal leads, the two protagonists usually go through the steps of the story *together*. Thus, each moment or choice in the story can be a source of entertaining conflict.

21 Jump Street, Ride Along, Identity Thief, The Heat . . . in these movies the two leads are polar opposites. Thus, they can find something to argue about in just about any situation.

That's what makes buddy comedies so easy to plot and so much fun for the audience. If the two buddies are well-matched, simply opening a door or walking down the street could cause enough tension to create a whole set piece. Each story beat involves a decision about which they can disagree. And that disagreement may be the funniest part of the movie. When that happens, the story slows down to

accommodate the funny leads. The plot requires fewer beats and becomes simpler to manage.

So if you're bad at plot and good at dialogue, consider a two-hander. Play to your strengths.

THE ENSEMBLE

Sometimes three hands are better than two. Even four can be good. That's why there are ensemble comedies. *Charlie's Angels (I & II), Wild Hogs, The Hangover (I, II & III), We're the Millers, This Is the End, Hot Tub Time Machine* . . .

Again—the more protagonists you have, the less story you're writing. Each major event has an effect on each character that must be charted and shown. Each character has a story arc that must be presented over the course of the larger story of the movie. If it takes forty scenes to track a solo protagonist, it takes ten beats each to track four protagonists. That might be two beats each for the four characters in Acts 1 and 3, and six beats each in Act 2.

Of course the ensemble comedy presents one big problem for screenwriters—the problem of distinguishing the protagonists. There are plenty of things to remember from this book about *writing* a screenplay, but there is only one thing you must always remember about *reading* a screenplay:

Nobody likes to read.

Not even—actually, *especially*—other screenwriters.

I don't know about you, but if I am forced to read somebody else's script, I look for any reason to put it down. And one reason other screenwriters give me on a regular basis occurs when I can't keep track of who is who in the story.

I will generally remember the first major character I read about, which is why you should always make that character your protagonist. And I'll make a decent effort to remember the second major character as well. But by page twelve or so, if I'm still running into new, major characters, I start to yawn.

Did the writer really need to have all these charac-ters? I ask myself. *There had better be a good reason for it*, I threaten the writer silently while turning pages, my eyes finding it harder and harder to stay open. Soon I'm half asleep and the script has tumbled from my hands onto the floor. In my final waking moments, I wonder, if per-haps I leave it there, will the maid get it when she visits on Thursday? Chances are, I *will* leave it. And chances are she will *not*.

How do you manage multiple lead characters in an ensem-ble comedy? Read the screenplays for any of *The Hangover* or *Charlie's Angels* movies. Read *any* good ensemble com-edy screenplay. Important characters are defined quickly and clearly so you don't forget them as you read on—even if they don't reappear for many pages.

As I've written earlier in this book, the best way to define characters is through *action*. Introduce each character and define that character in the same moment. Hit the nail on the head so hard that even casual, distracted readers can-not forget who they are reading about. Better yet, make those casual, distracted readers want to be reunited with that character later in the story so they never stop reading. Make them lick their chops. Make them want more of what you're cooking.

And what you're cooking had better have variety. An ensemble story with four characters cannot present four *slightly* different people. After all, if the four characters are not distinct enough from each other, the reader will wonder, *Why four and not three? Or two?*

Which brings us to a general rule of writing: *don't be redundant.* If the names of the characters are the only things distinguishing them from each other, you have more char-acters than you need.

To be clear, redundant characters are not the same as Shadow Characters, which I discussed in chapter 4. A shadow character shares certain basic traits with the pro-tagonist but remains unique. A redundant character lacks even that.

Remember: the more lead characters you have, the more definition you need. Immediately establish them, distinguish

them from each other, and get the action started. Your readers will thank you.

POP QUIZ!

1. A screenplay with a great first act and a great third act is . . .

 A) Pretty much as useless as a one-legged dodo bird unless it's got a great *second* act.

 B) Like a sandwich with no meat in the middle. (Sorry. If you're vegan, imagine chutney.)

 C) On the bottom of a pile of recycling right now on my office floor.

 D) All of the above.

2. A high-concept story is one in which:

 A) Bob Marley plays a role.

 B) Some wacky stuff happens in the story that is a tad out of the ordinary.

 C) The story is the kind of thing that could only happen in the movies.

 D) Please go back and take a look at C.

3. When the story gives the protagonist what he or she so badly deserves, we call it:

 A) Phil.

 B) Burt.

 C) Wendell.

 D) Comic Justice.

4. F.O.W. stands for:

 A) Foolish Orangutan Washboard.

 B) Fry Otto's Women.

 C) Fish Outta Wisconsin.

 D) Fish Outta Water.

5. You should consider writing a two-hander if:

 A) You love writing plot more than anything, and that includes peach cobbler.

B) All of the above. And, yes, I realize there's only one answer above.

C) You absolutely hate writing relentlessly clever dialogue that can only transpire between dual protagonists.

D) None of the above. Look, if you like writing little, funny moments between two lead characters and you want to simplify your plot, you should give serious thought to writing a two-hander instead of a story with a solo protagonist. There, that wasn't so hard, was it? Now let's move on to . . .

6

THE STRING OF PEARLS

Screenwriting is hard. Seems like it shouldn't be. After all, I've told you a screenplay is nothing more than a proposal for a movie. But that's why it's so hard.

The average screenplay has sixty to eighty scenes; you must make each one memorable, original, and unique. And then—even more importantly—they must fit together in a way that is—yes—memorable, original, and unique.

The whole string of pearls must shine from a distance. After all, it must be noticed among so many others. Unless you are an established, veteran screenwriter with a reputation and representation to set you apart from the crowd, your script had better be a beacon calling to buyers from across a wide, raging froth of competition.

This is the chapter that deals with the forest, not the trees.

So how do you make your string of pearls do everything I described?

You work on it relentlessly, never allowing yourself the luxury of thinking it is complete. There can be no imperfections, because your readers are looking for any reason to drop your script.

This brings us to a rule that needs little elaboration but must be constantly repeated:

When in doubt, cut.

So let's say it out loud, altogether now . . .

When in doubt, cut.

If you're re-reading any part of your script and you find yourself staring at a scene, a series of scenes, or even an entire act that leaves you unsure as to its usefulness to the story, cut it. If you think perhaps you can re-write it better than it's currently written, cut it. If you love a certain scene, but you suspect it may be a waste of a damn good minute of screen time, cut it. If a little voice in the back of your head is whispering to you, "That character may be a tad unnecessary," cut that character. If reading over a certain sequence of the story is a slog because you've grown bored with it, cut it.

Snip, snip, snip.

If it makes it any easier to rationalize the cutting, you can always save earlier drafts of your script. But if your heart is strong, you won't. You'll press forward without ever looking back. After all, there must have been a reason you cut it in the first place. Never chew your cud twice or re-make a decision.

Of course, once you start cutting stuff, you'll leave *ghosts*.

A ghost is my term for any element of a story—could be a scene, a setting for many scenes, a character, a sub-plot, etc.—that once existed to serve a purpose that's now long gone because you cut it.

So when you set a series of scenes at a monster truck rally because your protagonist is a good ol' boy from Alabama, but then you change him to a nerd from New Jersey, you need to throw out the truck rally.

But, you say, pleading, tears in your eyes, *What about all those great truck rally jokes I came up with?*

Those jokes are ghosts. They have meaning to you, the writer, because you still have a lingering sense of them somehow belonging in the story. But they no longer belong. To the reader who never knew the original reason for the ghosts, they carry no special significance and clutter the script. And if you're a great joke writer, you'll come up with great jokes for any new setting you dream up. Have faith in your funny.

6

THE STRING OF PEARLS

Screenwriting is hard. Seems like it shouldn't be. After all, I've told you a screenplay is nothing more than a proposal for a movie. But that's why it's so hard.

The average screenplay has sixty to eighty scenes; you must make each one memorable, original, and unique. And then—even more importantly—they must fit together in a way that is—yes—memorable, original, and unique.

The whole string of pearls must shine from a distance. After all, it must be noticed among so many others. Unless you are an established, veteran screenwriter with a reputation and representation to set you apart from the crowd, your script had better be a beacon calling to buyers from across a wide, raging froth of competition.

This is the chapter that deals with the forest, not the trees.

So how do you make your string of pearls do everything I described?

You work on it relentlessly, never allowing yourself the luxury of thinking it is complete. There can be no imperfections, because your readers are looking for any reason to drop your script.

This brings us to a rule that needs little elaboration but must be constantly repeated:

When in doubt, cut.

So let's say it out loud, altogether now . . .

When in doubt, cut.

If you're re-reading any part of your script and you find yourself staring at a scene, a series of scenes, or even an entire act that leaves you unsure as to its usefulness to the story, cut it. If you think perhaps you can re-write it better than it's currently written, cut it. If you love a certain scene, but you suspect it may be a waste of a damn good minute of screen time, cut it. If a little voice in the back of your head is whispering to you, "That character may be a tad unnecessary," cut that character. If reading over a certain sequence of the story is a slog because you've grown bored with it, cut it.

Snip, snip, snip.

If it makes it any easier to rationalize the cutting, you can always save earlier drafts of your script. But if your heart is strong, you won't. You'll press forward without ever looking back. After all, there must have been a reason you cut it in the first place. Never chew your cud twice or re-make a decision.

Of course, once you start cutting stuff, you'll leave *ghosts*.

A ghost is my term for any element of a story—could be a scene, a setting for many scenes, a character, a sub-plot, etc.—that once existed to serve a purpose that's now long gone because you cut it.

So when you set a series of scenes at a monster truck rally because your protagonist is a good ol' boy from Alabama, but then you change him to a nerd from New Jersey, you need to throw out the truck rally.

But, you say, pleading, tears in your eyes, *What about all those great truck rally jokes I came up with?*

Those jokes are ghosts. They have meaning to you, the writer, because you still have a lingering sense of them somehow belonging in the story. But they no longer belong. To the reader who never knew the original reason for the ghosts, they carry no special significance and clutter the script. And if you're a great joke writer, you'll come up with great jokes for any new setting you dream up. Have faith in your funny.

So cut all the ghosts. Cut them to save your string of pearls. No one wants to wear a bunch of ghosts around their neck.

Now let's talk about something that's actually bigger than comedy screenwriting but that you must know before you can write a great comic screenplay.

THE BASIC DRAMA RULES

You're thinking: *"Drama?* No, no, Greg. *Drama* doesn't matter to me. I write *comedy."*

But you can't write great comedy screenplays without observing the Basic Drama Rules (the BDRs). Because comedies are still dramas. They still need to compel the reader by creating and resolving tension within the confines of a story.

In fact, you must do more than just observe the rules I am about to set forth. You must *internalize* them. You can't write with confidence if you have to keep looking back at the rule book. To shine alongside the great luminaries of comedy screenwriting—Ephron, Reitman, Apatow, DePaul—you must use these maxims as a matter of habit.

The ancient Greeks first came up with these rules back in the . . . I dunno . . . *past.* If you want a more accurate date, Google it. What's important is that I blew dust off them, tweaked them, and updated them to apply to comedy screenwriting. So I hope you won't mind if I refer to them as "Greg's Rules."

Or you could call them the *Basic Drama Rules.* Up to you. Here they are:

1. **Conflict**. Yup, gotta have it. In fact, you gotta have *more* of it in a comedy than a drama or a thriller. Why? Because audience members who are looking to laugh don't care so much about the cinematic experience. Yes, they expect scenic sunsets, grand battles, spaceships, and more—when they are watching an epic. But when they choose to watch a comedy, they want to laugh. And that's much more likely to happen when every scene of your script is filled with conflict that makes the

characters do funny things to overcome obstacles and accomplish their goals.

2. **Tension** (AKA Suspense). The result of conflict, of course. Precious few comedy screenplays have enough tension; oddly, some writers hesitate to throw heaping amounts of this ingredient into the stew pot of their story. But without tension, you might as well serve a cold potato. Make the readers or viewers pay attention to all your clever jokes by forcing them to wonder, *What Happens Next?* Which brings me to . . .

3. **Escalation**. Yes, I realize these rules are somewhat overlapping and a tad redundant, but *that's how important they are.* Comedy screenwriters must constantly look for ways to escalate and heighten the tension in the story by coming up with both foreseen and unforeseen events that raise the . . .

4. **Stakes**. The ingredient that is often overlooked but always needed. After all, nobody wants to see a story that's arbitrary, where the repercussions of the outcome matter little to the characters. And if the repercussions don't matter to *them*, they sure as heck won't matter to us. So raise the stakes. Then raise them again. And when you're done raising them, well, you get the idea . . .

Think back on *The Heat*, where the writers kept escalating the tension by raising the stakes. What was at stake throughout the story as our two heroines battled badasses? For starters, their friendship. And their careers. Then, as if those two things weren't enough, throw in Mullins's brother, who just might get murdered by mobsters. And then throw in her whole family, whose lives are also put at risk. Those are quadruply high stakes. And for the record, *quadruply* is a real word and you don't need to look it up.

When you are coming up with the story for your huge comedy blockbuster—the one I know you're gonna write— keep trying to top yourself. That's the trick great comedy screenwriters like you and me use; we keep increasing the above-listed four elements. Imagine it's a game and the prize goes to the writers who can most unashamedly keep topping themselves.

Trust me. No producer ever gave this note: "Too much conflict."

Never. Not once.

THE CONCEIT

Anything the writer presents to the reader to be accepted—and not justified or explained—is a conceit.

A screenplay's primary conceit is usually set forth early in the story. That's because just about anything can be accepted by the audience if established early. Wait until the middle of the second act to present a conceit and you'll likely make the audience feel disrespected.

In a typical zombie movie, the conceit is that dead people are reborn as zombies who attack the living. Establish that early, and the audience will accept it. Introduce that idea—without any foreshadowing to prepare us for it—in the middle of the story, and you've screwed up.

What's a conceit in a comedy?

Think about *Old School*. Do you really believe that a group of middle-aged men living near a college campus can become a fraternity? As discussed earlier, it's pretty darn unlikely. That's why the screenwriters of *Old School* establish that conceit early and run with it fast. In fact, the entire "explanation" for the conceit is contained within one scene in which the dean of the college, played by Jeremy Piven, discusses the issue with his underling. If you happen to be getting popcorn when that scene plays, you never catch a whiff of it. And that's a good thing; after all, you came to this movie because you *like* the premise. And people who like the premise want it to make sense—so they easily accept it as a conceit. They don't want to be held back by annoying doubts about whether the story could "really happen."

That's the biggest advantage you have when creating a conceit—the audience is on your side. They want to believe.

How *exactly* did the bite of a radioactive spider give Peter Parker super powers? Who knows. Sounds fishy to me. But we do know radiation does whacky stuff to people, and we want to see Spiderman kick bad guys' butts all over town, so . . . we go with it. We just need the writer to make a

good-faith attempt at establishing the conceit early in the script. To satisfy us and to make us feel like the story is not arbitrary.

Of course you and I know that stories are created by arbitrary whim. I've never met the guys who wrote *Old School*, but I guarantee you they got the idea of a fraternity of middle-aged men before they came up with the paper-thin justification for how it could happen. It happened because they *wanted* it to happen. They may have thought up half the set pieces for that story before they ever considered how to introduce the conceit.

As I discuss in a previous chapter, you need not know the first act before you dream up the second act. You are well advised to reach for the stars when it comes to brainstorming premises. That's because—no matter how off-the-wall the concept may be—you can always find a way to justify it. And if, upon re-reading your work, you later find that justification to be rickety, you can just find another one. Because you're a writer. You make stuff up all the time.

To quote the great comic actor W. C. Fields: "If you can't dazzle them with brilliance, baffle them with bullshit."

Did I mention Fields was also a screenwriter?

COMEDIC ESCALATION

The screenwriters of *Anchorman* deserve an award for something that, until now, has gone largely unremarked upon—the award for Best Comedic Escalation.

Comedic escalation is an escalation in *tone*. Great comedy screenplays often feature bigger and more outrageous set pieces and jokes as they go on. The best and biggest, of course, are reserved for Act 3. It's like a fireworks display with the expected grand finale. At the end, you throw in the kitchen sink.

In *Anchorman*, there is some mildly broad (and by "broad," I mean hard-to-believe) comedy in the first act. In the second act, the tone broadens even more and we see a gang fight in which Brick kills a man with a trident and a man's arm is hacked off—stuff that's *harder* to believe than what we saw in Act 1. Since the movie is only half over

and there is still a thin level of believability to maintain, we are then shown a scene in which Ron and his buddies discuss the gang fight and speculate about whether the police may be looking for Brick. It's a fig leaf, delivered tongue-in-cheek, but it's there to rein in the tone. In the third act, however, all bets are off. We see a man wrestle a bear (that can talk to a dog), and the one-armed man's *other* arm is torn off. All pretense of believability is shed. The bubble has burst. The movie is over.

Seen *Get Him to the Greek*? The first half of the movie mines jokes and set pieces about sex and drugs in the world of celebrity rock stars. There's some broad humor there, yes. But it all comes within the context of what we already know about rock stars and their wild, partying ways. Hardly difficult to believe. But as the story goes on, believability is stretched. You may remember the fight between rock star Aldous Snow's father and his manager, which occurs late in the second act. They break objects over each other's heads and fire a gun. Aaron overdoses on drugs and is given a shot of adrenaline in the heart.

I don't think the screenwriters would have put those hard-to-believe moments in the beginning of the movie. After all, whatever happens in the first act must then sit in our minds—without suffering diverting critical examination—until the end of the film. No, I think those scenes are only acceptable if they occur deep into the story so that we won't have to believe in them for very long; after all, the movie is almost over.

Comedic escalation rewards relentless screenwriters who view every new scene as an opportunity to outdo whatever they wrote ten pages ago. The trick is not to strain believability too much and to remember you can pretty much do anything at the end.

So remember: bend it, don't break it.

FARCE

Well, there you go—I used the *F* word.

Some of you will pass right over this section as soon as you see that word. Well, let me tell you something—most

comedy, and most film comedy, is farce. Just like Shakespeare, just like Molière. And, by the way, just like pretty much all TV comedy.

Agents, producers, and executives, casting about for things to say to screenwriters, will constantly tell you that comedy should come from character. That's because they have no idea what to say, but they know they must say something to you in order to preserve their perceived authority as judges of what is good on the page. What they should say is, "Make me laugh," and let the screenwriter do the rest. We know how to do our jobs.

And part of doing our jobs is understanding that we are all practitioners of the fine art of farce.

Farce occurs when characters in a dramatic presentation pursue their individual goals—despite all obstacles—with such vigor that they do funny things that make us laugh. So the formula for farce is this:

Characters with Goals + Obstacles + Actions Taken to Overcome Obstacles = FUNNY

Just telling writers to create funny characters isn't enough; it's just the beginning. Those characters must also want to achieve their goals. The hotter they burn to achieve them, the more primed they are to enter the farcical situations you hope to create. So turn up their desire. Then beef up the obstacles to those desires. Then push your characters to achieve their goals anyway—despite the overwhelming obstacles.

Example: You're writing a script about a woman who loves a man who doesn't know she exists. Want to make it funny? Turn up her desire; take her from *want* to *need*. Make her mad for him. Make every pore in her body scream out for him.

Now increase the obstacles. Make him hate her. He should find her revolting. And make him in love with some other woman. Better yet—five other women. Or five *men*. Whatever makes her goal of winning him seem unobtainable. What we want to see is her jumping through incredibly high hoops to get what she wants.

High, *flaming* hoops. Hoops that will make her jump higher and faster so we'll want to watch her all the more.

This draws on a principle as old as dramatic writing itself and that transcends screenwriting. Here it is: love your characters, but *make everything tough on them.* Their adversity is our pleasure.

I can't tell you how many times writers have shown me a screenplay they are working on in which they've constructed a weak farce. The characters want certain things, but not enough. There are obstacles, but they aren't difficult enough. The comic sparks that are produced are, as a result, not enough. Maybe I occasionally chuckle as I turn the page, but the fault in the writing is clear.

Again, your agent or a producer may tell you, *The comedy is in the character.* What they are referring to is all those little ticks, those little habits that make us laugh.

But remember—not all of those ticks and habits are written on the page. Will Farrell does lots of stuff in a movie that makes us laugh, not all of which is in the script. But that doesn't help you, the aspiring screenwriter. You've still got to make the industry laugh when they turn the pages— long before Will Farrell is ever attached. So you've got to pump up your farce and make us laugh before actors get involved. Take nothing for granted, put the work on your shoulders, and expect no favorable assumptions.

Let's look at some successful screen farces from the last handful of years and examine why they are farces. As you'll see, protagonists usually have a single goal, but struggle with multiple obstacles.

21 Jump Street

Characters with Goals (CWG): Young cops who want to prove themselves

Obstacles (O): Vicious drug dealers / The cops' own ineptitude / Each other

Neighbors

CWG: Young parents who want peace and quiet

O: Frat guys / The parents' own repressed desire to party

The Heat

CWG: An FBI agent pursuing career advancement / A cop who wants to bust bad guys and protect her family
O: Criminals / Competition from other agents and cops / One cop's self-destructive family / Each other

We're the Millers

CWG: Four people who need money
O: Bad guys / The police / Their conflicts with each other / The difficulty of posing as a family

Identity Thief

CWG: A guy who needs to restore his reputation to save his job / A thief who needs to pay her bills
O: His boss / The police / Bad guys / Her inner desire to cut and run when things get difficult

The next time somebody tells you, "Comedy comes from character," correct that person—unless it's a producer or a studio executive. In that case, just smile politely.

But if that person is *not* a producer or a studio executive, say: "Comedy comes from character *plus goals plus obstacles.*"

That'll win you friends at your next Hollywood party.

PLOTTING

What's the right number of scenes for your story?

If, in your rom-com, you're showing the story of a lonely man who braves certain obstacles to win the love of his life, you're starting with the establishment of his character and proceeding until the end, when he wins his love. The question is, how many scenes are there in between and what do they consist of?

The average romantic comedy screenplay is about one hundred pages. Yes, I know yours could be longer or shorter, but one hundred is, broadly speaking, the norm. And, in most cases, the scenes that are going to fill those one hundred pages are about one to four pages long; the rare

five-pager would probably be either a master scene or some sort of set piece, both of which are discussed elsewhere.

So how may scenes do you need?

Could be as few as, say, thirty and as many as, say, sixty. And, assuming we're working in a Syd Field world—as we usually are—half of those scenes would likely be first and third act scenes, which constitute about half the total story length. The other half of the scenes would constitute that all-important second act.

Let me throw in a new wrinkle.

Romantic comedies usually have short third acts. After all, there is usually no castle to storm, no demons to wrestle to save the hero's paramour. Very often, the obstacles that seemed so formidable in Act 2 are quickly surmounted. That's because the protagonist is often wrestling with some form of baggage that she or he needs to let go of, which often happens quickly.

In *The 40-Year-Old Virgin*, Andy's problem is that he's scared of sex and intimacy. That's what prevents him from consummating his love with his girlfriend once she is ready to get busy. When he finally gets over his fear, there isn't a whole act worth of obstacles to overcome. That may be why Judd Apatow and Steve Carrell, the funny fellows who wrote the script, felt they could afford to throw in a superfluous, Bollywood-inspired dance sequence at the end of the movie.

In any event, your job—among others—is to fill your story with obstacles for your lead character to overcome. And you've got to build those obstacles higher as the story goes on so they escalate.

But let's say your heroine meets her love interest at the beginning of her summer vacation and doesn't "win" him until that big party on the Fourth of July. OK, I'm just riffing here, so go with me. That means that your overall story, including all the moments you don't need onscreen, takes place over the course of maybe a month.

So you're telling a screen story that starts on, say, June 1 and continues until the Fourth of July. And that brings up a big issue that writers rarely discuss (though we should) . . .

I call it the *referential* story. You could also call it the *overall* story, or the *broader* story. But no matter what you

call it, screenwriters are almost always telling a story that—for the most part—isn't seen. We're juggling events—many of which are shown, and many of which happen off-screen and are not shown but must be implied.

How do you manage that? You pick and choose moments to show based upon their importance.

When you choose what moments to show—out of all the myriad possibilities—you must keep your eyes focused tightly on the prize, which is the story. Only show scenes that help tell the story.

And to do that, you will depend on a very important storytelling strategy . . .

LATE POINT OF ATTACK

Start your story, and each scene within that story, as late as you can.

Note: this is a general strategy; there are exceptions. But, for the most part, honor this rule because it will shave years off your personal development curve as a screenwriter.

Writing a script about Napoleon and your climactic event is the Battle of Waterloo? Don't show us Napoleon one week before the battle. Don't show us Napoleon one *day* before the battle. Show us Napoleon *ten minutes* before the climax of the battle, when his generals come to his tent to beg him to retreat, only to be rebuffed by him.

Start your scene at its penultimate moment. And just in case you don't feel like going to dictionary.com, I'll define *penultimate* for you:

> *Penultimate*: next to last. In other words, the thing that is right before the ultimate thing.

The penultimate moment is a great place to start just about any scene. That's because the penultimate moment is usually when the obstacle is presented. And remember: it's the obstacle that gives the scene conflict. Thus, if the scene is about how Napoleon blew off the counsel of his generals, then the penultimate moment—where the scene should start—may be his top aide telling him to retreat because he cannot possibly win.

And when you write that scene, skip what I call the *boring beginning*—don't show the generals walking in, taking off their tri-cornered hats, saluting Napoleon, and saying their *Hellos* and *How are yous*.

Cut that. That's fat. You want muscle.

So we might have a scene that reads this way:

INT. NAPOLEON'S TENT — MORNING

General Schmuckler stands opposite Napoleon with a map of Waterloo between them showing the various armies represented by little wooden soldiers.

> GENERAL SCHMUCKLER
> We cannot win! We must pull back!

> NAPOLEON
> Bullshit! We attack!

As Napoleon sweeps his hand across the map, scattering the wooden soldiers, we . . .

> CUT TO:

And there you have it—the reason I don't write historical epics.

But you get the idea—the penultimate moment *starts* the scene. And that action presents the obstacle. The ultimate action—Napoleon overriding his aide and committing to battle—*ends* the scene.

Now, just to review some of the rules and strategies I discussed in earlier chapters, let's have a little fun and re-write that scene with all the bells and whistles that can drag a good scene down and exhaust our reader.

In other words, let's look at a bad—OK, *much worse*—version of that scene.

INT. NAPOLEON'S TENT — MORNING

The dawn's light seeps in through the door flap. Napoleon's lieutenants busy themselves

preparing his breakfast in the background, placing little sausages on china dishes and filling a chalice with orange juice for their vaunted leader.

Napoleon peers outside through the open flap at his massive army, which awaits his command. His right hand is perched in his left vest pocket, as per portraits from the period. He is truly at his peak, the apex of his career. As he takes a deep, if troubled, breath, contemplating the epic struggle he embarked upon and how history will one day view him . . .

General Schmuckler strides into the tent, fuming. His grey mustache twitches as he speaks with venomous anger. He closes the flap behind him, waving all others out of the tent.

After they scurry off . . .

> GENERAL SCHMUCKLER
> (saluting)
> My emperor.

> NAPOLEON
> (picking his nose)
> My second in command.

> GENERAL SCHMUCKLER
> I greet you this morning.

> NAPOLEON
> (still picking)
> I greet you back, General.

> GENERAL SCHMUCKLER
> May I say that it's a pleasure to
> serve you, my emperor.

 NAPOLEON
You may, General. And I hope you
received that basket of biscuits,
jams, and fine cheeses I sent you
last Christmas?

 GENERAL SCHMUCKLER
I did. My wife especially enjoyed
the cheeses.

 NAPOLEON
Splendid! And how's the kids?

 GENERAL SCHMUCKLER
Well, they're so-so. You know, the
usual: Little Nappy, named after you,
plays with his toy soldiers, and
Marie does pretty much whatever early
nineteenth-century girls do. Unfortu-
nately my mother-in-law has been
staying with us for some time and . . .

 NAPOLEON
No need to go on, General. Perhaps
we should get to the matter at hand.

 GENERAL SCHMUCKLER
Yes, indeed. The matter at hand.

There is a long pause, until . . .

 GENERAL SCHMUCKLER
 (breaking the silence)
Shall I start?

 NAPOLEON
 (annoyed)
Yes, by all means.

The General thinks, choosing his words care-
fully. Then, after mustering his courage, he
just blurts it out . . .

```
                    GENERAL SCHMUCKLER
               (his voice cracking from the
               pressures of war)
          We cannot win!
               (with emphasis)
          We must pull back!

Napoleon takes this in. Then looks General
Schmuckler right in the eye and says:

                    NAPOLEON
               (pounding his fist on the table)
          Bullshit!

Then he turns, and with dramatic intensity
says . . .

                    NAPOLEON
          We attack!

As Napoleon sweeps his arm across the table,
hurling the maps and everything else onto
the floor, we . . .

                                        CUT TO:
```

See how much better a scene can be when you start much earlier and add all that other, irrelevant crap? I mean, come on—does it rock or what?

If you want to avoid over-writing every scene you ever, uh, over-write, I suggest you go to sleep and wake up every morning repeating these four works: Late Point of Attack.

Say it over and over until it's part of your DNA. Then take a deep breath and start again. You won't be sorry, and we won't have to read scenes full of boring beginnings and unnecessary, descriptive nonsense.

Of course, another way to think about it is this: *don't show any boring stuff.*

THE JUGGLING ACT

How to manage multiple story lines?

With studios making more and more two-handers, comedy screenwriters are more and more likely to feed the beast what it wants and write two-handers. And that means the reader is following two story lines, if not more.

Or, if you're writing an ensemble comedy like *The Hangover*, you are going to need to create separate story lines for more than a couple characters. Each of those story lines will have its own arc stretched over the course of the script. For many writers, this creates an unmanageable problem: How do you track four story lines so that all major characters grow, encounter obstacles, and reach their stories' climaxes at about the same time in the story?

Get used to breaking your story down into separate component parts and putting it back together again. Just as Navy SEALs must learn to assemble and disassemble their weapons in a matter of seconds while blindfolded, comedy screenwriters must be able to break down and re-build their stories, scene by scene, at the drop of a hat.

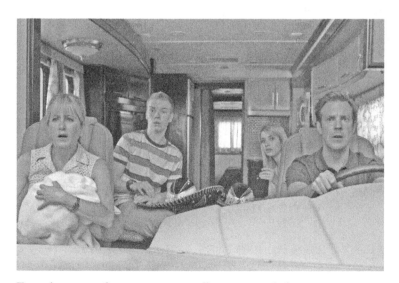

Four characters, four separate story lines, no seat belts.

Yes, that's right, I just compared comedy screenwriters to Navy SEALs.

The best way to demonstrate what I mean is to take a story we already know—*We're the Millers*—and add another level of specificity to the diagram we've already used. We do that by tracking the separate personal stories within the larger story of the film.

David, Rose, Kenny, and Casey. All four are introduced as loners without close connection to anybody. Over the course of the movie, they each come to realize the value of family. At the end, they *are* a family.

Let's look at the scenes that occur along the way and keep track of each of their individual stories within the larger whole:

WE'RE THE MILLERS (2013)
Screenplay by Bob Fisher & Steve Faber and Sean Anders & John Morris

Key
A) David's story
B) Rose's story
C) Kenny's story
D) Casey's story

A) David (played by Jason Sudeikis) lives by himself and DEALS dope.

A) David bumps into a friend who MAKES him feel inadequate for being childless.

B) Rose (Jennifer Aniston) STRUGGLES to get through her job as a stripper.

A/B) David TRIES to get money from Rose, whose boyfriend owes David money. They ARGUE.

A) David WORRIES that Kenny (Will Poulter), a teen, is living alone.

A/C) Kenny TRIES to buy drugs from David but David REFUSES.

C/D/A) Kenny STICKS UP for a homeless girl, Casey (Emma Roberts), being mugged, then David STICKS UP FOR Kenny, but bad guys BEAT him up and STEAL his stash and money.

A) Brad, David's drug boss, MAKES him agree to smuggle drugs across the border.

A) David gets an idea for how to cross the border with drugs.

A/B) David ASKS Rose to join his scheme, but she REFUSES.

A/D) David ASKS Casey to join. She DEMANDS cash, then AGREES.

B) Rose's boss ASKS her to be a hooker and she QUITS.

A) David MAKES himself over to look like a suburban dad.

A/D) David PUSHES the kids to pretend they're a family, but Casey RESISTS.

B) Rose AGREES to go but DEMANDS more money.

C/D/A) In the car to Mexico, the kids DEMAND to shoot fireworks but David REFUSES and WARNS them that this is a job, not a vacation.

A) David finally SHOOTS a firework to satisfy them.

A) They PICK up the drugs from drug dealers, but there's more drugs than they thought. David COMPLAINS to Brad, who TELLS him not to worry.

ALL) A Mexican cop STOPS them and wants sex or money as a bribe to let them

go. David TRIES to convince Rose to do it, then CONVINCES Kenny to do it, then DISCOVERS he has the money for a bribe, so nobody does it.

ALL) At border they PRETEND to be a family despite another family that almost EXPOSES them and a border guard that almost DISCOVERS them.

ALL) Driving back, the family RELAXES and BONDS despite David RESISTING acting like a family.

The drug dealers REALIZE they gave drugs to the wrong guy.

ALL) The car BREAKS down and they FIGHT. Rose and Casey WALK OFF.

B/D) Rose and Casey FIGHT.

ALL) They get help from the other family from before, but still must PRETEND to be family. David TELLS the other couple a pretend story about how he met Rose and it TOUCHES Rose. (49)

ALL) They LEARN the car repair shop is closed so they must spend the night with the other family.

B/D) When the other mom DEMANDS to hold Rose's baby, which is actually a bag of pot, Rose THROWS it onto the road and it breaks open, but Casey MAKES UP a lie justifying it.

B) Playing Pictionary, Rose TALKS dirty like a stripper and very much unlike a suburban mom.

C) Kenny FLIRTS with the suburban couple's daughter.

ALL) Rose and Casey PUSH David to advise Kenny about girls, so David ADVISES him, which TOUCHES Rose and Casey.

A/B) David and Rose try to SNEAK into the other couple's tent and the other couple CATCH them but think they're swingers, so Rose and David PRETEND to swing despite being grossed out.

B/C/D) To TEACH him how to kiss the other family's daughter, Casey and Rose KISS Kenny, but the other family's daughter CATCHES them kissing and is grossed out.

A) Don, the other dad, TELLS David he seems romantic with Rose, which intrigues David, so David ADVISES Don about romance.

ALL) The bad guys CAPTURE them all and TELL Brad that David was stealing his pot. Bad guys are about to kill them when . . .

ALL) Rose DISTRACTS bad guys by doing a stripper dance and everybody ESCAPES. (73)

C) Kenny STRUGGLES to drive the RV and they crash. A spider bites Kenny's testicles.

A) David GETS Brad to ADMIT that he lied to David and used him to steal, not pay for, the pot. David PUSHES Brad to give him more money because the job is so dangerous.

B/D) At the hospital, Casey FLIRTS with a creepy guy and Rose CRITICIZES her.

A/C/D) A doctor TELLS them Kenny needs time to recover, and David TRIES to get them to leave without Kenny, but Rose and Casey ADMONISH him for this, so they STICK around.

A/B/D) The creepy guy TAKES Casey out on a date but David and Rose ACT like prudish parents and GRILL him first.

A/B) David WORRIES about Casey. Rose NOTICES that he's becoming more like a dad and less like the selfish jerk he once was. David and Rose BOND while talking about their pasts. Rose REGRETS her stripper past, but David REASSURES her that she's a nice person and she REVEALS her real name. They almost kiss.

A/B/D) Casey returns. David and Rose ADMONISH her like parents do.

ALL) David PUSHES Kenny to come back with them because they're running out of time. Rose and Casey ADMONISH David for being heartless and PUSH him to REVEAL he's getting paid more than them for this job. They ARGUE. Casey WALKS OUT on the family.

ALL) David TRIES to get the rest to come with him, but they REFUSE and he LEAVES them all.

A) David DRIVES away STRUGGLING not to miss family.

B/C/D) Casey tries to BOND with the creepy guy, but he TRIES to get busy with her and Rose and Kenny RESCUE her.

ALL) David BEGS them to come back with him and PROMISES them more money. They AGREE. (91)

ALL) They run into the other family, and the daughter TELLS her parents what she saw. Under pressure, David, Rose, Kenny, and Casey REVEAL that they are drug runners. Some bad guys ATTACK and Don DEFENDS everybody using only his coffee mug.

ALL) A bad guy CAPTURES them and THREATENS to kill them. David TELLS Rose,

Kenny, and Casey that he loves them, TOUCHING them. They ESCAPE when Kenny PUNCHES the bad guy, IMPRESSING the other couple's daughter, who KISSES Kenny. David KISSES Rose. Don CONSIDERS arresting them, but ALLOWS them to leave.

(ALL) Don and the police ARREST Brad and PUT David and family in witness protection where they now LIVE as a real family.

So there we are. All I did was take my diagram for *We're the Millers* and add designations for the four characters' different personal story lines. I could have added a story line for the bad guys, whose story growth is relevant to the movie. I could also have added a story line for the other family that the "Millers" meet along the way. I could even track the story lines of all three of the characters in *that* family.

But here's why I won't—because part of what makes research so useful is its ability to retain meaning months, or even years, later when you look at the research again. Make it too complicated and you lose that. A diagram that's only a few pages long is just about right for me—especially when it is one of dozens I might review before starting a new script in that particular genre.

Now let's say I'm the screenwriter of *We're the Millers*. Ka-ching! I just made beaucoup bucks because that film was a raging box-office success. Sadly, however, I did not write *We're the Millers*. But let's pretend I did because it helps me help you understand how to juggle sub-plots.

If I were doing a re-write of the script and I wanted to make changes to Kenny's story, I would go to my diagram and pull his story out of it. I'd peel the other stories away so I can focus on scenes in which Kenny takes action or is affected by someone else's action. That includes all the scenes marked "C" in the diagram as well as many of the master scenes using all four main characters.

Below is the result. I edited out a lot of excess verbiage to make it easier to read.

WE'RE THE MILLERS (KENNY'S STORY)

C) **Kenny** TRIES to buy drugs from David.

C) **Kenny** STICKS UP FOR a homeless girl, Casey.

ALL) David CONVINCES **Kenny** to have sex with the Mexican cop.

ALL) At the border they PRETEND to be family.

ALL) Driving back, the family RELAXES and BONDS.

ALL) The car BREAKS down and they FIGHT.

ALL) They get help from another family but still must PRETEND to be a family.

C) **Kenny** FLIRTS with other couple's daughter.

ALL) David ADVISES **Kenny** about girls.

B/C/D) Casey and Rose KISS **Kenny** to TEACH him how to kiss.

ALL) The bad guys CAPTURE the "Millers," but they ESCAPE.

C) **Kenny** STRUGGLES to drive the RV. A spider bites **Kenny'**s testicles.

A/C/D) They LEARN **Kenny** needs time to recover.

ALL) David PUSHES **Kenny** to come back with them.

ALL) Rose, **Kenny,** and Casey REFUSE to go with David.

B/C/D) **Kenny** and Rose RESCUE Casey from the creepy guy.

ALL) David BEGS Rose, Casey, and **Kenny** to come back with him. Then David GIVES them money and they AGREE.

ALL) David TELLS everyone how he loves them all, which TOUCHES Rose, **Kenny,** and Casey. They ESCAPE when **Kenny** PUNCHES a bad guy. Other couple's daughter, impressed, KISSES **Kenny.**

ALL) David, Rose, **Kenny,** and Casey now LIVE as a real family.

———

The more you read it, the more familiar you become with—and the more easily you can change—Kenny's story.

Yes, I know there is plenty of screenwriting software you can buy that will—at the touch of a key—create this sort of character-focused scene list for you. I'm also sure that if you use one of those programs to do that work for you, you won't learn diddly.

Why?

Because you'll glance at the page, see Kenny's name pop up in every scene, and then go right back to sleep (as you probably just did). In other words, you won't really take stock of Kenny's progress in the story unless you do the annoying, time-consuming work of creating the list yourself. And by the way, the same can be said for all the diagrams in this book. You'll get little bang for your buck by using my diagrams. They won't resound for you, since you didn't write them. I include them only as examples. Only the *process* of writing diagrams and making character-focused lists of scenes imparts actionable knowledge. Experience you will draw upon when you write.

So suck it up and do this stuff yourself. Don't just put my book on your shelf and congratulate yourself that you know all there is to know. You don't. That's not what I sold you when you bought *Bring the Funny.*

This book is a *companion*—a resource you turn to, when in need, to remind yourself of certain techniques and strategies that will help you in the long run. Use the tools in this

book faithfully and know they are only as effective as the level of your devotion.

OK, sorry! Enough stern talk from Greg. Forgive me. I just want you to make it, OK? My tough talk comes come from a place of love. Writerly love.

Remember: you need to be just like a Navy SEAL, except funnier.

But before you strap on your helmet, load your trusty weapon, and rappel into battle, we need to discuss something rather important . . .

GAPPING

Shakespeare gapped. Tarantino gaps. Woody Allen does it too. Chances are, if you've been writing screenplays, you do it all the time.

What's gapping? It's everything you *don't* show in a screenplay. Remember the *Overall Story*?

Let's say you show a couple meet in a one-page scene, which occupies about one minute of screen time. Then you cut to the same couple getting married a year later in a scene that runs another minute. The Overall Story lasts one year, while the screen story lasts two minutes. The "gap"—what we never see—is everything in between.

Obviously, if the first scene ends with the couple arguing and the second scene begins with them happily marrying, you are implying that they made up over the gap. If they are blissful at the end of the first scene and arguing at the altar in the second scene, you are implying that, in the gap, they fought a lot. What you show onscreen indicates what happens in the scenes you don't show.

Whatever you do, don't screenwrite past the best moments. The audience will feel robbed if it doesn't get to see lovers kiss at the altar or the hero make the winning shot at the buzzer. In other words—*don't cheat the viewer.*

But also—don't waste a moment of precious screen time on scenes that don't tell us enough about what's been happening off-screen. Remember how I told you about Late Point of Attack? That's the key to good gapping.

Good comedy screenwriters know as much as possible about the off-screen story before writing what we will see onscreen. But that doesn't mean they write everything they know. When writers make that mistake—that is, when writers tell readers more than they need to know—I call that *writing the notes for the scene in the scene.*

Here's an example of writing the notes for the scene in the scene from a screenplay that does not exist (and hopefully never will):

```
INT. JIMMY'S HOUSE — DAY

Jimmy walks in. He's had a hard day on the
road. His truck broke down halfway across
the Mohave Desert, he was almost stabbed to
death by a meth addict in a bar in Abilene,
and his pet monkey, which ran off months
ago, is never far from his mind.

Jimmy sees Loretta, and instantly his
thoughts race back to that summer they
spent on Cobb Island, the love they made in
her dad's houseboat, and the meticulous way
she folds up paper bags before recycling
them.

               JIMMY
         Hi, Loretta.

They kiss.

                                   CUT TO:
```

Or you could just write:

```
INT. JIMMY'S HOUSE — DAY

Jimmy and Loretta. They kiss.

                                   CUT TO:

        ————————
```

Everything else is irrelevant.

In the first version of the scene we see something that should never appear on the page—the writer's *notes*. It may be important to the writer that he or she knows where Jimmy has been or why Jimmy feels a certain way, but that doesn't mean it's important to the reader. After all, if it was important for us to know, the writer would have shown it to us onscreen. And the writer didn't.

If the reader needs to know about events that have already happened, you, the screenwriter, have two ways to tell us. You can (1) show those events or (2) have a character tell us about them. When a character walks in and gives an explanation of where she has been, that's called a *messenger speech*, and it's rarely used in film.

But whatever you do, don't leave your notes on the page.

REALLY IMPORTANT COMEDY SCREENWRITING RULE #99

You knew there had to be something like this, right? A rule to trump all the other rules. Well here it is . . .

Despite everything I've told you up to this point about what to write, and what not to write, there is one huge mega-exception to every rule of comedy screenwriting:

If it's really, really funny, leave it in.

To be clear, there are two *reallys* in the paragraph above. Two. That's because just being funny—or even really funny—doesn't justify leaving an unnecessary scene in your story.

However, if what you've written is so incredibly (as in really, *really*) funny that it leaves readers choking on their

own tongues, you should find a way to justify it and leave it in—at least until someone who matters (like, say, the president of production) tells you to cut it.

Until then, keep it.

REALLY IMPORTANT COMEDY SCREENWRITING RULE #100

There's always a caveat, right? Even to Really Important Comedy Screenwriting Rule #99. Here it is:

Never sell your character out for a joke.

If a joke requires a character to behave in a way that is contrary to his or her character, cut it—even if the joke leaves readers choking on their own tongues with laughter.

Why?

Because you blow your story to hell when you make us doubt your characters. Their integrity must be paramount. So never do that.

POP QUIZ!

1. **The BDRs are:**

 A) Badass Dog Rappers.

 B) Bodacious, Darwinian & Recalcitrant.

 C) Booties, Dingdongs & Rumps.

 D) Really freaking important, especially for comedy. So figure out what they are and have it tattooed somewhere on your body where you can't miss it. The hip works. Use your hip.

2. *Farce* **is a word that correctly describes:**

 A) Silly plays written by writers in, like, the Renaissance, or some other long-dead era, and that are totally irrelevant today.

B) The marriage of Bill and Hillary Clinton. (Sorry, I shouldn't have gone there. No more politics, I swear.)

C) A dramatic presentation where the characters pursue their goals despite escalating obstacles, hopefully prompting laughter.

D) A dramatic presentation where the characters pursue their goals despite escalating obstacles, hopefully prompting laughter. (I figured if I wrote it twice, you'd have double the chance of getting it right.)

3. **When deciding where to start a scene, it is usually best to:**

A) Start as early as possible so you can get in as many *Hellos* and *How are yous* as possible before ever-so-slowly settling into the important stuff.

B) Summon the spirits of great writers such as Shakespeare, Goldman, Ephron, and DePaul before making your decision.

C) Mix yourself a stiff drink and hope for the best.

D) Use Late Point of Attack.

4. **The most important rule in comedy screenwriting is:**

A) If it's really, really funny, keep it in the script.

B) Never sell your character out for a joke.

C) Learn from Greg. Just Greg. There are no other teachers but Greg. Have I mentioned how much you should appreciate Greg?

D) A & B.

7

THE PEARLS THEMSELVES

For years I taught screenwriting in the conventional manner, which is to make students write a feature script by starting with idea creation: *What's your premise?*

Once they came up with one-sentence version of their ideas, which often took weeks, they would expand it to a three-sentence story, representing the three acts. This was followed by an ever-growing outline that eventually showed the sixty or so scenes that would make up their screenplays. And then they wrote.

But I no longer teach that way. Here's why:

First, that method emphasizes structure above all. Now don't get me wrong—structure is *critically* important. But there's no point in building a frame if you have nothing to put in it. And that's just what students did—they labored for months on idea and story and plot and then failed to fill their big structural contraption with anything worth working on for months (or longer) afterward. So the method didn't lead to a good script.

Second, I teach *comedy* screenwriting. And the comedy screenwriter has an obligation—actually, I would argue it's an *ethical* obligation—to be funny.

Sixty unfunny scenes in a row is the definition of failure in the world of comedy screenwriting. If you write that

script, you've just demanded that some poor reader spend about two hours sitting with your script *not* laughing. And for those of us who have written coverage for agents and producers, we know just how painful two hours of not laughing at a comedy screenplay can be. It's about as much fun as swallowing hot sand—except there's no trip to the beach. On the other hand, you can do it in the privacy of your own room—kinda like suicide.

Eventually I got sick of teaching people to write what they couldn't fill with funny. Or story. Or characters. Or great moments. All of which is necessary to sell a script.

So I changed my approach.

Now I teach students how to diagram and understand movies, as well as the Basic Drama Rules, and then I give them *assignments*.

A typical early assignment is to write a scene that would take place in a screenplay that we have studied in class. Like *The Heat*. I'll ask students to write a two-page scene using characters from *The Heat*. Perhaps Detective Mullins wants something badly from Agent Ashburn, who refuses to give it to her. Perhaps both characters have strong agendas and pursue them with reckless abandon. And maybe there's a ticking clock . . .

The primary goal of that scene-writing assignment is to force students to craft powerful scenes that have conflict and some sort of beginning, middle, and end. To help them get there, I temporarily relieve them of their usual responsibility to create characters and concept. This allows them to focus on the moment-to-moment scene writing they need to do. As a result, students very often come to see a marked improvement in their screenwriting. Suddenly, they are creating explosive scenes full of conflict and *What Happens Next?*

And when you are making readers ask *What Happens Next?* you're winning your battle with them—the battle to keep their attention.

WHAT'S IN A SCENE?

If you come to comedy screenwriting after having written plays or sketch comedy, you may not need to ask this

question. Playwrights and sketch writers with any experience rarely have to be told what's in a scene.

But if you come to comedy screenwriting having previously written nothing, or having written prose, the nature of a scene can beguile you. I've already told you where to begin a scene—as late as humanly possible—but that doesn't give much hint as to what to include in the scene itself.

Let's just be clear about the kinds of scenes we're talking about here. We're not discussing scenes—often written into shooting scripts—that look like this:

```
EXT. THE WHITE HOUSE—DAY

Establishing.

                                        CUT TO:
```

I'm talking about *meaningful* scenes. Not establishing shots, montages, or scenes in which very little happens. OK, yes, I realize montages can be meaningful, but . . .

I'm talking about scenes in which the story is furthered. The muscle of your script. Here's how to approach those scenes:

Think of each scene as an idea—a unique pearl—and remember never to repeat the same idea. This is what makes good comedy screenwriting so difficult to pull off—you need to generate fifty to seventy pearls to fill a feature script.

Memorable scenes from great comedy films usually show us the protagonist pursuing something she wants, grappling with some obstacle, and either achieving her goal or failing. And, unless we're in the third act of the film, the protagonist is not likely to get what she wants by the end of the scene, so she must *toil onward* . . .

And usually a bigger question is raised at the end of the scene that makes us want to know *What Happens Next?* Just as in a novel where each chapter ends with a cliffhanger that compels us to read the next chapter.

Remember the scene in *The 40-Year-Old Virgin* in which Andy is forced to confess that he is, in fact, a virgin? It comes about ten minutes into the film, and it launches us into the story of the movie.

The setting is a poker game. Andy is, for the first time, socializing with his co-workers. The subject of sex comes up, and each guy tells his raunchiest sex story. When Andy's turn comes, he struggles to dream up a story, leading to the discovery by his friends that he is a virgin, which leads to the agreement by his friends to help Andy lose his virginity. It's a funny scene that advances this idea: *Andy's virginity is a problem to be solved.*

Every pearl in a comedy screenplay has three elements:

1. A setting.
2. A conflict (and sometimes more than one).
3. A question (*What Happens Next?*).

In the scene just mentioned, the setting is a late-night poker game. There are two conflicts. In one conflict, Andy battles his own inability to tell a dirty story. In the other, Andy battles his new friends, who force him to admit he is a virgin. The question raised at the end of the scene is, *How will they get him laid?*

Remember the scene in *Neighbors* where Mac and Kelly, the married couple, ask Teddy, the frat boy, to lower the volume on his massive house party so they can sleep next door? That scene has these three elements:

1. A setting: the frat house.
2. Two conflicts:
 A. Mac and Kelly versus Teddy.
 B. Mac and Kelly versus themselves. After all, they want to convince Teddy to calm his party down, but they don't want to look like a boring, old married couple.

 * Note: Teddy wins Conflict A by exploiting Conflict B. He sees that Mac and Kelly desperately want to appear cool, so he invites them into the party, which they accept, and which raises . . .

3. A question. With Mac & Kelly partying at the frat house, who's watching the baby? Will something bad happen?

The writers could have broken the scene into three smaller scenes in order to accomplish the same task. They

could have shown Mac and Kelly in Scene A as they try to convince Teddy to turn his music down and he rejects them. Then they could have shown a Scene B in which Mac and Kelly argue about what to do at home minutes later. Then they could have sent Mac and Kelly back to Teddy's frat house the next morning to try to convince him again—that would be Scene C. And Scene C could have ended as the scene, above, ended—with Teddy inviting Mac and Kelly into the party. There would still have been a setting, a pair of conflicts, and a resolution that raises a new question.

Instead, the writers chose to do as much as they could in the most efficient manner—which is why the scene they wrote works so well and keeps the story moving.

In either case, a story beat is presented to the reader— either through a sequence of scenes or through a single scene—and the reader is left wanting to know more. Which means the page gets turned.

When the film gets to the movie theatre or shows up on TV, that scene—if well-directed—should leave the viewer wanting the same thing.

MASTER SCENES

As discussed, the poker scene from *The 40-Year-Old Virgin* is a master scene. That's a scene where main characters gather and discuss whatever is going on in the story. Master scenes are usually longer (say, four or more pages) and usually touch upon more than one plot. It's like a big pearl with many smaller pearls inside it. A poker game, a family sitting around the dinner table, an office party, a rehearsal dinner . . . all good settings for a master scene.

If you've seen *Little Miss Sunshine*, there are a number of well-written master scenes in that movie to use as examples. One in particular takes place in the first act. All the characters in the family are eating dinner. Various sub-plots are touched upon. One character recently attempted suicide, and another is failing in his career as a motivational speaker. We also learn that Olive, the young girl, has entered a beauty contest to be held some distance away. The question at the end of the scene—the take-away question—is, *Can we get her there?*

The setting of a master scene is usually a forum—a place of discourse or contest where the dramatic goals of the characters are discussed or pursued and then either frustrated or satisfied (though, more commonly, frustrated), and finally a question is raised. That question leads us to the next scene.

Writing the master scene is like writing a scene from a play—the action is primarily undertaken with words. Sit characters down and plant the camera on a tripod: we're in for some talk. And while your screenplay may only have a few master scenes, they are often crucially important to the story.

So you'd better get good at . . .

DIALOGUE

If you have taken a class in feature screenwriting, you have probably been told that a movie is "a story told in pictures."

That's wrong. A *silent* movie is a story told in pictures.

You remember silent movies, don't you? You might have seen one in a museum once or watched one in film school. But you're not going to *write* one, are you?

You live in the twenty-first century, and, for you, a movie is actually a story told in pictures *and sound.*

Sound comprises three elements in a movie: music, sound effects (also known as Foley), and *dialogue.* We won't concern ourselves with movie music and sound effects. Leave that to the director and her crew.

We screenwriters focus on dialogue—a crucial element of every movie and especially important in comedy.

We've all heard dialogue that crackles and excites our ears. I'm going to lay out some strategies you can use to generate successful dialogue. And, for our purposes, successful means it pushes the story forward and makes the readers laugh their butts off.

Four Strategies for Successful Comedy Dialogue

Strategy 1: Write the way people actually talk, then shut them up fast.

Young writers are often taught to eavesdrop on conversations to learn how people really talk so they can replicate it

on paper. That's wise. The problem is when they start down-loading all they've learned onto the page . . . and don't stop.

When it comes to realistic dialogue, a pinch is all you need. If your character is from Alabama, throw in a few "y'alls" and you may well be done. If she's from Queens, give her a few "youz guys." But please don't lengthen scenes with verbiage no matter how regionally or ethnically accurate it is. And as for all the ellipses . . . well . . . um . . . let's just say . . . that, um . . . they tire the eyes.

Strategy 2: Become your own best actor.

When you are writing dialogue, speak it out loud. Play all roles. Just make sure you hear what it sounds like to speak the words you have written. This is a sure-fire way to detect and screen out overly written, unnecessarily elaborate language that has no place in your work. And then, of course, the next step is to sit down with actors and hear your entire script read aloud. Assuming you're work-ing with good actors, you'll soon learn which words can be cut. In many cases, they'll cut them for you by editing as they go.

Strategy 3: No repetition.

You only need to tell us that all-important revelation once. Then move on. For example, don't do this:

```
INT. GREG'S HOUSE OF BAD WRITING—DAY
Bill and Wendy.

          BILL
     Wendy, I love you.

          WENDY
     Really?

          BILL
     Yes, really. I love you.

          WENDY
     Oh. I see.
```

 BILL
 Did I mention I love you?

 WENDY
 Yup. Got it.

 BILL
 And just FYI—

 WENDY
 I get it, OK! You love me.

 BILL
 Yes, I do. I love you.

Finally, he moves to kiss her, but she has
strangled herself out of sheer boredom.

 CUT TO:

 And if that doesn't annoy the bejeezus out of you, wait
until you read this frustrating miasma:

INT. SAME PLACE—DAY

Bill and Wendy again.

 BILL
 I've, uh . . .

 WENDY
 Yes?

 BILL
 Got something . . . um . . . I kinda,
 um . . . want to . . . you know . . .
 say . . .

 WENDY
 Come on, out with it.

 BILL
 Well, it's just . . .

 WENDY
 I'm serious, Bill. I know you're
 a little on the shy side and the
 screenwriter is trying to build

on paper. That's wise. The problem is when they start down-loading all they've learned onto the page . . . and don't stop.

When it comes to realistic dialogue, a pinch is all you need. If your character is from Alabama, throw in a few "y'alls" and you may well be done. If she's from Queens, give her a few "youz guys." But please don't lengthen scenes with verbiage no matter how regionally or ethnically accurate it is. And as for all the ellipses . . . well . . . um . . . let's just say . . . that, um . . . they tire the eyes.

Strategy 2: Become your own best actor.

When you are writing dialogue, speak it out loud. Play all roles. Just make sure you hear what it sounds like to speak the words you have written. This is a sure-fire way to detect and screen out overly written, unnecessarily elaborate language that has no place in your work. And then, of course, the next step is to sit down with actors and hear your entire script read aloud. Assuming you're work-ing with good actors, you'll soon learn which words can be cut. In many cases, they'll cut them for you by editing as they go.

Strategy 3: No repetition.

You only need to tell us that all-important revelation once. Then move on. For example, don't do this:

```
INT. GREG'S HOUSE OF BAD WRITING—DAY
Bill and Wendy.

          BILL
     Wendy, I love you.

          WENDY
     Really?

          BILL
     Yes, really. I love you.

          WENDY
     Oh. I see.
```

 BILL
Did I mention I love you?

 WENDY
Yup. Got it.

 BILL
And just FYI—

 WENDY
I get it, OK! You love me.

 BILL
Yes, I do. I love you.

Finally, he moves to kiss her, but she has
strangled herself out of sheer boredom.

 CUT TO:

 And if that doesn't annoy the bejeezus out of you, wait
until you read this frustrating miasma:

INT. SAME PLACE—DAY

Bill and Wendy again.

 BILL
I've, uh . . .

 WENDY
Yes?

 BILL
Got something . . . um . . . I kinda,
um . . . want to . . . you know . . .
say . . .

 WENDY
Come on, out with it.

 BILL
Well, it's just . . .

 WENDY
I'm serious, Bill. I know you're
a little on the shy side and the
screenwriter is trying to build

```
up to this moment and all, but
this is really annoying the crap
outta me. Say it!
          BILL
I . . . uh . . .

          WENDY
Oh, forget it.
```

She gets up and leaves, annoyed.

 CUT TO:

———————

Just have characters come out with what they need to say.

Years ago, I worked as a reader for an agent. I would read dozens of scripts in a weekend, and I was looking for any reason to stop reading and give a script a bad write-up. In fact, every time I was about to read a new script, I would flip to the last page to see how long it was. If it was less than one hundred pages, I was already in a good mood because I knew the writer respected my time.

So respect everybody's time and don't tease scenes out that can easily be concluded with a line of dialogue or an action. Get to it and move on.

Strategy 4: The Doctrine of Inadvertency.

Funny characters are usually unaware of how funny they are. Serious for them is funny for us. And when they are in frantic motion, pursuing their goals, they are at their peak funniness—tripping over themselves to get what they need.

Ask this question about every character in every scene: *Has this character tried hard enough to get what he or she wants?* I'm not just talking about the protagonist but *every* character. Leave no stone unturned in your search for comedy.

I once worked with a director who, when editing, looked for every opportunity to add something funny. Actors were often brought into the editing room to record funny lines over scenes in which their backs were turned and they were

walking away from the camera. Just another chance to throw in a joke, another quippy line.

Whenever someone onscreen would throw an object *off-screen*—a rock, baseball, a tin can—this director would insert the sound of a cat screaming as if it had been hit with what was tossed away. *Hey*, he figured, *why not? It makes people laugh.*

I'm not saying you should add random animal screams to a movie, especially if it's a serious flick along the lines of, say, *American Sniper* or *Schindler's List.* But I am telling you that my friend didn't get to be a big-time comedy director without searching for every last opportunity to make the audience laugh.

You should do the same. Within reason, of course, and without ever selling your characters out for a joke.

Because every laugh matters.

THE STANDARD

What do you do when you've tried your damnedest to make every scene unique and remarkable, and yet you still look at it and say, "That's such a *typical* meet-cute," or "Holy crap! I just wrote the *usual* hero-saves-the-girl scene."

What if you write the scene where the depressed ex-boyfriend walks alone in the rain until he suddenly realizes he made a huge mistake for leaving the love of his life and then runs to find her?

In other words, what do you do when you realize you've written the standard scene?

You embrace it.

After all, the audience has its expectations. People don't go to romantic comedies to see the lovers fall off a cliff and die. They know that when they're watching a Fish Outta Water story the fish will eventually learn to thrive on land. They know the underdog must win. That's why they watch movies—to get the same darn thing every time, over and over . . .

They just want it a little different each time; that's all. They want to be pleasantly surprised but never shocked or left wondering why they came.

So when you realize you've written the standard scene for a particular type of story, rest assured. You're not far off. You just need to sprinkle some magic screenwriter dust on it and season to taste. You don't need to throw it all out and reinvent the wheel.

And don't worry that studio readers and producers' assistants will stop your script at the gates for not being truly unique. Far from it. Their job is to direct scripts to their bosses that give the people what they want—just in some novel, entertaining manner.

Don't sweat the fact that screenwriting requires you to exploit long-established formulae by simply filling them with your unique content. Some of your scenes will always be reminiscent of past movies. When some brilliant screenwriter writes a script that harkens back to nothing whatsoever and shines with true originality on every page, you give me a call.

But, until then, I encourage you to steal when necessary and write without guilt.

THE FOUR MOST IMPORTANT SCENES

Good screenwriting is decisive writing.

Sure, filmmaking is collaborative, but, unless you are writing with a partner, screenwriting generally is not. We all know the director can shoot your movie any way he or she wants and stars can say what they want when the cameras start recording, but, if you are writing a script to sell, you must write with authority.

In particular, there are three places in every comedy screenplay where no ambiguity can be tolerated: the ends of Acts 1, 2, and 3. If we're talking about a one-hundred-page script, those points are around pages 25, 75, and 100.

Act breaks should be clearly defined. They should read as if a curtain is coming down hard—*Whomp!*—onto the stage, signaling to us that now things are going to change. Readers read for that. Audiences look for that. You need to write that.

Go look at the screenplays for some of the most successful recent comedies and look at the act breaks.

1. ***This Is the End***: Act 1 ends when a huge cataclysm rains fire and destruction down on the world, killing just about everybody except, of course, the lead characters. Act 2 ends when a fire kills one of the lead characters and forces the rest to leave the house they've been hiding in throughout the second act. Act 3 ends with the leading characters being sucked up to heaven.

2. ***Parental Guidance***: Act 1 ends when the parents drive away, leaving their children with the kids' grandparents. Act 2 ends when the parents return to find their family in total disarray. Act 3 ends with the parents' realization that their kids' grandparents actually did the children good.

3. ***We're the Millers***: Act 1 ends when the "family" goes to Mexico to smuggle drugs. Act 2 ends when David, the "father," decides he's had enough of the family and drives off on his own, abandoning them. Act 3 ends with the family back together and living as a real family in the witness protection program.

Ya see? Definite act breaks. Very definite.

Notice how often act breaks involve someone showing up somewhere or leaving for a long time. Entrances and exits are another way to bring that curtain down—*Whomp!*—onto the stage. Act breaks are almost never subtle.

Whether it's because they've been taught to think this way or because of some inner psychological need, the audience wants to know when they've entered the next stage of the three-act structure. It's up to you to tell them where in the story they stand.

Oh, and I almost forgot—there's one more place where you must be very clear that a change in the story has occurred: the inciting incident. I didn't include it in the previous discussion because it's not an act break, but it's important, so . . .

The inciting incident is when we find out what the movie is about. We almost always meet the protagonist in the first handful of pages. That's where we see her in default mode; we see how she is living her life before the story starts. Then, suddenly, something happens that lets us know that this day

of her life will not be like any previous day. It usually comes between pages 5 and 10. See Syd Field's book *Screenplay: The Foundations of Screenwriting* if you are unclear on this.

And just as with act breaks, inciting incidents must be strong and clear. To use the same movies we just discussed:

1. *This Is the End*: The inciting incident occurs when two of the lead characters leave a party to get some food and suddenly witness the beginning of the end of the world.
2. *Parental Guidance*: The inciting incident occurs when the parents first bring up the idea of having the kids' grandparents watch the kids.
3. *We're the Millers*: The inciting incident occurs when Mike, a powerful drug dealer, tells David to smuggle drugs.

In all of these cases, the inciting incident tells us what kind of movie we're dealing with and what to expect. The train we want to ride has arrived.

SUBTEXT

And now we embark upon a discussion that is better left between screenwriters.

Unlike the three-act structure and well-known writing strategies like Fish Outta Water, subtext is a subject that producers and executives usually have little interest in. Perhaps that's because the movie industry's biggest workhorses— the engines that pull the freight—are now comic book movies. And comic book movies are not known for their subtext.

But comedies still have subtext. Especially romantic comedies. That's because subtext exists whenever characters must conceal their intentions. When characters' intentions are hidden or masked, yet they take dramatic action to achieve their goals, subtext blossoms.

Subtext rewards the intelligent viewer who enjoys the challenge of discerning the true intentions of characters in a dramatic story.

Robert McKee gives a line-by-line understanding of subtext in his book *Story*, and it's still worth reading today. The

purpose of *this* book is to help you bring the Funny—hence the title—so I won't chart the subtext in an existing film. Instead, I will assume you've read McKee and give you a primer in how to create subtext in every scene of a comedy screenplay.

1. Load the Situation

There is a tendency to write scenes in which one character— usually the protagonist—has an agenda and the other characters do not. Don't fall into the trap. Give everybody an agenda and let the sparks fly. You will have more subtext because you will have more characters trying to accomplish their goals in the presence of other characters from whom they wish to conceal those agendas. In other words—*give everybody something to do.*

2. Impose a Gag Order

Find strong reasons why your characters cannot just tell everyone their agendas—reasons beyond mere civility. In *The 40-Year-Old Virgin* we learn in the first ten pages that Andy is deeply embarrassed about being a virgin and doesn't want anyone to know about it. Then, when he dates Trish—the woman we want him to be with—he must fight to keep his virginity a secret while trying to romance her. That's subtext—what the actor plays underneath the script.

3. Try This Million-Dollar Subtext Exercise

I once read a script that sold for one million dollars. The script was a thriller and was made into a not-very-good movie, but that doesn't matter. It was a fantastic script. The screenwriter wrote this on the first page:

```
Dialogue in parentheses is not spoken.
```

Throughout the script, the writer put parentheses around thoughts his characters were thinking but did not express. It looked a little like this:

```
        MAN
(I hate you.) How's it going?

        WIFE
(I hate you, too.) Fine.

        MAN
(Look, even though I still want
to kill you for sleeping with my
brother) I bought these flowers
for you.

        WIFE
Oh how nice (that you got me
week-old grocery store flowers).

        MAN
Well, I (feel so uncomfortable that)
have to go now.

        WIFE
Yes, maybe we'll talk later. (Go jump
in a lake. A lake of flaming shit.)
```

And so on throughout the entire script. It made for a lively read and infused the dialogue with deeper meanings. Good for him.

I've never used that trick on an actual script that I've tried to sell, but I have used it to help me write. When I'm writing new pages, I put the unspoken verbiage in parentheses in the first draft to see how it will read. Then, when I'm editing later drafts of the script, I cut those parentheticals out.

Training wheels. That's what they are. But they work. So I offer them to you. If your results are half as good as mine, you'll be quite pleased that you can now create some serious subtext.

SET PIECES

A set piece is a scene, or sequence of scenes, that occurs in one location and derives the most comedy bang for the buck from that location. Having a character walk through the kitchen of a busy restaurant, trip and fall for one laugh, and then leave the kitchen—that's not a set piece. That's a missed opportunity.

In a comedy, that character should trip all over the place, knocking people and cutlery everywhere. Plates should break, knives should be flying, and the whole place should be on fire when he walks out. That's a set piece.

Traditionally, there was a production-necessary efficiency to set pieces. After all, if the script calls for a gladiatorial arena to be built and thousands of extras to be hired, it's just not cost-effective to film a single short scene on that set that supports only a single joke. If you commit the resources to setting a big scene, you had better get your money's worth (in laughs) out of it.

Steve Martin is the master of the set piece. Did you see *The Pink Panther*? Martin goes into a hotel bathroom to get a Viagra pill and somehow manages, bumbling around, to start a fire and a flood, which causes him to crash through the floor and land in the lobby below.

Most comedy screenplays have second acts that are buoyed by set pieces lasting three to six pages, thus taking up three to six minutes of screen time. I can give a zillion examples of great set pieces you'd remember from recent comedy movies, but here are eight:

> The police taser sequence from *Meet the Fockers*.
> The hair removal sequence from *The 40-Year-Old Virgin*.
> The drunken barroom sequence from *The Heat*.
> The *Today Show* sequence from *Get Him to the Greek*.
> The gang fight between rival news crews in *Anchorman*.
> The touch football game in *Wedding Crashers*.
> The tailgate party in *Silver Linings Playbook*.
> The kids' baseball game in *Parental Guidance*.

Ideally, a good comedy screenplay should have at least six set pieces, but there are no established guidelines, no official ordinances governing their use. However, more is generally better. These are the scenes and sequences that producers are looking for when they read your script. This is the stuff that leads to funny trailer moments and big box-office openings. The audience anticipates the humor coming in jabs until it escalates into roundhouse punches

and finally that big knockout blow that leaves us roaring with laughter.

I could go on and on, but you've got scripts to write. Funny scripts that use great set pieces to earn big laughs.

POP QUIZ!

1. **Every scene in your comedy screenplay should have:**

 A) A setting, a conflict, and a question.

 B) A guy getting kicked in the privates by a little kid.

 C) A scene where the protagonist's geek sidekick hacks into the bad guy's computer system.

 D) Whoa. You're still reading? I suggest you consider Answer A. And B, too. It never hurts to have a kid kick some guy in the balls.

2. **The important thing about a master scene is that:**

 A) It be written masterfully.

 B) It read like a stage play incongruously jammed into your movie script. Sorta like a scene from *Our Town* stuck in the middle of *Transformers*.

 C) It would require subtext to write, and I don't know what that is.

 D) There are times—even in a twenty-first-century comedy—when we need to see all the main characters sit down, break bread, and just talk. And you need to practice writing those scenes so they kick ass.

3. **A "story told in pictures" is:**

 A) At best, an incomplete way to describe a movie.

 B) Something that annoys the crap outta me every time I hear it.

 C) Here's the deal—comedies need dialogue. Great dialogue. And you're not going to abandon your responsibility to write it by telling yourself that a movie is just a story told in pictures. So get to work. And I say that with love.

 D) All of the above.

4. The way to write set pieces is to:

A) Write a boring, old drama scene, then toss in a joke or two.

B) Set up a great comic situation in one location, squeeze every drop of funny out of it, and leave it in a shambles when you're done.

C) Yup, it was B.

D) B!

Act 3

YOU vs. THE WORLD

8

THE BIZ

You may wonder why so many chapters in this book exhort you to work harder, commit yourself to comedy screenwriting, and, well, enjoy life less.

If you're in the one tenth of one percent of all aspiring screenwriters who just happen to be closely related to someone who's a big player in the entertainment industry, then—for Pete's sake—put this book down and go schmooze that person now. Does he need a backrub? Give him a backrub. Does she like truffles? Buy yourself one of those truffle-sniffing pigs they use in Italy to find truffles and start searching.

Oh, and remember—you love his work. You *always* love his work. I'm talking about your close relative, the big player, not the pig.

But if you're one of the ninety-nine and nine-tenths percent who don't have that advantage, keep reading this book. And when you're done, start again. You still won't be on an even footing, career-wise, with the person who's related to the big player, but at least your comedy screenwriting will improve. Plus you don't have to buy the pig.

The industry is *that* competitive.

Successful screenwriters balance two worlds—the inner world of the writer, and the external world of Hollywood. Art and money. Yin and yang. Some like to pretend they

don't care about money at all. They will tell you that, when they are writing, they have no other concerns. Maybe. But sooner or later they'll have to put on their business hat, make calls, lunch with the right people, and sell themselves.

But the real winners, the ones who kick ass, make lots of money, and succeed over and over again—they meld the two worlds. For them, there is only one world—that of the Hollywood screenwriter. And, in that world, art and money are not opposites; they are mutually complementary. Those writers don't hold their noses while dining with agents and pitching to studio executives. They breathe it all in. They love the combination of the two environments.

They don't see writing and power as contradictory—they see writing *as* power.

Those writers—assuming they're also very talented and hard-working—rise to the top. They become show runners in TV and have multiple movie projects in development at the same time. Hollywood is their oyster. They never complain about how it's too sunny in California or how nobody on the West Coast has read the right books . . . because they never liked New York to begin with. They live for this. There is no duality. Yin *is* yang.

I've known more than a handful of those screenwriters, and I admire them. Since I am also a playwright, there is still a part of my soul that cannot totally enjoy Hollywood. And that holds me back.

But I advise you, the aspiring comedy screenwriter, to make peace with all that is Hollywood and travel farther into this industry than I have ever gone. I will wave to you as your ship leaves and pray that your star never fades. And I will call you up the next time I'm in Beverly Hills, and we'll do lunch.

Until that time, however, your career demands that you learn more about . . .

THE COMEDY-INDUSTRIAL COMPLEX

As I write this, the movie industry is drying up, feature screenwriters are scrambling to break into TV, and

Hollywood is perusing the internet—not a pile of spec scripts—for the next great comedy writers. Or so it is said.

But there's one thing to remember—this has happened before. In the fifties, when TV swept the world, plenty of folks thought movies were dead. And it looked that way until Hollywood came up with something TV couldn't provide— lavish musicals. When VCRs came out in the eighties and cable broke the broadcast TV monopoly in the nineties, again, the film industry seemed inches from death.

But comedy screenwriters like us have strong reasons to be hopeful. The first is that comedy tends to be cheaper to make than most genres. So studios keep making them.

And then there's the animation revolution. In the beginning, it was all *Lion King* and *Finding Nemo*, which didn't threaten live action's hold on comedy. But more and more animated movies are now straight-up comedies—not just animal movies with the occasional laugh line—but comedies. *Ice Age, Toy Story, Shrek, Madagascar, Monsters, Inc., Despicable Me, Chicken Run*: all comedies.

More good news: the basic rules of comedy screenwriting that you find in this book *doubly* apply to animated movies, which are usually created with painstaking care. And for writers, here's an added benefit; in animated movies, we don't have to worry about actors screwing up our lines or—worse—improvising. The nature of animation means that what's on the page is what's on the screen. They can't re-animate a whole scene because an actor had a funny idea, so actors and directors take what's in the script seriously.

Of course, few animated movies are made from original spec scripts. Instead, writers who have earned "fans" with their original spec scripts are often invited to come in and pitch their "take" on an existing property. That's how you get to be the writer of one of those animated comedies.

So what types of comedy spec scripts *are* getting bought? As of this writing, it seems high-concept stories helmed by a single actor are fading out. What's fading in are two-handers, female-centered stories, and cop stories.

Oh, and romantic comedy never dies. It's never a foolish decision to write a rom-com.

Now for the bad news—there are a handful of producers (Judd Apatow being the king) who dominate live-action comedy. Getting into their orbit is painfully difficult, and getting a green light for a script without being in their orbit is nearly as difficult. But if you love the craft of comedy screenwriting, you won't let that stop you. After all, you could be the *next* king.

In any event, if your goal is to write comedy for the big screen, there are still screens for which you can write.

However, as a practical matter, you should also write for every other kind of medium under the sun: TV scripts, sketch comedy, web series, etc.

Haven't ever written something funny on a cocktail napkin? Start. But keep your basic voice and style the same. If you write buddy comedy feature screenplays, try a buddy comedy spec pilot. Stick with your strong suit, genre-wise. Remember that the basic rules and strategies of comedy writing apply to all of its forms.

The career path of a screenwriter twenty years ago—in which young aspirants went to film school before settling into years of spec-writing in Los Angeles coffee shops until hopefully selling a screenplay—is now only one of the possible paths to success. There are people making movies on their phones, distributing them via websites and social media, and basically operating as one-person mini-studios.

But most of them—I'm talking ninety-nine percent—aren't making a profit from it. To do that, you still need to break into Hollywood.

PITCHING

A few years ago I was invited to speak to aspiring screenwriters at the Austin Film Festival. After a night of counseling young scribes, I decided to grab a beer before hitting the pillow. I meandered around State Street, the center of Austin nightlife, finally drifting into a cozy bar. I was hoping to avoid the hubbub and movie talk that dominated the handful of city blocks around the festival's central location. I failed.

The bar, which was packed, had a stage. Nearby, a long line of people waited . . . but for what? Was this karaoke night?

Sadly, it was not.

Onstage were two chairs. In one sat a man in his thirties. Across from him was a woman in her forties. As she stood up from her chair and reluctantly walked away, only to be replaced in the chair by a person waiting behind her, I remembered something I had read in the festival program and realized I was at a pitch competition.

Yup, it was a contest. Aspiring screenwriters waited in line to sit across from a Hollywood studio executive and pitch him a movie—a movie the writers would presumably be hired to write if they impressed the executive. Or perhaps some of them had already written the movie they were pitching. In any event, I wanted no part of it and left without finishing my beer.

Pitching is a rarely used skill that only a small minority of Hollywood screenwriters ever need to master. In fact, if you really need to learn how to do it, it's probably because you've already had some success as a screenwriter.

Why would that be?

Because no sane producer or executive wants to buy a pitch from a writer who cannot execute what they pitch. In other words, there is no point to pitching it unless you can *write* it. And, generally, the people who sell pitches in Hollywood are screenwriters with long resumes.

Would you hire a contractor to build you a house if the contractor had never built one before? I doubt it. No, you'd want to see a house the contractor had built beforehand to judge her or his ability to build one for you. In fact, you might very well go to see such a house before hiring the contractor so you could assess her or his work.

That's why *pitchfests* and *pitching contests* are such a waste of time.

By the way, I have sold more than a handful of feature film pitches to major studios. I know of what I speak. And that's why I don't want you to waste a second of your precious time as a soon-to-be-successful comedy screenwriter learning how to pitch—because it will be time taken away from the more important goal of learning how to screenwrite.

Here's an analogy: Imagine you are a talented young basketball player. You are working to impress coaches and

scouts and break into the NBA. You know that, if you make it, you'll need to learn how to sell sneakers on TV because that's how you'll someday make a bundle of extra money. But here's the thing—you can learn to sell sneakers when you become a star. For now, you need to spend every waking minute on your three-point shot, your ball-handling, etc.

Now that I've warned you away from pitching, I'll discuss it anyway. I do this because (A) I could be wrong, (B) you, the reader, will hopefully someday become an experienced screenwriter in a position to pitch something that could actually get bought, and (C) occasionally pitching actually helps writers write.

But remember this rule as long as you screenwrite:

If you have written a script, don't pitch it.

Pitching is, after all, a way for a veteran writer to get paid *before* writing. That's the primary purpose of pitching—to avoid the risk of writing a spec that may not sell.

When aspiring writers tell me they've written a script and then go about pitching it to me, I beg them to stop. They usually won't, so I hit them with a brick. I do that to wake the poor bastards up.

After all, if you have written a script, you want people to *read* it. The reason has to do with the purpose of writing a spec. Since almost no specs ever sell, the secondary—more commonly used—purpose of writing a spec is to show what a great writer you are.

But you can't do that if readers don't read you. You can't show them what a great writer you are by sitting them down and starting a sentence with the words, "We open on a . . . "

No.

You don't want them to listen to a two-minute version of your story. And you certainly don't want them to listen to a *twenty*-minute version of it, which is what an attempt at a two-minute version usually becomes.

If you want to break into comedy screenwriting, I strongly propose you do one thing over and over until you get there—*write*. Don't talk. Write. If your writing is excellent and industry people enjoy what they read, *then* you can pitch.

Sadly, it was not.

Onstage were two chairs. In one sat a man in his thirties. Across from him was a woman in her forties. As she stood up from her chair and reluctantly walked away, only to be replaced in the chair by a person waiting behind her, I remembered something I had read in the festival program and realized I was at a pitch competition.

Yup, it was a contest. Aspiring screenwriters waited in line to sit across from a Hollywood studio executive and pitch him a movie—a movie the writers would presumably be hired to write if they impressed the executive. Or perhaps some of them had already written the movie they were pitching. In any event, I wanted no part of it and left without finishing my beer.

Pitching is a rarely used skill that only a small minority of Hollywood screenwriters ever need to master. In fact, if you really need to learn how to do it, it's probably because you've already had some success as a screenwriter.

Why would that be?

Because no sane producer or executive wants to buy a pitch from a writer who cannot execute what they pitch. In other words, there is no point to pitching it unless you can *write* it. And, generally, the people who sell pitches in Hollywood are screenwriters with long resumes.

Would you hire a contractor to build you a house if the contractor had never built one before? I doubt it. No, you'd want to see a house the contractor had built beforehand to judge her or his ability to build one for you. In fact, you might very well go to see such a house before hiring the contractor so you could assess her or his work.

That's why *pitchfests* and *pitching contests* are such a waste of time.

By the way, I have sold more than a handful of feature film pitches to major studios. I know of what I speak. And that's why I don't want you to waste a second of your precious time as a soon-to-be-successful comedy screenwriter learning how to pitch—because it will be time taken away from the more important goal of learning how to screenwrite.

Here's an analogy: Imagine you are a talented young basketball player. You are working to impress coaches and

scouts and break into the NBA. You know that, if you make it, you'll need to learn how to sell sneakers on TV because that's how you'll someday make a bundle of extra money. But here's the thing—you can learn to sell sneakers when you become a star. For now, you need to spend every waking minute on your three-point shot, your ball-handling, etc.

Now that I've warned you away from pitching, I'll discuss it anyway. I do this because (A) I could be wrong, (B) you, the reader, will hopefully someday become an experienced screenwriter in a position to pitch something that could actually get bought, and (C) occasionally pitching actually helps writers write.

But remember this rule as long as you screenwrite:

If you have written a script, don't pitch it.

Pitching is, after all, a way for a veteran writer to get paid *before* writing. That's the primary purpose of pitching—to avoid the risk of writing a spec that may not sell.

When aspiring writers tell me they've written a script and then go about pitching it to me, I beg them to stop. They usually won't, so I hit them with a brick. I do that to wake the poor bastards up.

After all, if you have written a script, you want people to *read* it. The reason has to do with the purpose of writing a spec. Since almost no specs ever sell, the secondary—more commonly used—purpose of writing a spec is to show what a great writer you are.

But you can't do that if readers don't read you. You can't show them what a great writer you are by sitting them down and starting a sentence with the words, "We open on a . . . "

No.

You don't want them to listen to a two-minute version of your story. And you certainly don't want them to listen to a *twenty*-minute version of it, which is what an attempt at a two-minute version usually becomes.

If you want to break into comedy screenwriting, I strongly propose you do one thing over and over until you get there—*write*. Don't talk. Write. If your writing is excellent and industry people enjoy what they read, *then* you can pitch.

Now, for those who need to know, there are two types of pitches. You can pitch an original story, and you can pitch to write what are sometimes called "assignment" scripts.

An assignment script is one based on some existing property that you do not own. When a studio or producer controls a property—say, a comic book or a video game—and needs a screenwriter to write the movie version, the studio executive or producer calls all his or her favorite screenwriters to come in and pitch how they would write that script. A call may be put in to the major talent agencies: *Send your best writers to come take a crack at this book/play/article/video game, etc.*

And if you are one of those writers you will go and pitch your version of what a script based on that property would be like.

They might hear pitches from three writers, and they might hear twenty. They will most likely ask the finalists to return many times, each time bringing changes made in response to their notes on the previous versions. They will not, however, pay any of these writers a dime for any of that work. Only one writer (or writing team) will win the pitch-off, and only that writer will get paid for the work.

And sometimes *no* screenwriter wins. Sometimes the producers or executives are simply listening to pitches to determine if they want to make the movie at all. If they don't hear something they like, they may just drop the whole project altogether. Wash their hands of it. Like it never happened.

Sound like fun? My wife did the same thing to three or four contractors when we decided to renovate our kitchen. Each contractor came up with his own design and pitched it to us. Nobody got paid for that work. Naturally, we went with the guy who best responded to our list of *gotta-haves*. We had to have a certain type of cabinetry, a certain brand of fixture, a particular stain on the wood floor, etc.

And the contractor's job was to make it all work together. Somehow. That's what screenwriters do when they write scripts based on existing properties—they season to taste. And the producer paying the tab is the taster. Fail to hand the producers a script they love and you will quickly be replaced by someone who will.

There are two advantages to assignment jobs, as opposed to selling a spec script. One is that you don't have to create your premise and characters out of whole cloth; those elements are usually given to you. The other is that you get paid to write, as opposed to being paid for *having written.*

But know this—the process of meeting with producers and studio executives, then pitching and re-pitching their ideas and properties back to them, can easily drag on for months or years. Plenty of screenwriters toss entire eras of their lives away on these fruitless campaigns without ever seeing a dime of compensation. You are hereby warned.

The same is sometimes done for re-writes as well. Experienced screenwriters may be invited to come pitch how they would re-write a script the studio owns but isn't ready to shoot. Perhaps the writers are asked how they would "punch up" that script. Or perhaps they want a "page-one re-write."

Either way, some screenwriters are meeting with some people in power and telling them what they would do if they were to be paid to do it—and not before.

These are a few of the many reasons why pitching is for experienced professionals and not those fighting to break into the business. So, unless you are in that first category, I advise you to avoid it at all costs.

After all, your time is valuable; you are an up-and-coming comedy screenwriter.

AGENTS

Here again we have a subject matter that is far less important than most aspiring comedy screenwriters believe it to be. If you've written a hot spec that's leaving readers begging for more, you should be thinking about an agent. If you're still working toward that hot spec, keep writing and ignore the temptation to show work that is not ready.

Don't get me wrong—a great agent can make or break your comedy screenwriting career. Meet as many as you possibly can. Get to know them. Pretend to laugh at their jokes. Date them if you can stand it. But do not, under any

circumstances, show them that script you're toiling away on, the one you know damn well isn't close to being finished.

And stop being scared. Agents aren't gods, and they're not miracle workers. They sell stuff; that's all. They're middle-men (or middle-*women*; OK, that sounds odd). They charge ten percent of their clients' gross income from writing because they bring something very valuable to the relationship—friends.

Literary agents cultivate readers—those who can buy scripts and the people who work for them. Since they stand in that huge empty space between the writer and the buyer, it is their job to know both ends of that spectrum.

It's easy to get to know *you*. They can take you out to lunch and learn everything about you before the check comes. After all, if you've attracted the attention of a literary agent, it's probably because you spend all your time alone in your apartment, writing your butt off, keeping your A in the C. By the time some agent finally calls you to lunch, you are more than excited to take that first shower in days, throw on your only collared shirt, and meet him or her at a restaurant.

But before you actually head off to your first meeting with an agent, let me tell you what *not* to do. Do not concern yourself with the issue of whether or not the agent understands you. It doesn't matter if the agent *gets* you. The agent only needs to be able to *sell* you. It's more important that she or he gets the *buyers*.

Do not concern yourself with the agent's age and whether the agent strikes you as hip or cool. What's cool is selling a script.

So when you first sit down with a prospective agent, ask the agent what scripts she has sold. Go ahead. Ask. Then ask what potential buyers the agent has access to. Once the agent starts selling herself, focus on one thing—the agent's ability to make you money. Just remember that no matter what the agent tells you, she is concerned only with that very same thing.

Agents are constantly trying to determine what their readers want and doing their damnedest to give it to them. Hopefully, you have that on the page.

Until you have it, agents are worthless to you.

Trust me. If you have a great script, agents will come. Many of them. Like sharks to blood. You'll be cleaning them off your windshield with a squeegee. All you need is that script.

When my former screenwriting partner Hank Nelken and I were looking for representation, we managed to get a script to an agent in Beverly Hills. A few days after he received it, he called us. Instead of revealing the agent's name, I'll give him a fake name—Jon Klane. That phone conversation is reproduced, more or less, in the scene below.

```
INT. MY CRAPPY LOS ANGELES APARTMENT—DAY

Me and Hank writing when the phone rings and
I pick up.

                KLANE'S ASSISTANT
         Hank, Greg, I have Jon Klane for you.

                 ME & HANK
                (thrilled)
          Holy crap!

                 JON (O.S.)
                (groans in pain)
          Unh . . . ah . . . Hi, guys. I just
          read your spec and I love it. I abso-
          lutely must represent you. Can you come
          to my office?

Hank and I high-five and run outside, forget-
ting our shoes.

                 JON (O.S.)
                (unaware we're gone)
          Good. Thing is—I'm lying on my face
          right now getting acupuncture. So gimme
          a couple hours, OK?

As we jump in Hank's car and peel out . . .
                                        CUT TO:
```

It was that simple. Klane loved the script and wanted to represent us. We loved it too and wanted to be represented by him. Instant marriage.

That story represents an ideal situation for a screenwriter (or, in this case, screenwriting *team*). Now I'm going to tell you about a more common situation, one that many screenwriters find themselves in and that should be better understood.

It's called *hip-pocketing*. Hip-pocketing is when an agent maintains a connection with a writer but does little to advance the writer's career. You can tell when a writer is being hip-pocketed because the writer will say something like, "My agent told me that, as soon as some producer gets interested in me, I should tell that producer I'm represented by her and she'll totally take the producer's call."

Here's the thing: an agent will always take a call from *money*. If a producer wants to buy your script, you can get any agent to take that call and negotiate on your behalf because that's ten percent easily "earned."

To make things worse, many writers who are being hip-pocketed will come to believe that they must somehow remain *loyal* to that agent. They may stay up nights worrying that, by having coffee with another agent, they are somehow showing disloyalty to the agent who's hip-pocketing them. But that's silly—like being loyal to a hooker. Here's the thing . . .

Agents don't earn their money by negotiating deals. Well, they do negotiate deals, but that's easy stuff. Icing on the cake. Agents earn their money by *promoting their clients*. If you have an agent who isn't melting the phones telling everyone in town what a fantastic writer you are, you don't have an agent. And if you don't have an agent, you don't need to worry about being loyal to that person. You can do what you please. You can flirt with as many agents as you like.

To be clear, you can *always* meet with as many agents as you like. After all, even if you have an agent, you still need to maintain social connections with other agents. Why?

Because screenwriters can change agents as fast as they can change their pants. And very often, they should. After all, agents sell their contact lists. That's what they offer—their lists of friends. Friends they can call. Once they have called them all and done their best to convince them you are a fantastic writer, capable of moving mountains with your laptop, their usefulness to you is largely exhausted.

And that usually happens in the first couple months of any writer-agent relationship.

After that, if there is no success, you are effectively hip-pocketed. After all, they called all their friends and sent them your latest script. But, if they didn't dig it, the last thing the agents want to do is bring you up again. They've learned their lesson.

The only question remaining is this: Did you learn *yours*? Or will you stick with the agent as nothing happens in your career for months or years?

Your only alternative is a new agent, one with different friends who haven't met you yet. And getting a new agent usually requires providing him or her with a fresh, new script. And that requires you, the comedy screenwriter, to make another pot of coffee, sit your A back down in the C, and get writing. Again.

Welcome to the life and career of a Hollywood screenwriter. I recommend a Mr. Coffee or a Melita micro-brew with a reusable wire filter.

The thing to remember about agents is that, for the most part, they are just as desperate and manic as screenwriters. Often, more so. If it's hard to make a living as a screenwriter, it's ten times as hard for an agent, who must have ten clients working to make the kind of money her clients make. After all:

10% × 10 Clients' Incomes = 100% of the Average Salary of the Average Client

You may find it satisfying to know that agents get fired all the time—by their agencies and by their clients. Don't envy or fear them. Just use them.

Write a great script, make them want you, and use them.

MANAGERS

In California, which is pretty much the only state that matters to a comedy screenwriter, the law prohibits agents from producing their clients' work. Apparently it has something to do with conflict of interest, but invoking ethics when discussing talent agents is like invoking ethics when discussing talent agents.

Why be a manager?

Because you are an agent who wants to produce. Otherwise, a manager does pretty much the same job an agent does for a screenwriter.

There is a belief among many screenwriters that a manager should take a more hands-on approach to representing writing talent than an agent does. Thus, a manager would be sitting down regularly with writer clients, giving them detailed notes on their work and helping them improve their craft. And while that *should* happen, it rarely does.

When my manager made the deal to sell *Bride Wars* to Miramax, he called to tell me what he had done. I was certainly thrilled. That one gig would pay for me to live for three or four years, assuming I didn't eat out much and stayed away from Vegas. (I didn't, but that's another story.) Near the end of the call, he mentioned that he would be attached to executive produce the movie as well. To which I said, "Oh, OK. Cool."

What else was I going to say? I needed the sale. Moreover, why should I have stood in his way? He wanted to produce, and his credit cost me nothing.

Again, the main reason to *manage* writers is so the manager can produce the client's work. There is little value in *that* to the writer. But there *is* a value to being simultaneously represented by both an agent and a manager. In that case, you pay double the commission, but you may also get double the potential readers for your next script, which is priceless. You may even be able to get your manager and agent to compete for your affection. After all, this is Hollywood, and you're a writer. You'll take any little bit of power you can get.

As with agents, I recommend you give managers no special loyalty. When they have exhausted their list of potential fans of your work, they will drop you into their hip pocket without warning, and you will need to find new representation.

Now you know.

PRODUCERS

If you've been to film school, you know a producer's job can be a lot of work. The producer may be corralling actors for the shoot or renting equipment with which to shoot them. The producer may be obtaining necessary permits or staying up nights fiddling with the film's budget.

In Hollywood, a producer does none of those things.

Producer is a title. And that title can mean just about anything. It could mean that the person holding that title was the first person to read and advocate for the script—a very important person indeed. It could also mean that the studio has a deal in which every movie distributed of a certain type or budget automatically lists a certain name in the credits as a producer. I spent three months on the set off a movie I co-wrote, and yet there are two people listed as producers of the film whom I never met. Go figure.

When a producer acts as an advocate for a writer and helps sell that writer's script to a studio, the producer is attached to produce. That means, at the very least, that the producer's name will appear on the movie poster. And that, for a producer, is like getting on base. In a minor-league game. Getting a name on the poster for a hit movie is like hitting a homer in the World Series.

So producers have a lot at stake. They also have a lot of influence over the scripts for which they advocate. Which means they usually give notes to the writers.

Are those going to be good notes? Will they help the script?

Who knows.

But be realistic; if you want to work with the producer, you'll take the notes and use them. After all, the producer—like your agent or manager—is essentially an intermediary.

The producer stands between you and the buyer, in most cases a studio.

When I was pitching *Bride Wars*, I was working with a full house of producers; however, Alan Riche was the wise man among them who pushed me to make smart changes. That's what great producers bring to the *writing*—notes that get the movie made. What they bring to the *deal* is relationships—with executives, other producers, and talent.

Remember: if you want to write what moves your soul, write a poem. There's no money in poetry, but you don't have to take anybody's notes.

EVERYBODY ELSE

OK, there isn't anybody else. I mean it. There isn't.

If your goal is to break into comedy screenwriting, there's only you and the industry you must embrace—with all its faults, excruciating humiliations, and exceedingly rare and precious victories.

That means you pretty much have to do whatever it takes to be an insider. After all, you can move to Los Angeles and still be very much on the outside. Most aspirants are. Los Angeles is a big city spread over a massive space. You can live in Hollywood and feel a hundred miles away from what's happening on the inside because you don't know anybody who has broken in. Hell, you can live down the street from Fox or Paramount and, if nobody will return your phone calls, you might as well be in Poughkeepsie.

So how to pursue your dream of comedy screenwriting and continue to live as a regular person—the kind who has regular friends, works a regular job, and lives a regular life?

You can't.

Regular people don't break into this business. That has never happened. Manic people break in. Desperate people break in. Insane people . . .

The point is that if you want to become a working, professional comedy screenwriter, you need to budget more than a handful of years to the task and dive into every element of the business—the writing, the schmoozing, the

abandoning of all pretense that you're headed for a normal life. That's all gone now. Drop your civilian boyfriends or girlfriends because they can't help you. And don't think they'll keep you sane; you don't want to be sane. You're not headed for sane. You're headed for Hollywood. Collagen and colonics.

You are entering a contest in which there are very few winners and many leave broken-hearted. And oh—a contest in which youth is a fleeting advantage. So don't waste it.

Here's a story:

In college, I was friends—not good friends, mind you, but friends—with a guy who went on to become an A-list comedian and movie star. I won't name him because it might make me look a tad old. And, as a comedy screenwriter, I cannot afford to look old. But suffice it to say, he's big.

When I knew him, he was a young comedian with a bright future. He was surrounded by a cabal of friends—many of whom went on to become his producing partners, co-writers, directors of his movies, etc. In other words, being a part of his entourage in college paid off big for those who took the time to join up when he was small-time.

But I didn't join up. I didn't make the extra effort to follow him to comedy clubs or hang with him into the late hours. I suppose I could have, but at that time I had no idea I would go on to become a comedy screenwriter.

However, looking back—I should have. It could have saved me years.

By the time I decided I wanted to go to Hollywood, my friend was long gone from my friendship circle, and I was forced to break in without his help.

Now, to be clear—I don't mean to imply that the people who benefited from being part of his entourage in college were untalented or undeserving. Quite the opposite—that crew went on to make movies that I've enjoyed. More power to them.

But you see where I'm headed. Every opportunity to make friends with someone on the way up should be grabbed while it can be. You can do all the great writing you want, but, without friends on the inside, you're just, well . . . on the outside.

So don't struggle as I did. Don't make it harder on yourself than it needs to be. Take every advantage you can get. Hollywood is not a meritocracy, and the only reliable rules are those that can be inferred from experience. So learn from mine. If you're headed for comedy screenwriting glory, skip making friends with anybody who cannot help you. The day you give up and leave Hollywood for good is the day you can afford to hang with folks who cannot help you.

Do I sound a bit cruel? If so, I'm sorry. I've just spent a great deal of my life fighting for recognition and a living in a cruel industry. And I've had my successes. Which have made me proud.

But I want you—the comedy screenwriter holding this book—to have it easier that I did.

Now take the quiz below, read the next chapter, and remember to keep this book very close to where you sit and write every day. I want you to pick it up whenever you need advice. I want to be the voice in your head that keeps you writing. I also want to be thanked very publicly at the Oscars, so don't forget me, OK?

POP QUIZ!

1. **To break into the film industry as a comedy screenwriter, you must:**

 A) Sell your soul.
 B) Sleep with the devil.
 C) Take a bath in blood.
 D) Do all of the above, over and over, until you get an agent. From then on, have *the agent* do it.

2. **Pitching is best done by:**

 A) Noon. People get sleepy after lunch.
 B) Aspiring writers who are too lazy to write.
 C) Herb, who lives in a cardboard box on Ninth Street in Santa Monica. I'm telling you: give your script to Herb and let him pitch it to studio executives. The guy's a screenwriting savant. That's why he lives in a box. Trust me: you don't want people to actually *read* your script. You want Herb to pitch it.

D) Screenwriters who are so successful that, frankly, they probably don't need this book. But, to be clear, they should still buy it so that aspiring writers who visit their Hollywood mansions will see it on their bookshelves and feel inspired . . . to buy it.

3. **Hip-pocketing is when agents:**

A) Wear their pants too high.

B) Give their clients ninety percent of everything they earn. (Sorry, that's from the agents' perspective.)

C) Do everything possible to promote their clients. (OK, actually that's called *agenting*.)

D) Take advantage of naive screenwriters who think they're being represented.

4. **To break into comedy screenwriting, you must do one thing:**

A) Become Jewish. Or a Scientologist. Or both.

B) Sleep with a star, making sure to quote excerpts from your latest spec script during the heights of passion. Stars love that.

C) Understand the biz.

D) Write, you fool. You must write and write well. And C helps, too. But most importantly—*write*.

5. **In Hollywood, producers:**

A) Do all the grunt work of a production: they keep the budget, manage equipment, make sure everybody shows up on time, etc. In short, they do everything that, in theory, a producer should do.

B) Are, for our purposes, primarily intermediaries between writers and buyers. Oh, and they get their name on the poster.

C) OK, the answer is B. There's no need for a fourth option. It's B, and I want you to remember that. OK? Now enough of this. Let's move on to . . .

9

THE LIFE

There are many paths to success as a comedy screenwriter. Unfortunately, almost all of them go through Hollywood. I'm not just talking about the geographic Hollywood, though the fact that you've read all the way to the last chapter of this book tells me that you may be thinking of gassing up your car and heading out there.

I'm talking about the whole movie industry, which is run by a veritable handful of people. And those people live and work as a herd. If one of them likes you, it's a solid bet they all will. And if one of them *dis*likes you . . . well, as I wrote earlier, it is actually possible to live in Hollywood and be, for all purposes, thousands of miles away from the movie business. In fact, most of the screenwriting population of Hollywood is effectively on the outside, far from connection with any of the players who could help them fulfill their life's ambition. I know. I've been there. In fact, I've parked my car and stayed all night.

Unless you get incredibly lucky, your struggle to break into the biz will take at least a few years, if not a sizable chunk of your life. This book will ideally be one of many you will read—hopefully, more than once—along the way. And while I am not an A-list writer, I have had significant success. I hope you can see the virtue in sacrifice and perseverance, whatever comes your way.

Of course, I'm just one example of a screenwriter who broke in.

We comedy screenwriters are an increasingly diverse group. However, there are some constants in our experience. One is that our ranks have no middle class. There are no blue-collar screenwriters. Nobody makes a "decent living" at it. Nobody punches in and out daily, knocking off at 5:30 and not doing a lick of work until they show up the next morning. That never happens.

And our peculiar profession tends to attract and cultivate certain personality types. Psychologist Dennis Palumbo—a former screenwriter who specializes in treating creative professionals—says screenwriters are "self-loathing narcissists." I have found this to be true in my own case and in the case of the many screenwriters I have known.

Let me tell you more about what I know about you, or at least about the person you are trying to become.

You are a writer, but you are not a true artist—at least not when you are screenwriting. You are above-the-line talent, but you will likely be ignored on the set of any movie you write, if you are even allowed on set. (By way of disclosure, I was banned from the set of *Bride Wars*, which I wrote. Apparently my presence would have been jarring to the confidence of the writers hired to revise my work. And, yes, the first thing they did was to re-write my character names. They took my "Liz" and transformed her into "Liv." My "Abby" became "Emma." I often wonder, *Did that take a long weekend or what?*)

I digress. But that's another thing you ought to know about us screenwriters; we pity ourselves with reckless abandon. Which brings me to the subject of . . .

SACRIFICE

Just about all working screenwriters have a story about the days in which they were not working. The day they showed up in Hollywood, laptop in hand, ready to eat the bear.

For me, Hollywood was a last chance to become somebody and make my mark. Living on the East Coast, I had written songs for a rock band—songs that never made me

a dime. I had written freelance articles for the *Washington Post*—again, you can't live off that. I was a playwright—no money there.

But I wanted to earn a living as a writer. So I left the East Coast in a beat-up Toyota Tercel and headed West.

Los Angeles is no paradise for a newcomer. I rented a studio apartment in a bad neighborhood and took a day job. There I was, selling books for a publishing company while toiling away on my scripts at night. My biggest advantage was my unpopularity—without a girlfriend or social life, my nights and weekends were open . . . for writing.

I experienced near-constant depression mixed with occasional exhilaration—it was scary, lonely, and, yet, thrilling. I was on my own in a strange land without friends.

I wrote, but I also researched. Every night I watched three or four movies, which I rented at a mom-and-pop video store just across the street from my apartment on Venice Boulevard. I stayed up late to get it all done and went to work groggy-eyed every morning. I was in my groove—my desperately lonely, hard-typin' writer's groove. In fact, I was so caught up in that groove that I paid little attention to my surroundings.

One night, right before closing, I walked into that mom-and-pop video store to return the movies I had rented the night before and rent some more. I was working my way through the comedy section—determined to watch and diagram every movie they had. And as I stood in the back corner of the store, reading the DVD box for a movie called *Eddy and the Cruisers*, a guy walked up and put a gun to my head.

The thief had already robbed the cash register and made the cashier and his girlfriend lie face down on the floor. He had locked the front and back doors of the store, trapping us inside. And now he was demanding that I empty my wallet. I had only spare change and a gum wrapper to give him. With the gun shaking in his hand, he berated me: *I'm gonna kill you, motherfucker! KILL YOU!*

Luckily, he didn't and eventually ran off into the night. When the cops came, I could tell them little about the gunman—my eyes never left the gun. I went back to my

studio apartment, called my parents and friends back on the East Coast, told them what happened, and then lay down to sleep for what had to be the loneliest night of my life.

I just kept thinking, *If I had died out here in L.A., would anybody have cared?*

If you made a movie about my early life in Hollywood, that night would have been a good place to end Act 2. And by the way, if you *do* make that movie, I want producer credit. And Brad Pitt for the lead.

In any event, from that night onward, I felt I had paid my dues in Hollywood. I know it doesn't make any sense and I know I could have gotten held up at gunpoint *anywhere*, but . . . to me it felt like God was exacting a price from me. Like I had passed through a gate and come out the other side.

From then on, I started staying up even later, writing even harder, and schmoozing even, uh, schmoozier.

Eventually I broke in. But I didn't do it alone, which brings me to . . .

COLLABORATION

When people say that filmmaking is a collaborative business, they are usually about to tell you to make changes to your script.

In most cases, you have no choice. After all, screenwriters sell their work. Thus, we have no control over the product. That is often a good thing because the product can be hellaciously bad—a clusterfrick sandwich. And when that happens, we blame the director, the producers, the actors. Nobody listens, of course, but we blame them. And that's fair because they blame us as well. The difference, of course, is that people listen to them.

For us screenwriters, filmmaking is almost never truly collaborative. We write, we sell. If we're lucky, they make. And, while they make, we go back and write more—and in a hurry, because nobody stays hot forever.

Comedy screenwriters who toil away on features live on an alternate plane, far from TV writers who may go to an office every day and actually work with other writers. In other words, we're loners.

But sometimes we find a friend, a comrade who walks hand in hand with us through the desert. I'm not talking about a spouse. I'm talking about someone who truly matters—a writing partner.

The classic comedy screenwriting partnership is two people sitting in a room—one pacing while the other types. That was Hank and I for five years. We worked two shifts per day, lunching together and often breaking only for dinner before working into the early hours of the morning. And by the way, this is still the most common and successful method of screenwriting partnership.

I have heard occasional stories about writing partners who don't work in the same room. I've heard about writers who email drafts back and forth from miles away, re-writing each other over time. Or writers who divide tasks—one writes story, and the other writes scenes or jokes. Or maybe one writes and the other merely paginates.

But in our case—mine and Hank's—we were both good at all the major elements of comedy screenwriting. One of us wasn't stronger at dialogue or writing action. Instead, we were similarly talented and driven; we both contributed.

And that's where partnership pays off and confers a benefit—when it doubles the comedy screenwriting power of the writers. The problem, of course, occurs when the partnership lacks competitiveness between the partners. That's because two people working together to slay a dragon can either agree to take turns—one slashing at the beast while the other rests—or agree to simultaneously attack it with all their might. The second choice is the only one I've ever seen work.

Two comedy writers working at full capacity are an intimidating force. They bring double the assets, double the desperation, and, in the optimum, double the Funny.

And doubling the Funny is what a comedy writing team must do to succeed. This is where the competition between the partners actually helps serve both. When they are crafting a scene, talking their way through the actions and dialogue, they inevitably try to one-up each other. And when it's time for punch-lines, they will throw the Funny back and forth, competing to come up with the best line. And that's

where the partnership brings something unique to the writing that very few solo writers can provide.

And producers know that. Just look at all the successful movies written by writing teams in recent years.

Now before you go running off to the local bar, Match .com, or JDate to find yourself a suitable writing partner, you need to know the downsides to being part of a writing team:

1. You Make Half the Money

Yup, half. Producers don't pay you more because you're a team. Hank and I sold our first script to a low-budget production company. They paid us $45,000. Sounds like decent money, right? And to a pair of struggling screenwriters, it seemed so until we paid ten percent to our agent and five percent to our lawyer. That left us $38,250.00 . . . to split. At the end of the day, we each walked away with a whopping $19,125.00—*before* taxes. For a feature film with a budget of more than two million bucks. Ouch.

2. You Are Joined at the Hip—Forever

At least it feels that way. Aspiring screenwriters work round the clock if they want to break in. So does a writing team, which means you're spending every working minute in each other's face. Which can turn friends into enemies. One of the benefits of a writing partnership is the enhanced brainstorming that comes with two people beating their heads against the same wall at the same time. But that also means experiencing the frustration and self-immolation of day-to-day screenwriting with another person. And I don't know about you, but I'm like a cat—when it's time to suffer and die I just want to crawl off into an alley and be by myself. Not that way with a partner—you take the good and bad together. And that can suck.

3. Did I Mention You Make Half the Money?

Yes, I think I did.

But sometimes we find a friend, a comrade who walks hand in hand with us through the desert. I'm not talking about a spouse. I'm talking about someone who truly matters— a writing partner.

The classic comedy screenwriting partnership is two people sitting in a room—one pacing while the other types. That was Hank and I for five years. We worked two shifts per day, lunching together and often breaking only for dinner before working into the early hours of the morning. And by the way, this is still the most common and successful method of screenwriting partnership.

I have heard occasional stories about writing partners who don't work in the same room. I've heard about writers who email drafts back and forth from miles away, re-writing each other over time. Or writers who divide tasks—one writes story, and the other writes scenes or jokes. Or maybe one writes and the other merely paginates.

But in our case—mine and Hank's—we were both good at all the major elements of comedy screenwriting. One of us wasn't stronger at dialogue or writing action. Instead, we were similarly talented and driven; we both contributed.

And that's where partnership pays off and confers a benefit—when it doubles the comedy screenwriting power of the writers. The problem, of course, occurs when the partnership lacks competitiveness between the partners. That's because two people working together to slay a dragon can either agree to take turns—one slashing at the beast while the other rests—or agree to simultaneously attack it with all their might. The second choice is the only one I've ever seen work.

Two comedy writers working at full capacity are an intimidating force. They bring double the assets, double the desperation, and, in the optimum, double the Funny.

And doubling the Funny is what a comedy writing team must do to succeed. This is where the competition between the partners actually helps serve both. When they are crafting a scene, talking their way through the actions and dialogue, they inevitably try to one-up each other. And when it's time for punch-lines, they will throw the Funny back and forth, competing to come up with the best line. And that's

where the partnership brings something unique to the writing that very few solo writers can provide.

And producers know that. Just look at all the successful movies written by writing teams in recent years.

Now before you go running off to the local bar, Match .com, or JDate to find yourself a suitable writing partner, you need to know the downsides to being part of a writing team:

1. You Make Half the Money

Yup, half. Producers don't pay you more because you're a team. Hank and I sold our first script to a low-budget production company. They paid us $45,000. Sounds like decent money, right? And to a pair of struggling screenwriters, it seemed so until we paid ten percent to our agent and five percent to our lawyer. That left us $38,250.00 . . . to split. At the end of the day, we each walked away with a whopping $19,125.00—*before* taxes. For a feature film with a budget of more than two million bucks. Ouch.

2. You Are Joined at the Hip—Forever

At least it feels that way. Aspiring screenwriters work round the clock if they want to break in. So does a writing team, which means you're spending every working minute in each other's face. Which can turn friends into enemies. One of the benefits of a writing partnership is the enhanced brainstorming that comes with two people beating their heads against the same wall at the same time. But that also means experiencing the frustration and self-immolation of day-to-day screenwriting with another person. And I don't know about you, but I'm like a cat—when it's time to suffer and die I just want to crawl off into an alley and be by myself. Not that way with a partner—you take the good and bad together. And that can suck.

3. Did I Mention You Make Half the Money?

Yes, I think I did.

4. You Get Half the Glory

Have any success as partners and the industry will see you as one entity. One soul. Decide to break up—even amicably, as Hank and I did—and you may find yourself on the far side of the moon. Without a paddle. Your agent will scratch her head like she has lice, and the town will refuse to recognize what, to you, will seem obvious—that you each have talent and unique gifts. *Don't confuse us*, the industry will say.

You'd think getting a divorce from your writing partner wouldn't shock anybody in Hollywood. After all, actors make a ritual out of divorce.

But writers? Your agent and manager will cry as if their parents had split. And then been killed in a fiery car wreck, their bodies burned beyond recognition. So don't do it unless you want to fight for your new identity, which is almost like starting all over again. In fact, you might as well pack up and leave Los Angeles, change your name, get plastic surgery, then move back to L.A. again.

OTHER SCREENWRITERS (AND EVERYBODY ELSE)

Meet your new family. That's right—other screenwriters aren't just the competition; they're your brothers and sisters in arms.

It is almost impossible for a writer to succeed in Hollywood without the help of other writers. Literary agents don't read unsolicited scripts, so you need a friend—usually another screenwriter—with an agent to be read by an agent. Thus, you need to impress, and earn the respect of, other screenwriters. They should be your first and best fans.

You also need other screenwriters to be your advisors, mentors, and, sometimes, collaborators. They should be the first in your friendship circle to read early drafts of your scripts. Hopefully, when they do, it marks the beginning of your long march to victory and a house in the Hills. With a pool, of course. And a blonde (of either gender) lying next to it.

Which brings me to a subject you probably never imagined would be covered in this book: *ethics*.

I'm talking about how we screenwriters treat each other and how we treat the rest of the industry.

Hey, don't laugh—this is important. I'm imagining a decades-long career for you in Hollywood, complete with Oscars, Golden Globes, and a private room in an assisted-living facility located within wheelchair distance of Canter's Deli (where you can comfortably lunch with your old screenwriter cronies well into your nineties).

To make that happen, you're going to need to need to get along with a great many people. Therefore, I suggest you adopt and live by . . .

DEPAUL'S ETHICAL CODE OF CONDUCT FOR COMEDY SCREENWRITERS

1. Treat Your Colleagues Better than the Industry Does

As I've alluded to many times in this book, Hollywood will kick you in the stomach, steal your milk money, and pedal away laughing. That's understood, just part of the biz. But writers shouldn't do that to each other because, as I said, we're *family.*

And when your sister calls, you pick up the phone, right? When your brother needs help, you help him, right?

I've explained how you need your brothers and sisters to get ahead. I've told you how important they are to your writing—and reading and re-writing—process. So treat them well.

But if it takes your brother months to read your script, that's not help; that's an obstacle. If your sister gives you terrible notes that aren't constructive, that's an obstacle. And if you waste your sister's valuable time by begging her to read work that's not ready to be read and responded to—you've rolled a big boulder of wasted time in her path to success.

So put your family on speed dial. Read their scripts as soon as they show up in your email inbox, give your siblings your utmost attention, and respond with meaningful notes.

And by meaningful notes, I mean notes that are *constructive*. That help your sister re-write. Don't overlook problems in the writing, but don't beat your brother over the head, either. And, most importantly—*never ask your brother or sister to read work that's not ready*.

After all, your first draft is probably barely readable for *you*. So don't burden the rest of your family with it. Again, I implore you—*don't show anybody a script until you can't do a lick more work on it*. Only when you've run out of ways to improve your script should you foist it on other writers and ask for notes.

Until then, stay in the woodshed until your fingertips bleed and keep piling on the re-writes. The more you work on it before you hand it to me, the more I'll respect you and come to think of you as worth my help.

2. Treat Actors with Respect

If other screenwriters are your siblings, actors are your cousins. And you know how cousins are—they don't *have* to visit. They could stay distant, or they could be close. As I've already told you, you want them close so they can read your scripts—out loud, if possible—and you can quickly learn what's funny and what's to be cut.

But your cousins need to be respected. If you need to take an acting class to rub shoulders with actors and understand them, do it. The more you understand them, the more you can work with them.

If you ask them to read your work, make sure you provide adequate libation. Acting is thirsty work. And remember the cardinal rule of workshopping scripts with talented actors: *never ask an actor to show up for a reading and then give the actor a tiny part*.

Nobody wants to kill a night sitting around waiting to say one line. When you do that to an actor, the actor remembers—and doesn't show up again.

So play nice with your cousins. Find out what they need to be happy and provide it. If you do, they'll come around more often and you'll get to hear your words more often. And that will speed up your learning curve.

Jack and I—metaphorical cousins literally rubbing shoulders.

3. Treat Directors with Respect

I know they don't deserve it. After all, writers and directors can be like fire and water. But it pays to understand what directors do and how you can work with them.

If you are—contrary to all Hollywood norms—asked to collaborate with a director on a film you've written, consider yourself lucky and be accommodating. The set is the director's turf; play by the director's rules.

Now that you've read this book, you know a screenplay is nothing more than a proposal for a movie. Once you've turned in your proposal, stand back and let the director make the movie. Unless the director asks for help. And then tread carefully—it's the director's baby now. After all, if you had wanted to keep it, you would have written a play, a poem, or just about anything other than a screenplay.

Oh, and you would never have signed a certificate of authorship. Remember that? That thing they took from you when they handed you that check?

Also, you may not become a gun-for-hire screenwriter like myself. You may actually want to *make* the stuff you write, or even make stuff *other* people write. Well, good for you. Screenwriters who have any success put themselves in

a great position for advancement. Get on set, mind the rules, watch, and listen. The people who could hire you want to believe you're a team player. So play nice and maybe soon you'll get to be the one behind the camera.

Until then, keep this book wherever you write. And buy another copy for the bathroom. Oh, and it makes a great Christmas present . . .

POP QUIZ!

1. **To make it as a comedy screenwriter, you will most likely have to:**

 A) Sell everything you own, say goodbye to friends and family, load up your Toyota Tercel, and drive to Los Angeles.

 B) Get robbed at gunpoint in a video store while reading the back of the *Eddie and the Cruisers* DVD box.

 C) Write a really, really sincere letter to Stephen Spielberg asking for a three-picture deal.

 D) OK, it's A. But you don't absolutely have to drive a Tercel. Could be a Camry.

2. **I was banned from the set of *Bride Wars* because:**

 A) I showed up dressed as one of the brides, which caused some confusion, though I did get to work with Kate Hudson for a few scenes until she noticed my Adam's apple.

 B) Anne Hathaway and I couldn't work together after what happened between us in that hotel room in Monte Carlo. OK, I've never been to Monte Carlo, so this answer may not be entirely truthful.

 C) One is simply not allowed to arm-wrestle Candice Bergen for money, even if she taunts.

 D) I fought for credit on the movie I conceived and wrote.

3. **Screenwriting partnerships suck because:**

 A) You make only half as much as a solo screenwriter.

 B) It's like being married, but without the sex. Actually, it's just like being married.

C) The industry will treat you as one writer, and nobody wants to be *half* a writer.

D) All of the above. If you're going to partner up, be sure you know the costs.

4. **You need your brothers and sisters because:**

A) Someone's gotta read your work and give you notes before you show it to the industry.

B) Somebody's gotta start treating screenwriters with respect, and it only seems appropriate that it should be other screenwriters.

C) Poor, struggling people need to stick together, if only for warmth.

D) They're your family, dammit! Just love them and hope they love you back.

10

SUCCESSFUL LIVE ACTION COMEDY MOVIES 2000–2016

Key:

2H A two-hander.
Ens A true ensemble. Multiple protagonists.
* Everything else. A movie with a solo protagonist, albeit with a love interest and/or supporting ensemble.

2016 (so far)

Ride Along II	2H

2015

Daddy's Home	2H
Spy	*
Sisters	2H
The Intern	2H
Mall Cop II	*
Trainwreck	*
Get Hard	2H
Pitch Perfect II	Ens

2014

22 Jump Street	2H
Neighbors	2H
Ride Along	2H
Dumb and Dumber To	2H
Tammy	*
The Other Woman	Ens
Let's Be Cops	2H
Night at the Museum III	*

2013

The Heat	2H
We're the Millers	Ens
Identity Thief	2H
Anchorman II	*
Hangover III	Ens
This Is the End	Ens
Bad Grandpa	*

2012

Ted	2H
21 Jump Street	2H
Silver Linings Playbook	*
Think Like a Man	*
The Campaign	2H
Parental Guidance	2H
This Is 40	2H
Pitch Perfect	Ens

2011

The Hangover II	Ens
Bridesmaids	Ens
Horrible Bosses	Ens
Just Go with It	2H
Bad Teacher	*
Crazy Stupid Love	*
Zookeeper	*
Jack and Jill	2H
No Strings Attached	2H

Midnight in Paris	*
Friends with Benefits	2H

2010

Grown Ups	Ens
Little Fokkers	Ens
Date Night	2H
The Other Guys	2H
Valentine's Day	Ens
Due Date	2H
Sex and the City II	Ens
Get Him to the Greek	2H

2009

The Hangover	Ens
The Proposal	2H
Paul Blart: Mall Cop	*
It's Complicated	2H
Couples Retreat	Ens
He's Just Not That into You	Ens
Medea Goes to Jail	*
The Ugly Truth	2H
Zombieland	Ens
I Love You, Man	2H
17 Again	*
Bride Wars	2H
Night at the Museum II	*

2008

Hancock	*
Get Smart	2H
Four Christmases	2H
The House Bunny	*
Step Brothers	2H
Yes Man	*
Pineapple Express	2H
What Happens in Vegas	2H
27 Dresses	*
Fool's Gold	2H
Role Models	2H

Forgetting Sarah Marshall	*
Baby Mama	*

2007

Wild Hogs	Ens
Knocked Up	2H
Rush Hour III	2H
Superbad	2H
I Now Pronounce You	
Chuck and Larry	2H
Blades of Glory	2H
Evan Almighty	*
The Game Plan	*

2006

Talladega Nights	*
Click	*
The Break Up	2H
Failure to Launch	2H
The Santa Clause III	*
Pink Panther	*
Nacho Libre	*

2005

Wedding Crashers	2H
Hitch	*
The Pacifier	*
Fun with Dick and Jane	2H
The 40-Year-Old Virgin	*

2004

Meet the Fokkers	*
50 First Dates	2H
Dodgeball	*
Starsky & Hutch	2H
Along Came Polly	2H
Mean Girls	*
Anchorman	*
White Chicks	2H

2003

Bruce Almighty	*
Elf	*
Cheaper by the Dozen	*
Bad Boys II	2H
Bringing Down the House	2H
Something's Gotta Give	2H
Freaky Friday	2H
How to Lose a Guy in 10 Days	2H
American Wedding	Ens
Daddy Daycare	*
Legally Blonde II	*
School of Rock	*
Old School	Ens

2002

My Big Fat Greek Wedding	*
Austin Powers in Goldmember	*
Men in Black II	2H
The Santa Clause II	*
Sweet Home Alabama	*
Mr. Deeds	*
Maid in Manhattan	*
Two Weeks Notice	2H
Barbershop	Ens

2001

American Pie II	Ens
Legally Blonde	*
America's Sweethearts	2H
The Wedding Planner	2H
Saving Silverman	Ens

2000

What Women Want	*
Meet the Parents	*
Rush Hour II	2H

ABOUT THIS LIST

Obviously, "successful" is a relative term. I don't know the profit margin of each of these films. For the most part, movies made it onto this list because they earned over $50 million at the domestic box office.

Again, notice all the two-handers and ensemble comedies. Hollywood seems to be making more of both. Something to keep in mind.

11

MOVIE DIAGRAMS

As I've said, you should write your own diagrams. That being the case, you might as well have these, which I just happened to have sitting around. Please don't check every scene and page number to make sure I've correctly described them; you'd only be missing the point. I wrote them to help myself research and write comedy screenplays. I also wrote them to remind myself—over and over—that every scene needs action, that every comedy screenplay needs creative set pieces, and that I'll have to screenwrite my butt off to compete with the talented writers of these movies.

THE HEAT (2013)
Written by Katie Dippold

Act 1

FBI agent Ashburn (Sandra Bullock) FIGURES OUT where drugs and guns are hidden in a bust, but EMBARRASSES herself by being too cocky.

Ashburn TRIES to get a promotion from her boss, but he SAYS she's arrogant. He ASSIGNS her to a case in Boston and OFFERS to promote her if she does well.

Police Detective Mullins (Melissa McCarthy) JOKES while BUSTING a john for hiring prostitutes, despite him BEGGING her not to.

Mullins JOKES AROUND while BUSTING a drug dealer despite the john ESCAPING.

Ashburn INVESTIGATES a bad guy, then arrogantly tries to ACT cool despite almost causing a car accident.

Ashburn STEALS a parking space from Mullins despite Mullins BERATING her.

Ashburn DEMANDS access to the drug dealer Mullins busted despite the chief REFUSING.

Ashburn INTERROGATES him while Mullins STRUGGLES to park her car. (17)

Mullins DEMANDS Ashburn stop questioning her prisoner, but Ashburn REFUSES and they FIGHT.

The Captain GIVES the case to Ashburn despite Mullins BULLYING him.

Ashburn LECTURES Mullins about why Ashburn must lead the investigation. Mullins PRETENDS to agree, then STEALS documents from Ashburn.

Mullins DEMANDS her brother Jason give her information on her target, but he CLAIMS he has none.

Ashburn CONFRONTS Mullins about stolen documents and DEMANDS she leave the investigation.

Mullins REFUSES. Ashburn TRIES to get Mullins removed, but her boss MAKES her work with Mullins and THREATENS to deny her the promotion if she doesn't.

Act 2

Mullins FORCES Ashburn to admit she needs her, and they AGREE to go forward as a team.

Ashburn INTERROGATES a suspect the nice way, then Mullins INTERROGATES her the nasty way,

but she REFUSES to tell them anything. Ashburn cleverly GRABS a piece of evidence. (33)

Mullins tries to MAKE NICE with Ashburn by SHOWING Ashburn her home despite the fact that it's a pit.

Ashburn and Mullins INVESTIGATE with help from another FBI agent, who HITS ON Ashburn despite her IGNORING him.

A guy tries to romantically CONNECT with Mullins, but Mullins DISSES him despite Ashburn CRITICIZING her for it.

Ashburn BOASTS about solving a previous case, but Mullins MOCKS her.

Ashburn PLANS to plant tracking device on suspect but FAILS.

They PLAN to act like bar girls to get information, but Ashburn is uptight so Mullins GIVES Ashburn a makeover despite Ashburn RESISTING.

Ashburn DANCES her way into the target's arms.

A rival DEA Agent DETAINS them and TELLS them to drop the case but Ashburn and Mullins REFUSE. (50)

Ashburn NOTICES Mullins's brother Jason meeting with the main suspect in a video.

Ashburn ASKS Mullins to help her find Jason, but Mullins REFUSES.

Mullins BREAKS into Ashburn's house to LEARN more about her, and they BOND. (54)

They go to Mullins's family's house to find Jason. Mullins's family BERATES Mullins. Mullins BERATES them back.

Mullins DISCOVERS bad guys have tortured Jason. She FORCES Jason to TELL her that the bad guys killed a guy.

Ashburn and Mullins INVESTIGATE the dead body with the help of the Coroner and FIND a clue.

Other FBI guy GIVES them a clue and TELLS Ashburn to be nice to him.

Ashburn and Mullins SNEAK into bad guy's hideout and see a murder. Bad guys CAPTURE them, but they ESCAPE, KILL one bad guy, and ARREST the top bad guy.

Ashburn and Mullins DEBATE how to interrogate bad guy, but Mullins THREATENS him with a gun until he talks. (67)

Ashburn TELLS Mullins to back down, HURTING her feelings.

Mullins CONSOLES Ashburn by TAKING her to a bar. Mullins totally DISSES a sweet ex-lover she sees there. Ashburn CONFESSES to Mullins that she's divorced and has trouble meeting guys because she's so dedicated to her job. They BOND by PARTYING hard. (73)

Somebody BLOWS UP Ashburn's car. They DECIDE there is a mole giving information to bad guys. Ashburn LEARNS bad guys are THREATENING Mullins's family so they GO to Mullins's house without telling any higher-ups because of the mole.

They EVACUATE Mullins's family despite them FIGHTING each other.

They ARGUE about what to do next when guy in restaurant CHOKES on food and Ashburn GIVES him tracheotomy despite not knowing how to do it.

Jason GIVES them information about bad guys despite Mullins FIGHTING Ashburn because she wants him to come home and stop taking risks.

Ashburn ATTEMPTS a big bust, but she's wrong and there's no drugs so FBI Chief FIRES her from case.

Ashburn GOES to SUPPORT Mullins, but Mullins REJECTS her help.

They both separately INVESTIGATE case.

Act 3

Ashburn STICKS UP for Mullins in front of other agents.

Mullins BUSTS some bad guy, but bad guys get the drop on her until Ashburn SAVES her and they REUNITE to SEARCH for bad guy Larkin.

They BULLY suspect into giving them information.

They try to BUST the bad guys, but bad guys CAPTURE them and TORTURE Ashburn. Ashburn CONFESSES that her big bust from years ago was a mistake; a guy in prison must be innocent. They DISCOVER who the mole / bad guy is and ESCAPE, and they LEARN the bad guys will kill Jason.

They RUSH to hospital to SAVE Jason. Bad guy is about to kill Mullins, but Ashburn SAVES her.

They BOND as Ashburn goes to get treatment for a wound.

Everybody celebrates as Mullins gets award, and Ashburn DECIDES to stay in Boston. They BOND as sisters.

IDENTITY THIEF (2013)
Story by Jerry Eeten & Craig Mazin
Screenplay by Craig Mazin

Act 1

Diana (Melissa McCarthy) STEALS Sandy's (Justin Bateman's) identity and wildly PARTIES at a bar on his credit card until the

bartender STOPS her and she ASSAULTS him, getting arrested under Sandy's name.

At home with family, Sandy WORRIES about money and HOPES to get promoted.

Sandy's boss INSULTS him and makes him cut checks for other people to get bonuses.

Sandy CUTS the checks then FINDS OUT somebody in Florida is making appointments in his name.

Other employees OFFER him more money to leave the company and he AGREES.

Diana CHARGES lots of stuff on Sandy's cards.

Sandy LEARNS his cards don't work and his bill is huge.

Cops ARREST Sandy for Diana's crime in Florida, but the truth comes out and Sandy LEARNS it could take a year to stop Diana.

Sandy's new boss THREATENS to fire him, but Sandy MAKES a deal whereby he has one week to bring Diana to face charges to save his job.

Act 2

Sandy GOES to Florida and FOLLOWS Diana, but she CRASHES into his car. He CONFRONTS her, but she PUNCHES him and ESCAPES.

Sandy's wife GIVES him a clue and Sandy LEARNS where Diana lives.

Sandy SNEAKS into Diana's house, and they FIGHT until a bad guy BREAKS IN and they ESCAPE. (31)

Sandy DEMANDS that Diana come back with him to talk to his boss, and he PROMISES not to tell the cops.

Ashburn GOES to SUPPORT Mullins, but Mullins REJECTS her help.

They both separately INVESTIGATE case.

Act 3

Ashburn STICKS UP for Mullins in front of other agents.

Mullins BUSTS some bad guy, but bad guys get the drop on her until Ashburn SAVES her and they REUNITE to SEARCH for bad guy Larkin.

They BULLY suspect into giving them information.

They try to BUST the bad guys, but bad guys CAPTURE them and TORTURE Ashburn. Ashburn CONFESSES that her big bust from years ago was a mistake; a guy in prison must be innocent. They DISCOVER who the mole / bad guy is and ESCAPE, and they LEARN the bad guys will kill Jason.

They RUSH to hospital to SAVE Jason. Bad guy is about to kill Mullins, but Ashburn SAVES her.

They BOND as Ashburn goes to get treatment for a wound.

Everybody celebrates as Mullins gets award, and Ashburn DECIDES to stay in Boston. They BOND as sisters.

IDENTITY THIEF (2013)
Story by Jerry Eeten & Craig Mazin
Screenplay by Craig Mazin

Act 1

Diana (Melissa McCarthy) STEALS Sandy's (Justin Bateman's) identity and wildly PARTIES at a bar on his credit card until the

bartender STOPS her and she ASSAULTS him, getting arrested under Sandy's name.

At home with family, Sandy WORRIES about money and HOPES to get promoted.

Sandy's boss INSULTS him and makes him cut checks for other people to get bonuses.

Sandy CUTS the checks then FINDS OUT somebody in Florida is making appointments in his name.

Other employees OFFER him more money to leave the company and he AGREES.

Diana CHARGES lots of stuff on Sandy's cards.

Sandy LEARNS his cards don't work and his bill is huge.

Cops ARREST Sandy for Diana's crime in Florida, but the truth comes out and Sandy LEARNS it could take a year to stop Diana.

Sandy's new boss THREATENS to fire him, but Sandy MAKES a deal whereby he has one week to bring Diana to face charges to save his job.

Act 2

Sandy GOES to Florida and FOLLOWS Diana, but she CRASHES into his car. He CONFRONTS her, but she PUNCHES him and ESCAPES.

Sandy's wife GIVES him a clue and Sandy LEARNS where Diana lives.

Sandy SNEAKS into Diana's house, and they FIGHT until a bad guy BREAKS IN and they ESCAPE. (31)

Sandy DEMANDS that Diana come back with him to talk to his boss, and he PROMISES not to tell the cops.

A Drug Lord in jail TELLS the bad guys to kill Diana and Sandy.

Diana MAKES Sandy REALIZE they can't both fly since they have the same identity so he DECIDES to drive home with her. (37)

A skip tracer is hired and SEARCHES for Sandy.

At a restaurant Sandy TELLS Diana not to order much to save money, but she LIES to waitress to get more food.

Diana FLIRTS with a guy named Big Chuck and BRINGS him back to their hotel room for a threesome despite Sandy TELLING her not to.

Diana PLANS to drug Chuck and steal his car until he TELLS her he's a widower and needs love, TOUCHING her. So Diana HAS SEX with Chuck then STEALS his car until his kids CALL on phone and she breaks down and RETURNS his stuff.

The skip tracer CAPTURES Diana and DRIVES AWAY. Sandy CHASES in his car, and, to free her, Diana PUSHES Sandy to RAM the skip tracer's car and they CRASH. Sandy FREES Diana, and they CAPTURE the skip tracer and DRIVE away in his van.

A bad guy FORCES Big Chuck to POINT them to Sandy and Diana.

Sandy and Diana LEAVE skip tracer and WALK the road. Diana tries to BEFRIEND Sandy, but he RESISTS.

They CAMP OUT in the woods. A snake bites Sandy so he THROWS his pants away and Diana CARRIES him to a bus station.

They BUY a car and DRIVE.

The skip tracer and the bad guys FOLLOW them.

In the car Diana keeps YAPPING so Sandy SHAKES car to SHUT HER UP. (75)

They DECIDE to steal his old boss's identity to get money to keep traveling. They GO to the local branch of Sandy's employer and STEAL important records.

With the boss's credit card, Sandy PREPARES to drive home, but she DEMANDS to take a break, so they LIVE it up at a hotel. Diana GETS a makeover. Sandy and Diana BOND. Sandy PUSHES her to reveal stuff about herself and she REVEALS she had a rough life and never even knew her real name so he feels sorry for her and EXPRESSES affection for her despite her RESISTING his affection.

Police ARREST them for fraud. (89)

Act 3

The bad guys FIGHT each other.

Diana BUSTS her and Sandy out of the cop car, and they ESCAPE.

Cops CATCH the skip tracer and the bad guys.

Sandy THANKS her for helping him, and they DRIVE home.

Diana CHARMS Sandy's family.

Diana TELLS Sandy's wife he loves her, and wife is touched. Sandy CONSIDERS turning Diana in for her crimes, and wife URGES him not to. Sandy DECIDES not to turn Diana in, but Diana SURRENDERS to cops and CLEARS Sandy's name.

A year later, Sandy and family VISIT Diana in jail and she's studying to improve her life. Sandy GIVES Diana her birth certificate so now she knows who she is. Diana PUNCHES a guard.

NEIGHBORS (2014)
Written by Andrew Cohen & Brenden O'Brien

Act 1

Mac (Seth Rogan) and Kelly (Rose Byrne), married, try to HAVE SEX while their baby watches.

Mac and Kelly HOPE a nice couple moves in next door.

Mac's boss PRESSURES him to work faster. Mac and his friend Jimmy SNEAK OFF and GET HIGH at work. (5) Jimmy BOASTS of singlehood, which makes Mac feel old.

Jimmy's ex-wife PUSHES Mac and Kelly to go to a dance club, and they DECIDE to bring the baby. PREPARING to go with baby takes forever, and they fall asleep and miss going out. (10)

Teddy (Zac Ephron) and his rowdy fraternity MOVE IN next door. Mac and Kelly DEBATE how to tell them to keep it down.

Mac and Kelly meet Teddy and try to ACT cool by smoking pot before asking him to keep it down.

The frat guys CELEBRATE their history of partying and BOND.

Mac and Kelly COMPLAIN about the noise, and Teddy ASKS them into party to get them on his side.

Teddy and the frat PARTY hard with Mac and Kelly despite their baby being left alone next door.

Teddy MAKES Mac and Kelly PROMISE to call him before calling cops if the frat gets too loud and rowdy.

Act 2

The frat PARTIES hard. Mac and Kelly CALL the cops, but Teddy CONVINCES the officer to ADMONISH Mac and Kelly by SHOWING video of Mac and Kelly partying from the night before, and the cop SAYS don't call us again.

Teddy and the frat HARASS Mac and Kelly in a variety of ways (montage).

Mac and Kelly try to RALLY other neighbors, but the frat CURRIES favor with the neighbors to stop them.

Mac and Kelly try to SELL their house, but the realtor SAYS nobody will buy it because of the frat house next door.

Mac and Kelly SEEK help from the dean, but she SUPPORTS the frat.

Mac and Kelly DECIDE to SABOTAGE the frat house.

Mac secretly BREAKS a pipe at the frat house causing a flood that the frat can't afford to fix.

Teddy COMES up with an idea to sell sex toys and MAKE money to pay for repairs, which works and allows them to BUY a hot tub and have bigger parties.

Kelly COMES UP with a new plan to destroy the frat.

Kelly, Mac, and their friends go to a frat party and try to TRICK the guys into fighting over women.

Kelly MAKES Pete (Teddy's second-in-command of the frat) KISS Teddy's girlfriend while Mac DIVERTS Teddy in a dance-off.

The plan works, and Teddy and Pete FIGHT.

Mac PROMPTS them all to throw stuff off the porch, and they HURT some guy walking past.

Mac and Kelly CELEBRATE by having sex.

Kelly starts to FEED baby, but Mac STOPS her because she has alcohol in her system, and she DEMANDS he MILK her and he DOES.

The Dean PUTS the frat on probation for hurting the guy on the street.

Teddy and Pete BOND as friends again.

Teddy tries to GET a job, but his grades suck so he fails. (53)

Teddy TEASES Mac in the front yard.

Mac and Kelly CONVINCE their friend to help them sabotage the frat despite his reluctance.

Mac and Kelly CONVINCE a frat pledge to wear Google glasses to record secret hazing rituals, but Teddy FINDS OUT and FOILS the plan.

The frat guys BOOBY TRAP stuff and HURT Mac and his buddy.

Kelly DEMANDS they stop the war, but Mac REFUSES and she WALKS OUT.

Pete QUESTIONS if the frat is going too far. (63)

Teddy REFUSES to back down and ADMIT he's scared to graduate and grow up despite Pete trying to REASON with him.

Teddy TELLS Mac and Kelly that even after he graduates the next frat guys will still torment them.

Mac and Kelly DECIDE they must get rid of the frat house.

Act 3

Mac and Kelly CONVINCE Teddy the probation was lifted.

Teddy PLANS a big party, and Mac and Kelly INVITE street people to ruin it.

Teddy DISCOVERS he's been duped and tries to BREAK UP the party.

Mac calls the cops, but when they get there there's no party so Mac SNEAKS into house to turn stuff back on. Teddy CATCHES him and they FIGHT.

Kelly BRINGS the cops back, and they BUST the party.

Teddy TELLS Pete to LEAVE the frat because Pete has a future.

Months later, Mac and Kelly ENJOY being old parents.

GET HIM TO THE GREEK (2010)
Written by Nick Stoller

Act 1

Rock star Aldous (Russell Brand) and wife Jackie PROMOTE his new album, *African Child*.

Fans REJECT the album. Jackie REJECTS Aldous for being sober and boring, DIVORCES him, and GAINS custody of their son.

Aldous's dad PUBLISHES a book taking credit for his success. Aldous DRINKS and PARTIES, making the media WONDER if he's washed up for good. (5)

Aaron (Jonah Hill), a young record company executive, tries to CHEER UP his overworked girlfriend, Daphne.

Sergio, Aaron's record company boss, BERATES his employees for not bringing him any good ideas. Aaron PITCHES the idea of an Aldous comeback concert, but Sergio REJECTS it. (10)

Aaron tries to INCLUDE Daphne in his record industry socializing, but she's too tired from work and REFUSES.

Sergio TELLS Aaron that Aldous will do the concert and GIVES Aaron the job of bringing Aldous from England to the show in seventy-two hours.

Sergio LECTURES Aaron on how to treat Aldous and tells him this is his one chance to make it in this business. (16)

Aaron TELLS Daphne about his big chance, and she TELLS him she has a new job in Seattle and they should move there. He REFUSES to move there, and they FIGHT and "TAKE a break" from relationship. (20)

Act 2

Aaron FLIES to London and MEETS Aldous. Aldous wrongly ACCUSES Aaron of changing the date of the show, and Aldous chooses to AGREE and APOLOGIZES.

Aaron tries to MAKE Aldous get to the airport to go to L.A. despite Aldous IGNORING him and ARGUING with his mother in front of Aldous.

They GO to a restaurant, and Aaron again tries to MAKE Aldous go to the airport, but Aldous AVOIDS doing so and PUTS Aaron on the spot, FORCING him to KISS his ass by saying he loves *African Child* even though he hates it.

Aldous PARTIES instead of going to the airport so Aaron tries to CONVINCE him to go. Instead, Aldous CONVINCES Aaron to have sex

with a groupie, and Aaron DOES. They PARTY even harder. Aaron wakes up with little time left for the flight.

Aaron PUSHES Aldous to get to the airport, and they barely make it.

On the plane to NYC, Aldous ASKS Aaron why people now hate his music. Aaron makes the mistake of TELLING him why, and now Aldous SAYS he hates Aaron. (30)

Driving to the *Today Show*, Sergio calls and TELLS Aaron to keep Aldous sober. To keep Aldous from smoking weed and drinking booze, Aaron starts SMOKING and DRINKING it all up.

Drunk, Aaron goes to the *Today Show* with Aldous, but Aldous FORGETS lyrics to "African Child," so he DEMANDS that drunk Aaron get him the lyrics. Aaron tries to GET them, but Aldous SAVES the day by CHANGING songs and WINNING the crowd over.

Daphne CALLS to make up, and Aaron SAYS they're broken up.

Aaron tries to CONVINCE Aldous to go to the concert, but Aldous BROODS over his dad, whom he hasn't seen in years. Aldous makes Aaron DRINK absinthe; they get really high and PARTY more. Daphne CALLS again and overhears Aaron HITTING ON a woman. (43)

Aldous BROODS over his ex-wife Jackie so he CALLS her and LEARNS Jackie has a new boyfriend, but Aldous SWEET TALKS her anyway.

Before getting on plane to L.A., Aldous BUYS heroin and DEMANDS Aaron smuggle it in his rectum. Aaron calls Sergio for help, and Sergio ORDERS him to smuggle it. Aaron SMUGGLES the drugs.

Before the plane for L.A. takes off, Sergio DECIDES to visit his dad in Vegas, and they FLY to Vegas instead.

On the plane, Aaron REFUSES to give drugs to Aldous until after the show.

In Vegas, Aldous DEMANDS the drugs, and Aaron REFUSES. They FIGHT and Aaron DESTROYS the heroin.

Aldous MAKES Aaron get more drugs despite not knowing anyone in Vegas. (66)

Aaron tires to SCORE heroin in Vegas and FAILS when the dealer gets stabbed and Aaron TAKES him to the hospital.

When he ADMITS failure to Aldous, Aaron LEARNS that Aldous already scored the drugs.

They go to MEET Aldous's dad despite Aldous REPRESSING his love for him. His dad PRO-VOKES trouble by CRITICIZING Aldous, but Aaron ENCOURAGES Aldous to invite Dad to the show in L.A. and Aldous DOES.

As Aaron is LYING to Sergio over the phone, Aaron ARRIVES in Vegas and PLANS to "mind fuck" Aldous into leaving Vegas for L.A. (61)

Aaron tries to LEAVE and go to bed, but Sergio MAKES him have sex with a groupie who HURTS him.

Aldous and his dad BOND playing music but then FIGHT when Dad tries to take credit for Aldous's success.

Aldous and his dad CONVINCE Aaron to smoke a joint, but it has angel dust in it and Aaron FREAKS OUT.

Aldous's dad INSULTS Aldous's mom so Aldous and his dad FIGHT. Meanwhile Aaron freaks out, overdosing, so Aldous INJECTS him with adrenaline to save him. Sergio and Aldous's dad FIGHT more and more and CAUSE a fire. Finally Sergio CHASES Aldous and Aaron into a limo going to L.A. (72)

In the car to L.A., Aaron TELLS Aldous he's going to beg Daphne to take him back and ADVISES Aldous to do the same with Jackie.

Act 3

Aldous BEGS Jackie to take him back and get married, but she REFUSES and SAYS his son, Naples, is not actually his son.

Aldous BONDS with Naples and tries to DISTANCE himself (by getting him to stop calling him Dad) from Naples, but he cannot; he loves him.

Aaron BEGS Daphne to take him back and she REFUSES, but Aldous INTERVENES and SUGGESTS they have a threesome, and Daphne AGREES. They FOOL AROUND until Aaron STOPS and gets angry at Aldous because this idea is crazy. Aaron and Daphne REUNITE. (86)

Aldous is depressed and thinks maybe he won't do the show, so he SEEKS consolation from his mom and she CONSOLES him.

Minutes before the show, Aldous CONSIDERS suicide and BEGS Aaron for help.

Aaron shows up to see Aldous JUMP off a roof into a pool. Then Aldous APOLOGIZES to Aaron and EXPLAINS his depression. (91) Aaron MAKES Aldous feel good about himself. Aldous DECIDES to do the show despite being injured.

When Sergio tries to DRUG Aldous to perform despite his injury, Aaron QUITS working for Sergio.

Aaron BEGS Aldous not to do the show because he doesn't need to, but Aldous DOES the show because he feels happy now.

Six months later, Aaron—who now lives in Seattle with Daphne—is happily WORKING with Aldous on a new live show.

SILVER LININGS PLAYBOOK (2012)
Screenplay by David O. Russell based on the novel by Matthew Quick

Act 1

Pat (Bradley Cooper), in a psychiatric hospital, PRACTICES the speech he hopes to give his ex-wife Nikki to win her back.

Pat leaves the hospital and LIES to his mom to MAKE her drive his friend Danny home, too.

Pat comes home, but Pat Sr., his dad, WORRIES Pat left the hospital too soon. Pat Sr. lost his job, is now a bookie, and is planning to open a restaurant when he gets enough money. Pat SAYS he wants to win Nikki back, but his parents DISCOURAGE him.

Pat READS books related to Nikki so he can understand her, but THROWS a fit and WAKES parents when he TAKES ISSUE with something in a book by Hemingway.

Pat THROWS a fit when he hears his wedding song at his therapist's office.

In therapy, the therapist ADMITS he played that song to test Pat. Pat ACKNOWLEDGES beating up his ex-wife's boyfriend, lying to police about them, and being bi-polar.

At home, Pat REFUSES to take his meds, but his parents INSIST. Pat Sr. INSISTS Pat watch the football game with him and bring good

luck. His mom WARNS him to stay away from
Nikki. (16)

Pat VISITS Ronnie, his old friend, who INVITES
him to dinner despite his wife, Veronica, hating
Pat. Pat ACCEPTS.

Pat tries to call Nikki, but Pat Sr. STOPS him.
They STRUGGLE. Police Officer Keogh VISITS to
WARN Pat to respect the restraining order
against him. (21)

Pat's therapist ADVISES him to GET a strat-
egy to deal with his problems.

At dinner with Ronnie and Veronica, Ron-
nie CONFESSES his own fears and pressures.
Ronnie INTRODUCES Pat to Tiffany (Jennifer
Lawrence). Pat CONFRONTS her with awkward,
insensitive questions despite Ronnie TELL-
ING him not to. (26)

Act 2

Pat and Tiffany TRADE talk about their meds
and DISCOVER they both have serious issues.
Tiffany DECIDES to leave despite Veronica's
anger. Tiffany ASKS Pat to have sex, but he
REFUSES because he's "married," so Tiffany
SLAPS Pat and leaves.

Pat loses control and SEARCHES for his wed-
ding video in middle of the night despite
angering his mom and dad. They all FIGHT and
HIT each other. Officer Keogh WARNS Pat to
calm down and SAYS he must write a report
that Nikki will see, but Pat BEGS him not to.

Tiffany CHASES him on the street to CONFRONT
him, and they REVEAL painful truths about
themselves.

Pat's shrink ADVISES him to get closer to Tiffany. Pat ASKS him to deliver a letter to Nikki, and the shrink REFUSES.

Tiffany CHASES Pat again, and he INVITES her to dinner.

Pat and Tiffany SHARE depressing stories of their lives. Tiffany OFFERS to get a letter to Nikki for Pat, but Pat blows it by SAYING he's not as crazy as her, and she TAKES back her offer and LEAVES, but he CHASES. They ARGUE, and she BERATES him for judging her and GETS other people to come to her aid. Officer Keogh shows up and RESTRAINS him. Pat FREAKS OUT, but Tiffany SOFTENS and HELPS him through it. Officer Keogh PROPO-SITIONS Tiffany and she LEAVES, hurt. Pat CHASES her and she AGREES to deliver his letter. (52)

Pat tries to VISIT Tiffany but she HIDES. Another guy comes to VISIT Tiffany for sex, and Pat ESCORTS him away to PROTECT Tiffany. Tiffany CHANGES her offer to help Pat and now will only help him if he dances in a contest with her. (58)

Danny comes over, LYING, saying he was released from the hospital. Everybody WARNS Pat to leave Nikki alone. Pat's brother shows up, and Pat LOVES him despite his brother BOASTING about his life being better than Pat's. Officer Keogh ARRESTS Danny.

Pat tries to DANCE with Tiffany despite wanting to stop. Tiffany TAKES Pat's letter and PROMISES to give it to Nikki despite not wanting to. Tiffany REVEALS how her late husband died, and Pat UNDERSTANDS her a lit-tle more. They BOND while dancing.

Tiffany strictly CONTROLS Pat during their dance rehearsal. Danny (out of the hospital again) TEACHES them even better moves.

Pat Sr. BEGS Pat to watch games with him and bring their team good luck because he's betting all his money against his friend Randy on the next game so he can pay for his restaurant, and he BEGS Pat to attend the game with his brother, Jake. But Pat RESISTS because he already agreed to rehearse the dance with Tiffany. (76)

Pat ASKS Tiffany if he can miss some of their rehearsal to be at the game, but she REFUSES to let him and TELLS him Nikki wrote him a letter back. She DEMANDS he practice dancing more before she'll let him read, and he tries to PRACTICE but gives up and BEGS to see the letter, and she GIVES it to him. He READS the letter from Nikki in which Nikki tells him to "show me something," which Tiffany USES to ARGUE he should work hard on the dance contest.

At the game, Pat tries to STAY out of trouble, but a fight starts and he can't so he FIGHTS and is arrested.

Pat Sr. BERATES Pat and ACCUSES him of causing the team to lose. Tiffany CONVINCES Pat Sr. that she is good for Pat's luck. Pat Sr. and Randy COMPETE to bet more, and they BET everything on whether the Eagles can win the next game and Pat and Tiffany score at least a "5" in the contest. Pat REFUSES to dance. Tiffany CONVINCES Pat's parents to LIE to him and say Nikki will be at the dance to get him to dance. Pat REALIZES Tiffany wrote the letter she gave him, not Nikki.

At the contest, Tiffany is HOLDING it together until she sees Randy and Veronica brought Nikki to the dance. Tiffany DRINKS and starts FLIRTING with men. Tiffany CONFESSES she wanted him but now hates him, but Pat MAKES her dance.

They DANCE well enough to WIN the bet for Pat Sr. Pat TELLS Nikki he doesn't want to get back together. Tiffany MISUNDERSTANDS and RUNS AWAY. Pat Sr. ADVISES Pat to chase her, and Pat CHASES her. Pat DECLARES his love for Tiffany, and they KISS.

THIS IS THE END (2013)
Screenplay and Screen Story by Seth Rogen & Evan Goldberg

Act 1

Jay Baruchel VISITS Seth Rogen in Los Angeles. Seth PICKS Jay up at airport.

Seth and Jay PARTY. Seth INVITES Jay to party at James Franco's house. Jay REFUSES to go, but Seth PLEDGES that he will be with Jay the whole time. They BOND.

At party, Franco BONDS with Seth, but Jay RESISTS enjoying the party because he resents Franco's friendship with Seth. Jay HANGS back at the party and CRITICIZES everything because he hates L.A.

Everybody NOTICES Jay is unhappy, and some of them TELL Seth to dump him.

Jay LEAVES the party, and Seth FOLLOWS, trying to CONVINCE him to start enjoying L.A. and make friends with his friends, but Jay REFUSES.

A huge cataclysm happens, and they RUN back to the party.

At the party, nobody BELIEVES Jay about what happened, and Seth DENIES it happened so he won't look foolish to his friends.

Then the cataclysm happens at the party, killing everybody except Seth, Jay, Franco, Craig Robinson, and Jonah Hill. (23)

Act 2

They LEARN there was a huge earthquake.

Jay SAYS he wants to go to Seth's house, but Seth SAYS he wants to stay.

They BOARD up the house with Franco's paintings and ARGUE over who can eat what provisions.

Franco TAKES a gun to bed for protection.

They all HUDDLE in one room out of fear.

Danny McBride comes over, COOKS all their food, and REFUSES to believe the cataclysm happened.

A man TRIES to get into the house. They ARGUE over whether to let him in.

They ARGUE and try to FIGURE OUT what's happening.

They JOKE around.

Emma Watson COMES IN and TELLS her story, but nobody knows what's going on yet.

They ARGUE about whether somebody might harm Emma, and she HEARS them so she STEALS their water and LEAVES. (49)

They ARGUE over who should go get more water and DRAW LOTS. Craig GOES for water wearing a safety rope.

They fail to HOLD onto safety rope attached to Craig, and he STRUGGLES out there alone against a mystery beast.

Franco SAYS there's water under the house so they DIG.

Craig expresses fear to Jay, and Jay REAS- SURES him while Danny LISTENS.

Franco BERATES Danny for using his porno mag, and Danny WALKS OFF.

Danny REFUSES to live by the rules and WASTES water.

They TELL Danny to leave.

Danny TRIES to shoot them all, then TELLS everybody that Jay once came to L.A. and didn't meet up with Seth, then Danny LEAVES.

Jonah CRITICIZES Jay, and Jay PUNCHES him.

Jonah ASKS God to kill Jay so Jonah can have him all to himself as a friend.

A beast ATTACKS Jonah in the night, and Jonah KEEPS it a secret.

They DRAW STRAWS to see who'll get water. Seth DRAWS short straw but REFUSES. Jay VOL- UNTEERS and Craig GOES too. (72)

The beast POSSESSES Jonah and SAYS the world is ending.

At another house, Jay and Craig FIND FOOD, and Jay SAYS let's stay here and not return, but Craig REFUSES.

A monster ATTACKS Craig and Jay, who RUN.

Possessed Jonah ATTACKS Seth and Franco, and they HIDE but Seth breathes too loudly.

They reunite, BEAT UP, and TIE UP possessed Jonah.

They PONDER the end of the world and whether they are good or bad people.

Craig REVEALS he once hurt a man badly and thinks he'll being punished for it by God.

Jay tries to EXORCISE Jonah, but Seth STOPS him because he thinks it won't work.

Jay ACCUSES Jonah of selling out (over the years), and Jonah ACCUSES Jay of not growing up.

They FIGHT and a fire starts. Jonah is killed in fire, and they LEAVE the house.

Act 3

Outside a dragon CONFRONTS them, and Craig OFFERS to sacrifice himself to save them because he thinks it'll make up for the evil he did when he was young.

Craig CONFRONTS a dragon and is saved, sucked up to Heaven.

Seth, Jonah, and Franco REALIZE they can be redeemed if they do good deeds.

Danny and a bunch of cannibals CAPTURE them.

Franco SACRIFICES himself to save Jonah and Seth, who ESCAPE, and is redeemed until he BOASTS about it and the redeeming stops and Danny EATS Franco.

A huge monster appears. Jay and Seth CONFESS their sins against each other and DECIDE to die together, but only Jay is redeemed.

Seth GRABS on to Jay, and Jay PULLS him up, but the monster FOLLOWS them until Seth DECIDES to drop off to save Jay.

Seth is redeemed for his sacrifice, and they both go to Heaven, and all is wonderful.

21 JUMP STREET (2012)
Story by Michael Bacall & Jonah Hill
Screenplay by Michael Bacall

Act 1

Flashback eight years ago: Schmidt (Jonah Hill), a nerd, ASKS girl to prom, but Jenko (Channing Tatum), a jock, HUMILIATES him.

The principal BARS Jenko from prom because his grades suck.

Present day: They meet at the police academy, where Jenko FAILS exam, so he ASKS Schmidt to be friends and help him. Schmidt AGREES.

They BOND as they help each other graduate.

As cops, they HATE their boring patrol jobs.

They SCREW UP a bust of drug dealers who go free. (9)

Their boss TRANSFERS them to a high school infiltration program where they will pose as students to find drug dealers in a high school. (11)

Their new boss (Ice Cube) INITIATES them, BERATES them, and GIVES them their mission.

Schmidt CONFESSES his fears of going back to high school.

Schmidt's parents EMBARRASS him in front of Jenko.

Jenko PREPARES Schmidt for his first day of school by EXPLAINING to him how to be cool. Schmidt WORRIES Jenko won't be his friend in school despite Jenko's promise to stay friends.

Act 2

They try to ACT COOL on the first day, but what constitutes cool has changed. Jenko PUNCHES a kid.

The principal THREATENS to expel them both. They FORGET their fake identities, and the principal GIVES them their schedules, which are the opposite of what they expected.

Schmidt TRIES to find the drug dealer and FLIRTS with Molly, a cute girl.

Jenko LIES to AVOID being discovered as an adult cop. A teacher FLIRTS with Jenko. (30)

Jenko and Schmidt MAKE drug deal, but dealer FORCES them to take the drugs.

They STRUGGLE to throw the drugs up.

The track coach CATCHES them in a hallway and FORCES Schmidt to join the track team.

They GET HIGH from the drugs and CONTINUE with their classes while tripping. They MAKE fools of themselves, but some students DECIDE they're cool. (39)

Jenko SEEKS study help from a nerdy kid and DISCOVERS the kid can turn cell phones into body mics.

Schmidt PROPOSES throwing a party to infiltrate cool kids who hang with the drug dealer.

Schmidt ASKS Molly to the party and FLIRTS with her despite his mom almost blowing his cover.

Their boss WARNS them not to throw a party. They LIE and say they won't.

They PREPARE for party by BUYING booze and drugs.

At party, Jenko STEALS drug dealer's cell phone and GIVES it to the nerdy guys to hot wire into a mic.

Dealer starts to LEAVE, but cell's not hot-wired yet so Jenko PUSHES nerds to hurry.

A new, even badder drug dealer THREATENS the old dealer, and Schmidt INTERVENES, THREATENING to fight him. The new dealer PUNCHES him, and Schmidt TRIES to get out of the fight. Jenko FIGHTS a bunch of guys to HELP Schmidt, but Schmidt DEFEATS a bad guy, IMPRESSING everybody at party. (52)

Schmidt's parents GET HIGH while returning to house.

Schmidt and Jenko RULE at the party.

Parents BREAK UP party while dealer ASKS Schmidt to work with him selling drugs.

Jenko TELLS Schmidt he bugged dealer's phone, but Schmidt DISAPPROVES and thinks it'll get them caught.

Schmidt BEFRIENDS dealer but DISTANCES himself from Jenko, who dealer thinks is uncool. (56)

Jenko FINDS OUT dealer's going somewhere, so he INTERRUPTS Schmidt's school play and they SURVEIL dealer, who MEETS with bad guys Jenko and Schmidt busted when they were patrol cops.

Jenko and Schmidt STEAL a driver's ed car and FOLLOW the bad guys.

They ARGUE about how to drive and RUN INTO the bad guys, causing bad guys to CHASE them.

Chased by bad guys, Schmidt TRIES to TEXT with Molly as he's late for the play. They STEAL another car.

They RETURN to the play. Jenko ACCUSES Schmidt of being in too deep, but Schmidt DENIES it.

Schmidt BARGES into the play, RUINING it, ALIENATING Molly. Jenko FIGHTS Schmidt onstage. They RUIN everything, MAKING a big scene. The principal EXPELS them both. (78)

Their boss FIRES them.

Act 3

The dealer ASKS them to PROTECT him at prom, where big deal goes down.

They PREPARE for the prom, but Mom makes them DO chores first.

They BECOME friends again and PREPARE to bust dealer at prom.

They BRING nerds to prom and GET them escort dates.

Schmidt LEARNS Molly is high, TELLS her he's a cop, and TELLS her to leave.

They GO to the big meeting with the supplier, and they LEARN the supplier is the track coach.

The bad guys LEARN they're cops, and they SHOOT IT OUT.

The track coach and the dealer ESCAPE, and Schmidt and Jenko CHASE.

Jenko USES chemistry stuff he learned in class to MAKE bomb to kill bad guys.

Schmidt SAVES the day by SHOOTING track coach, and Molly KISSES him.

PARENTAL GUIDANCE (2012)
Written by Lisa Addario & Joe Syracuse

Act 1

Artie (Billy Crystal), a sports commentator, ANNOUNCES a local baseball game on the radio, which he REVELS in.

The boss FIRES him for being old and outta touch.

Diane (Bette Midler), his wife, REASSURES him. Artie REJECTS teaching as an alternative and SAYS he wants to announce for the Giants despite Diane SAYING that'll never happen.

Alice (Artie and Diane's daughter) STRUGGLES to take care of kids while working from home.

Phil, her husband, DECLARES they're going on a business trip related to the automated cyber-house he designed (which they live in) that does everything for them. They STRUGGLE to DECIDE who can watch kids while they're gone. They WORRY that Artie and Diane will CRITICIZE how they raise their kids.

Phil and Alice ASK Artie and Diane to watch kids. Diane SAYS yes, but Artie TELLS Diane no because he thinks Alice disapproves of him, but Diane MAKES Artie agree to go. (12)

The kids (Harper, Turner, Barker) WORRY because they don't want grandparents to watch them.

Artie and Diane GIVE kids presents that RANKLE the kids and parents because they're so out of touch.

Artie TELLS cute story about Alice that TOUCHES her, but Alice struggles to HIDE the fact that she doesn't keep photos of her parents because she's not close with them.

Artie and Diane REALIZE they're the "other grandparents," the ones that aren't favored by the family.

They all go to a Chinese restaurant where the parents INSTRUCT the grandparents on how to parent, which ANNOYS Artie, while Diane tries to PLAY ALONG. (23)

Artie TOUCHES Barker's food, which MAKES him angry.

Phil and Alice struggle to LEAVE for their trip, while kids try to KEEP them from leaving.

Act 2

The grandparents struggle to FEED the kids despite the kids DEMANDING everything be exactly the way their parents serve it.

Artie and Diane struggle to TAKE kids to school despite Barker WEARING women's shoes. Artie PAYS him to change shoes.

Alice RETURNS for a while and REVEALS that she works for ESPN, which INTERESTS Artie.

Kids at school BULLY Turner, and Artie TRIES to help, but Alice STOPS him because Turner's therapist says not to.

Artie struggles to DROP Barker at school but can't get him out of car seat, so he TAKES him out *in* the seat.

Diane SUSPECTS Alice came back because she doesn't trust them with the kids.

Artie FORGETS to pick Alice up from where he dropped her off, making ALICE RESENT him more for being a bad dad to her over the years.

Artie WATCHES Barker's speech therapy, then QUESTIONS therapist's methods, then accidentally HURTS Barker when Barker overhears conversation.

Diane and Alice ENTERTAIN Harper by singing for her and BONDING.

Artie LEARNS from Turner how to talk to kids these days, then TALKS using modern kid lingo to Barker to APOLOGIZE. Barker AGREES to forgive Artie if he lets him watch a grown-up horror movie.

Artie secretly READS Alice's email and LEARNS about a job possibility for him and APPLIES.

Artie BREAKS Alice's rules and CAUSES family breakdown that scares Alice and CONFIRMS her worst fears that Artie can't parent.

Alice DELAYS her trip again to stay and help watch kids.

Diane BERATES Artie for screwing up and WARNS him that they'll blow it as grandparents if he doesn't "shape up."

Diane WATCHES Harper's violin lesson and PRAISES her, but violin teacher BULLIES her for not practicing enough so Diane THREATENS to hurt the teacher.

At baseball game, Artie REMINISCES with Alice about her youth but doesn't tell her he lost his job. Turner PITCHES well, but Artie COMPLAINS about super-sensitive rules for kids' baseball until a kid HITS Artie.

Unable to pull herself away from the kids, Alice REFUSES to go be with Phil, saddening him.

Diane PUSHES Alice to go be with Phil, ADVISING her that she needs to support her husband.

Artie and Diane GIVE UP trying to parent like Alice and Phil. They DECIDE to parent their way now. Alice LEAVES.

Artie FANTASIZES about calling games for the Giants.

Artie and Diane take kids to city but struggle to HELP Barker use bathroom until Artie USES his old parenting skills.

At the symphony, Barker ACTS OUT and Artie is about to SPANK him when everybody there sees this and he SERMONIZES to them about how parents these days should just say "No."

Artie PRETENDS to be his own agent to SCHEDULE audition for himself. (57)

Artie and Diane try to MAKE kids eat just one meal like an old-fashioned family.

Artie GIVES life advice to Turner.

Artie must BRING Barker to audition for the job of announcer at a skateboarding event and starts WINNING them over until Barker PEES on Tony Hawk, causing a disaster.

Artie LEARNS Turner got beat up using his advice so he GIVES Turner new advice.

Artie and Diane TEACH kids to play kick-the-can, a game from their era, and kids ENJOY it.

Alice and Phil ENJOY their trip until they see video on TV news about their kid at the skateboarding event and get super worried. (73)

Artie and Diane BOND over an old song and kids happily WATCH.

Artie ADVISES Barker how to deal with his imaginary friend, but it backfires and kid THROWS tantrum.

Alice and Phil RETURN to find family in disarray, and all Artie's lies are revealed.

Alice FINDS OUT all the things Artie and Diane have done, and the kids REBEL.

Alice BLAMES her parents. They all have a big fight.

Diane ADMONISHES Artie for selfishly auditioning when he should have been watching Barker.

Act 3

Phil TELLS Alice that Artie and Diane didn't do so bad, and Alice ADMITS she can never let Artie be right.

Artie APOLOGIZES to Alice for everything, CONFESSES that he lost his job, and TELLS Alice he doesn't feel welcome in her home. Alice ASKS why they don't get along anymore, and he SAYS she REJECTED him once she grew up, which hurt him, and he PRAISES her for being a great mom, which touches her.

To help Barker, they BURY his imaginary friend, and Artie IMPRESSES family by GIVING eulogy despite not approving of how the parents tolerated Barker having an imaginary friend.

At Harper's violin audition, Alice sees Harper doesn't want to do it, so Alice ALLOWS Harper to ditch the audition, WINNING Harper's love back while Turner steps on stage and GIVES the perfect speech that Artie taught him, CURING himself of his stutter and MAKING Alice happy.

FINAL THOUGHTS ON MOVIE DIAGRAMS

I wrote all of these diagrams. They merely constitute my subjective assessment of the stories presented in the movies. I show them for purely academic value. I've given the names of the screenwriters in order to fully credit these awesome writers for their work.

ABOUT GREG DEPAUL

Greg DePaul grew up in Maryland and graduated from New York University. After college, he worked for *The Washington Post* and earned a Master of Fine Arts in Playwriting.

In 1996, Greg moved to Hollywood to become a screenwriter, and that's just what happened. He wrote with Hank Nelken, and the pair sold numerous comedy screenplays, including *Saving Silverman*, which was produced by Columbia Pictures and starred Jack Black, Jason Biggs, Steve Zahn, Amanda Peet, and Neil Diamond.

Later, Greg wrote *Bride Wars*, produced by Fox New Regency, starring Kate Hudson, Anne Hathaway, Chris Pratt, and Candice Bergen. The movie grossed $115 million worldwide and was recently re-made in China. Greg has sold screenplays to Miramax, Sony, Disney, Fox, MGM, and Village Roadshow studios.

Greg teaches screenwriting at New York University and The New School for Public Engagement. His plays have been performed in New York and Los Angeles. He lives in the New York City area with his lovely wife, Dvora, and two wonderful children, Max and Sophie.

To learn more about comedy screenwriting, go to **bring thefunny.com**. To learn more about Greg, go to **gregde paul.com**.

INDEX

35308556R00129

Made in the USA
Middletown, DE
04 February 2019